LANDSCAPE
PHOTOGRAPHER OF THE YEAR

COLLECTION 4

Senior Art Editor: Nick Otway @ Alphaforme
Managing Editor: Paul Mitchell
Image retouching and colour repro: James Tims
Production: Rachel Davis
Indexer: Hilary Bird

Produced by AA Publishing
© AA Media Limited 2010
Reprinted September 2011

Published by AA Publishing (a trading name of AA Media Limited, whose registered
office is Fanum House, Basing View, Basingstoke RG21 4EA; registered number
06112600).

A04798

ISBN: 978-0-7495-6736-1

A CIP catalogue record for this book is available from the British Library.

Printed and bound in the UK by Butler Tanner & Dennis Ltd, Frome

theAA.com/shop

GREAT BRITISH BOOKS
PUBLISHED & PRINTED IN THE UK

BRIAN CLARK ⋯⫸

Ice Flowers, Rannoch Moor, Scotland

Several days of freezing weather produced this field of ice flowers on Rannoch Moor. The
cloud cover enabled me to shoot into the light, which revealed much of the detail on the
ice crystals. The star shaped ice pattern in the middle ground leads the eye towards the
mountains in the distance. By the following morning, the frozen loch was covered by 18
inches of snow.

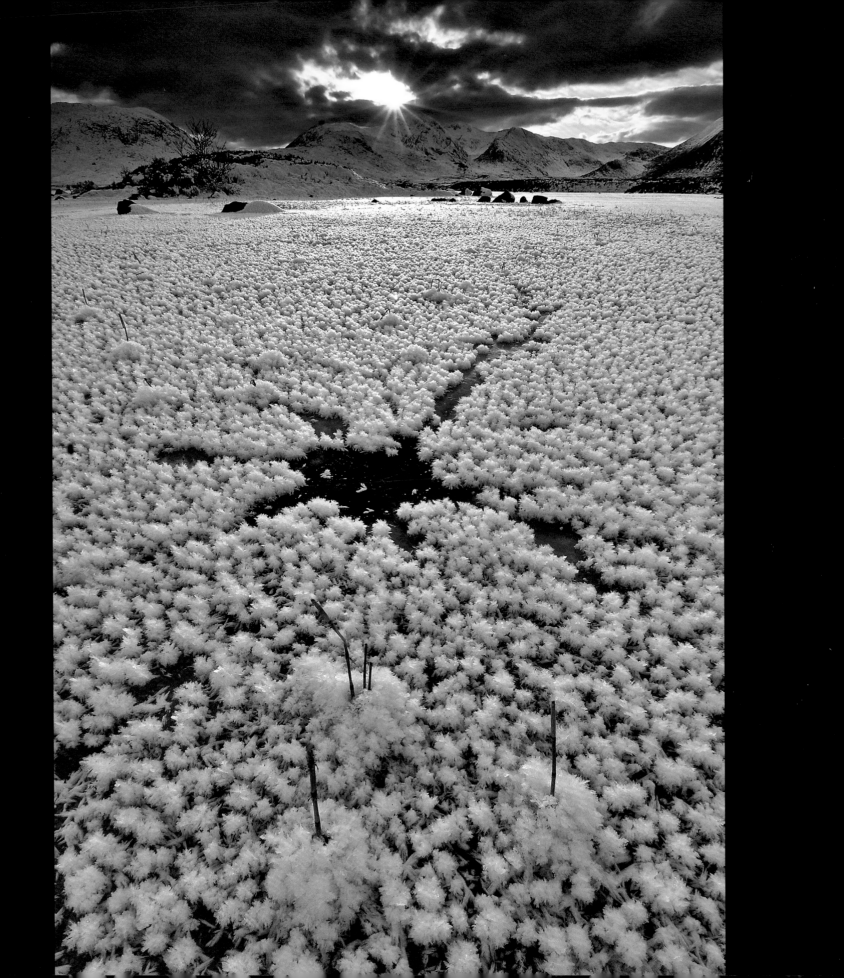

CONTENTS

JAMES OSMOND ···⟩

Quantock Hills, Somerset, England

One September, a friend of mine told me that the heather on the Quantocks was spectacular. About a week later, I managed to pop down there. She was right.

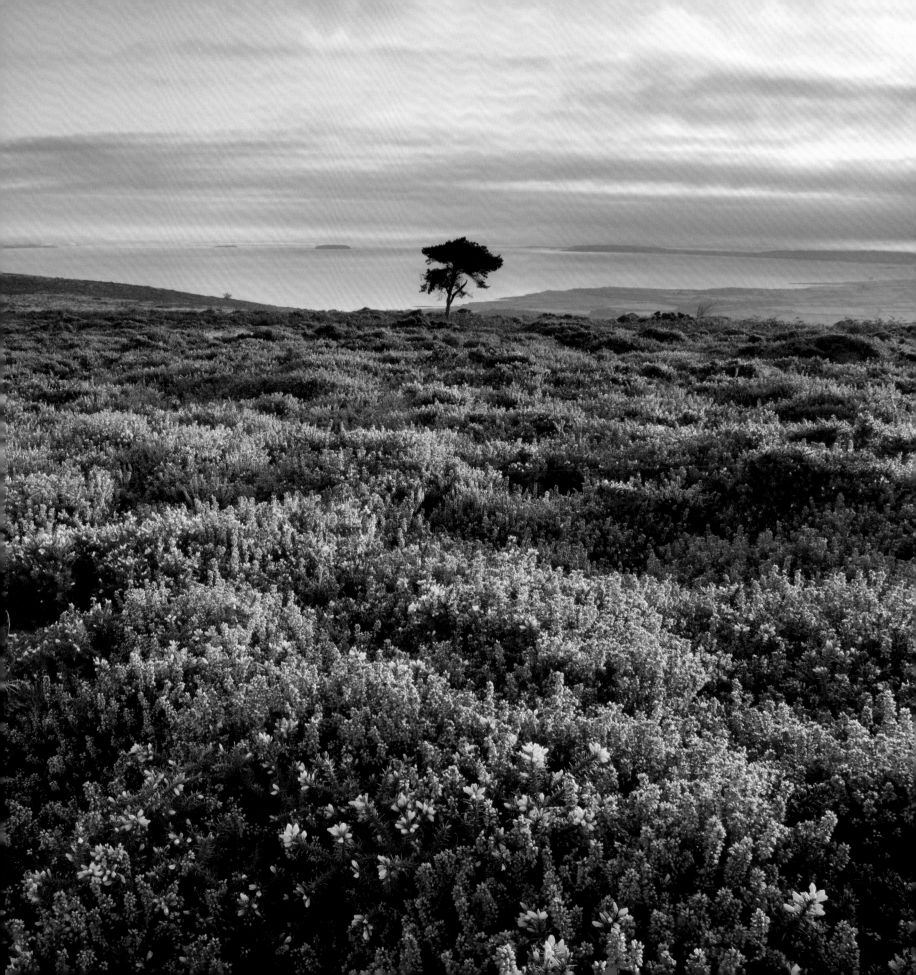

INTRODUCTION

THE COMPETITION

Take a view, the Landscape Photographer of the Year Award, is the idea of Charlie Waite, one of today's most respected landscape photographers. In this, its fourth year, the high standard of entries again proves that the Awards are the perfect platform to showcase the very best photography of the British landscape. This year's Awards would not have been possible without the invaluable help and support of Network Rail and Natural England.

Open to images of the United Kingdom, Isle of Man and the Channel Islands, Take a view is divided into two main sections, the Landscape Photographer of the Year Award and the Young Landscape Photographer of the Year Award. With a prize fund worth a total of £20,000 and an exhibition of winning and commended entries at the National Theatre in London, Take a view has become a desirable annual competition for photographers of all ages.

All images within this book were judged by the panel as *Commended* or above, a high accolade and a very small percentage of the total entry.

www.landscapephotographeroftheyear.co.uk
www.take-a-view.co.uk

THE CATEGORIES

Classic View

For images that capture the beauty and variety of the UK landscape. Iconic views; a view along a cliff-side path or of a historic village; a view down a valley; an urban skyline or snow-capped peaks; maybe showing the drama of our seasons. Recognisable and memorable – these are true classics.

Living the View

Featuring images of people interacting with the outdoors – working or playing in the UK landscape. From the peaceful tranquillity of a winter's stroll to a game of beach cricket or the thrills of free running, these images illustrate the many ways in which we connect with our outdoor environment.

Urban View

Statistics suggest that up to 80 per cent of the UK population lives in towns or cities. That's a huge number, so this new category has been introduced to highlight the surroundings that many of us live in every day. From the isolation of the seaside town in winter to the wonders of modern engineering, this category shows that all landscapes matter.

Your View

What does the UK landscape mean to you? Sometimes intensely personal and often very conceptual, the parameters of this category are far-reaching, with images showing a whole range of emotions and perspectives. Subjects vary from a dog bounding through a bluebell wood to the crashing waves of a violent storm.

KEY SUPPORTERS

www.naturalengland.org.uk

www.networkrail.co.uk

WITH THANKS TO

THE SUNDAY TIMES

EPSON®
EXCEED YOUR VISION

AA Publishing
Light & Land
Amateur Photographer
Bayeux
Environment Films Ltd
Campaign to Protect Rural England
Calumet Photographic
Outdoor Photography
Fujifilm
Páramo Directional Clothing Systems
Cooltide Interactive

SPECIAL PRIZES

The Network Rail 'Lines in the Landscape' Award

This Award is for the one photographer who best captures the spirit of today's rail network as it relates to the landscape around it. Entries had to be of the operational national rail network anywhere in Great Britain (excluding Northern Ireland). Judged by landscape photographer, Charlie Waite.

Natural England's 'Landscape on your Doorstep' Award

For the photograph that best demonstrates how everyday landscapes matter. Open to all age groups, this Award is for the image that captures an English landscape in close proximity to the entrant's home; 'low carbon' photography that best shows the accessibility of natural beauty. Judged by landscape photographer, Charlie Waite.

Environment Films Ltd 'Britain in our Hands' Award

This Award is given to the image, entered into any main category, that best demonstrates the scope of human impact – be it helpful or harmful – on the British landscape. Judged by co-founder of Bristol Wildlife Filmmakers, Sarah Pitt; Joss Garman from Greenpeace and the founder of Environment Films Ltd, Ella Todd.

FOREWORD

BY IAIN COUCHER,
CHIEF EXECUTIVE, NETWORK RAIL

LANDSCAPE PHOTOGRAPHER OF THE YEAR 2010

In my eight years working at Network Rail, I've been fortunate enough to travel right across Britain. We often forget what a beautiful, rich and varied country we have with many spectacular and breathtaking views. We are indeed a very lucky nation and it's wonderful that competitions such as Take a view remind us why our country is so revered by many and why millions 'staycation' and come here every year to explore our historic land.

For over 150 years, the railway has helped connect people across the length and breadth of Britain. It takes people to work, to home, to visit friends and family or to holiday destinations or days out. When we have the chance, each journey can be a visual experience like no other. Every train window frames a view of Britain, which can delight and inspire. Those travelling on the East Coast Mainline between Newcastle and Edinburgh can marvel as their train follows the rocky coastline. Views of trains passing through the Dawlish sea wall as the waves crash, is quite a sight, and almost every view through the Scottish Highlands is spectacular. And when I travel on a trans-Pennine service, I can be distracted from the laptop by the stunning scenery rolling by.

Even those journeys in built-up areas show a part of Britain that has a story to tell. That's why I think Network Rail has such a natural connection with this competition and is proud to support it. Not only do the tracks take you to thousands of places where you can take amazing photos, but the railway itself with its iconic structures is often the focus of the picture too. The huge response we've had to the Special Award for railway photography shows how much it is valued by people. Britain relies on the railway for its economic strength, but its historical connection with communities and the legacy of architecture and engineering of which we now have the honour to be stewards, is what draws so much appeal.

Imagery of the railway has always been a fascination of Britons. In the 1830s and 40s, artists produced thousands of lithographs of the railway. In addition, the first rail companies perfected printing processes to make advertising posters, which adorned stations across the country. Between the World Wars, artists from the Royal Academy were commissioned to produce works for posters to promote the railway but they often simply used landscapes, advertising just where the railway could take you.

But of course, this competition is more than just railways. I was simply blown away at the quality of the entries last year, which compelled me to get involved. They reminded me just how photography can draw you in and transport you to that place, if only for second. This competition shows how photography can be something we can all enjoy and be part of, and I'm certainly inspired. As I depart Network Rail for new challenges, I am proud that this partnership is something I've set in motion. This extraordinary collection of photographs is a wonderful journey in itself and truly a legacy of Britain that everyone should be proud of.

COMMENT

BY AWARDS FOUNDER,
CHARLIE WAITE

Over recent years, we have become increasingly aware of the need to nurture, revere and wonder at our natural world. Many of us have experienced a personal metamorphosis in our relationship with the environment, be it either through a sudden awareness of the significance and horror of landfill sites, dismay at needless wastage, or perhaps a loving and caring awareness of the crucial and pivotal role that the humble bee plays in our food production. Each desperate bee that I have rescued from an inside window pane somehow symbolises my wish that we might all step out into our own landscape and see, almost as if for the first time, a landscape that we can celebrate and contribute to, positively.

There is no doubt whatsoever that landscapes matter. Landscape is more than just 'the view'. It is about the complex, interacting, natural and cultural systems that make up each landscape. It is about the relationship between people, place and nature. The landscape can provide both spiritual fulfillment and aesthetic enjoyment and we need it.

Britain is one of the most urbanised and heavily populated countries in the world, with 80 per cent of us living in towns and cities. Consequently, urban life shapes the daily experience of the great majority of people and it is the context within which most of us encounter the natural environment. That natural environment, in towns and cities, is under pressure from a wide range of impacts and these include road transport, air and light pollution, increasingly scarce water resources, housing and other development.

Most of us have a passion for our country's landscape and we will have an intimate familiarity and a fondness for our own local green space. That space will have profound meaning to each of us; it is 'our' landscape on 'our' doorstep and it matters to us. From this recognition, a greater awareness and understanding of our natural world may evolve and word will spread outward and onward to future generations from whom, it is said, we are borrowing our country's landscape.

The railways have been with us for 150 years and perhaps, in the face of a tidal wave of car production and relentless road building, we have come round to making friends with the railway network once more. I have long been astonished at the many millions of man-hours that went into building such an extensive network and am thankful to those that now maintain our current infrastructure. I was utterly delighted that Iain Coucher, the Chief Executive of Network Rail, chose to support our Landscape Photographer of the Year Awards so decisively.

Natural England has contributed once again in so many very helpful ways to the success of the Awards. There is no doubt that without Natural England's tireless and sensitive overseeing of large areas of our land, we would be by far the poorer.

I have long maintained that the camera is more than a means to just record a scene or an event; it is a wonderfully creative device that can assist us to re-engage, from our possible erstwhile dislocation, to our natural world. I do so hope that everyone who enjoys this book will go forward with a reaffirmed feeling that our country, with all its extraordinary diversity, offers some of the finest rural, coastal and urban landscapes of any nation in the world. My gratitude to all these gifted landscape photographers who have reminded us of this so powerfully.

THE JUDGES

Damien Demolder
Editor
Amateur Photographer

Damien Demolder is the editor of *Amateur Photographer* magazine, the world's oldest weekly magazine for photography enthusiasts, and a very keen photographer too. He started his photographic professional life at the age of 18, but since taking up the editorship of the magazine he has been able to return to his amateur status – shooting what he likes, for his own pleasure.

With interests in all areas of photography, Damien does not have a favourite subject, only subjects he is currently concentrating on. At the moment his efforts are going into landscapes and social documentary. When judging photography competitions Damien looks for signs of genuine talent or hard work. Originality is important, as is demonstrating a real understanding of the subject and an ability to capture it in a realistic manner. He says 'Drama is always eye-catching, but often it is the subtle, calm and intelligent images that are more pleasing and enduring.' Damien's work can be seen at damiendemolder.com

Charlie Waite
Landscape Photographer

Charlie Waite is firmly established as one of the world's most celebrated landscape photographers. He has published 28 books on photography and has held over thirty solo exhibitions across Europe, the USA, Japan and Australia, including three very successful exhibitions in the gallery at the OXO Tower in London, each visited by over twelve thousand visitors.

His company, Light & Land, runs photographic tours, courses and workshops worldwide that are dedicated to inspiring photographers and improving their photography. This is achieved with the help of a select team of specialist photographic leaders.

He is the man behind the 'Landscape Photographer of the Year' Award and this ties in perfectly with his desire to share his passion and appreciation of the beauty of our world.

Julia Bradbury
Television Presenter

Credited with revamping Sunday night primetime television, Julia Bradbury is one of the small screen's most popular and versatile presenters. Having taken the helm on BBC One's rural affairs show *Countryfile* alongside Matt Baker in 2009, the show's ratings have since soared to over seven million viewers.

Her varied career has taken her to Hollywood (for GMTV) and seen her fight for consumer rights on Watchdog, but Julia's reputation as the face of the outdoors began when she fronted *Wainwright Walks*, a stunning BBC Four series shot in the Lake District. Julia has also filmed three additional sets of hiking exploits, in Germany, South Africa and Iceland, and has recently been shooting in Britain again, for the BBC One programme, *Secret Britain*.

As President of the Friends of the Peak District, Julia represents award supporters, Campaign to Protect Rural England, within the National Park. The role allows Julia to promote and protect the landscape where she first developed her love of the outdoors, on childhood walks with her father on the Monsal Trail. In Spring 2010, Julia was also elected President of the Ramblers.

Martin Evening
Photographer & writer

Martin Evening is a London-based advertising photographer and noted expert in digital imaging. As a successful photographer, Martin is well known in London for his fashion and beauty work, where he has won several awards. He was also inducted into the NAPP Photoshop Hall of Fame in 2008.

Martin has worked with the Adobe Photoshop and Adobe Lightroom engineering teams, consulting as an alpha and beta tester and is one of the founding members of Pixel Genius, a software design company producing automated production and creative plug-ins for Photoshop.

His recent books include: *The Adobe Photoshop Lightroom 3 Book*, *Adobe Photoshop CS5 for Photographers* and *Adobe Photoshop for Photographers: The Ultimate Workshop*, which he co-wrote with Jeff Schewe. He is sought after for speaking and lectures, mostly in the US, where he is a regular speaker at PDN's Photo Expo Plus Conference in New York.

Jon Jones
Director of Photography
The Sunday Times Magazine

Jon Jones is the recently appointed Director of Photography at *The Sunday Times Magazine*. He joined *The Independent* newspaper in 1988 as a photographer, covering such events as the release of Nelson Mandela and the first Gulf war. In 1991, he moved to the Sygma Photo Agency in Paris, covering conflict all over the world, most notably in Bosnia from 1991 to 1997.

His work has appeared in such leading publications as *Time*, *Newsweek*, *The New York Times* magazine, *The Sunday Times magazine*, *Paris Match*, *Stern*, *Life* and *Figaro*. In 1999, Jones joined the BBC as a cameraman and producer, working worldwide on magazine features, documentaries and news. In 2007, he joined *The Times* as deputy picture editor, working as visuals editor on the re-design of the main paper and its supplements, as well as conducting multimedia and video training. Jones has taught the Joop Swart Masterclass and his numerous international awards include two World Press Photo Awards.

John Langley
National Theatre Manager

John Langley is the Theatre Manager of the National Theatre, on London's South Bank. Alongside its three stages, summer outdoor events programme and early evening platform performances, the National has become renowned for its full and varied free exhibitions programme. Held regularly in two bespoke spaces, these exhibitions are an important, ongoing part of the London art and photographic scene. John is responsible for these shows and has organised over 300 exhibitions and played a significant role in presenting innovative and exciting photography to a wide and discerning audience.

When escaping from the urban bustle of the Capital, John particularly loves the coastal scenery of the United Kingdom, with the north Norfolk coast and Purbeck in Dorset being particular favourites.

David Watchus
Publisher, AA Media

David Watchus took over as Publisher at the AA at the beginning of 2006, having worked in a variety of roles within the business. His vision is to build on AA Media's strong base in travel, lifestyle and map and atlas publishing, areas in which the AA has many market-leading titles, while increasing the presence of AA Media in the wider illustrated reference market.

David's involvement in the Landscape Photographer of the Year competition is core to this vision and is also indicative of the quality of both production ideals and editorial integrity that is the cornerstone of the book-publishing ethos within AA Media.

Nick White
Epson UK

Nick White's photographic life began with his father's aerial photography company. From a school holiday job in the black and white darkroom, he later joined full-time and was involved in both commercial and aerial photography, whilst running the in-house processing facility.

It was natural that an appreciation of aerial landscapes developed and he feels that this was the origin of his interest in landscape photography today.

Nick's career switched to the trade side of photography, with lengthy stints at Durst and Fujifilm, before he joined the Epson large format team five years ago.

A keen sailor for many years, Nick is based on England's south coast. A former RNLI crewman, he is the volunteer operations manager of his local lifeboat station.

PRE-JUDGING PANEL

The pre-judging panel has had the difficult task of selecting the best entries to go through to a final shortlist. Every image entered into the competition has been viewed and assessed, with the chosen selection then going on to face the final judging team.

Julie Chamberlain, Photographer

Julie has had a passion for photography for as long as she can remember. She grew up in a small town on the edge of the New Forest National Park, which provided her with plenty of photographic opportunities from an early age. Her professional career has been primarily within the stock photographic industry and she started out in the agency Landscape Only, which, as its name suggests, specialised in landscape photography and represented some of the UK's best-known names. From picture editor to picture research, Julie has worked in a variety of creative roles and has also had a number of her own images published. Julie is based in Brighton but enjoys travelling around the whole of Britain, taking pictures on the way.

Trevor Parr, Parr-Joyce Partnership

Trevor's lifelong love of photography started at art college. He became an assistant to a number of fashion photographers before setting up on his own in a Covent Garden studio. He moved to the Stock/Agency business, seeking new photography and acting as art director on a number of shoots. In the late 1980s, he started the Parr-Joyce Partnership with Christopher Joyce and this agency marketed conceptual, landscape and fine art photography to poster, card and calendar companies. Trevor also owned a specialist landscape library that was later sold to a larger agency. He now concentrates on running Parr-Joyce from his base in the south of England.

Martin Halfhide & Robin Bernard, Bayeux

Robin and Martin are co-owners and directors of Bayeux, a professional imaging company that opened in 2001 and is now the largest in London's West End. With an extensive background in the pro-lab industry, both have experience in many technical areas. They were at London-based Ceta in the 1980s and then went on to be responsible for photographer liaison at Tapestry during the 1990s. Although very much attached to a London lifestyle, Robin escapes to the country at regular intervals, particularly the English Lakes. Martin favours the wilds of Scotland and visits every year.

and Charlie Waite

AWARDS DIRECTOR: Diana Leppard

I would like to once again extend my enormous gratitude to Diana Leppard who has contributed so very much to making 'Take a view Landscape Photographer of the Year 2010' such a success.

Charlie Waite

MIKE KEMPSEY ···⊱

Colmer's Hill, Symondsbury, Dorset, England

Colmer's Hill is named after Reverend John Colmer who owned the land in the early 19th Century. The characteristic Caledonian pine trees that crown the hill were planted during the First World War by Major W P Colfox MC. The original name for Colmer's Hill was 'Sigismund's Berg', named after a Viking Chief. The passage of time turned 'Sigismund's Berg' into 'Simondesberge' by the time of the Domesday Book, then during the following centuries it became 'Symondsbury', eventually giving its name to the nearby village.

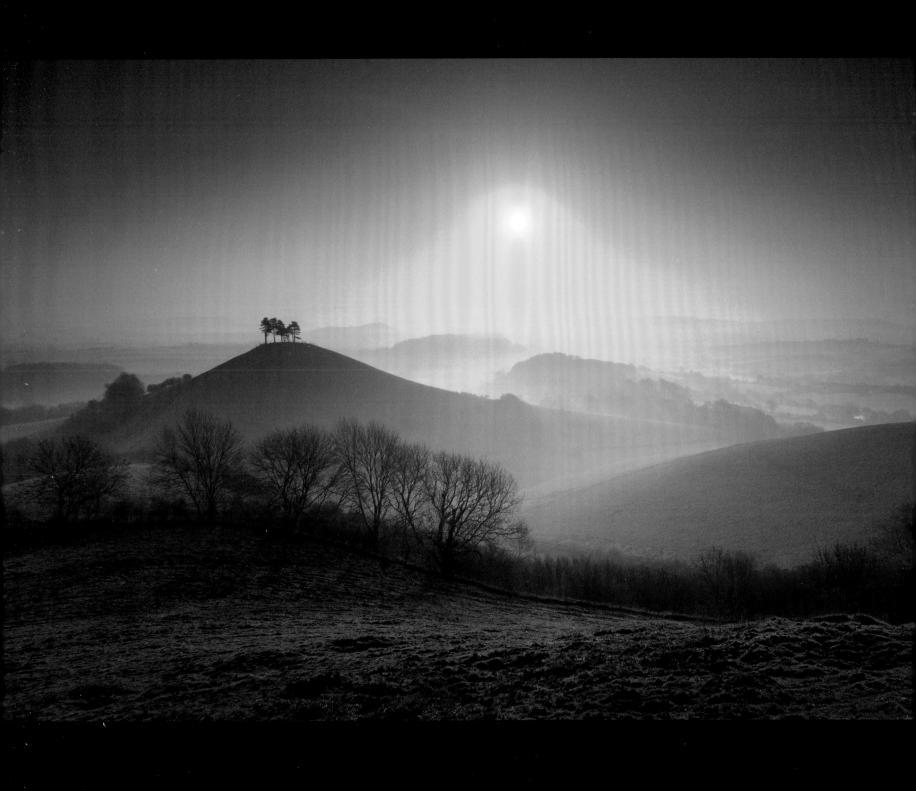

LANDSCAPE
PHOTOGRAPHER OF THE YEAR

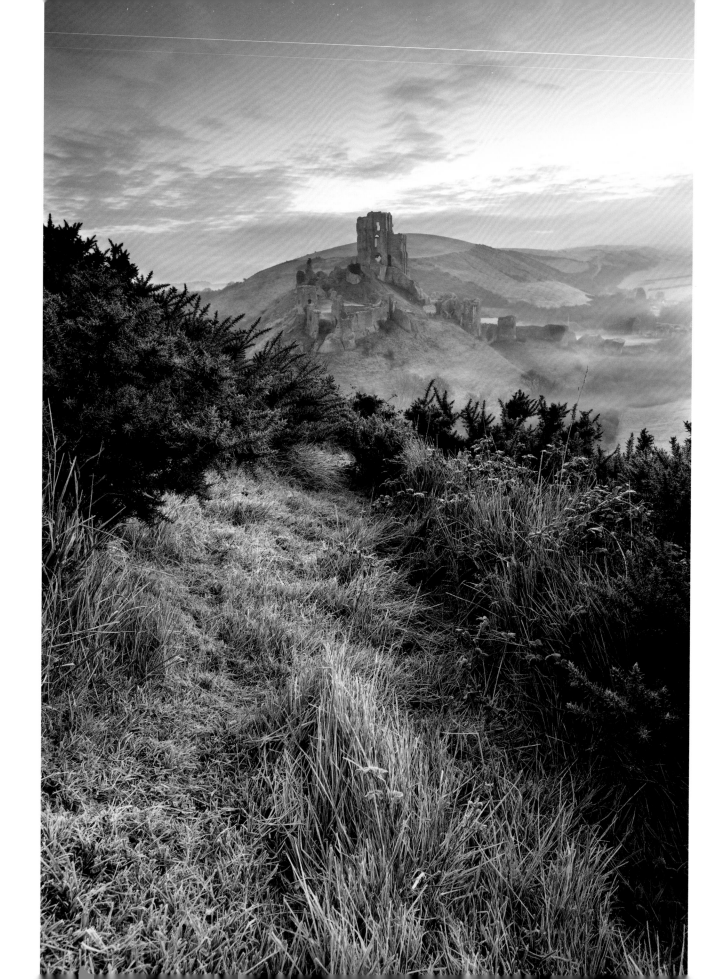

LANDSCAPE PHOTOGRAPHER OF THE YEAR 2010

OVERALL WINNER

◄··· **ANTONY SPENCER**

Winter mist at Corfe Castle, Dorset, England

I wasn't actually heading for this location on this particular morning but couldn't resist it with the gentle mist rolling in from Poole Harbour. As the clouds started to display these subtle colours I couldn't believe my luck. I really loved the frozen textures and tried to make the most of them in the foreground whilst using the path as the leading line towards the ancient hilltop ruin.

YOUNG LANDSCAPE PHOTOGRAPHER OF THE YEAR 2010

OVERALL WINNER

TALIESIN COOMBES ⸱⸱⸱⸱⸳

Breakfast view, Cardiff, Wales

I wanted something different from the traditional view of a steam train so went to a local café, which looks out over the approach to Cardiff Central Station. While waiting, we ordered a Great British Breakfast, so it seemed natural to put it in the foreground. Fortunately, the train was running early and the breakfast had only just arrived, so I was able to get the shot and enjoy the breakfast. The train was a charter to mid Wales.

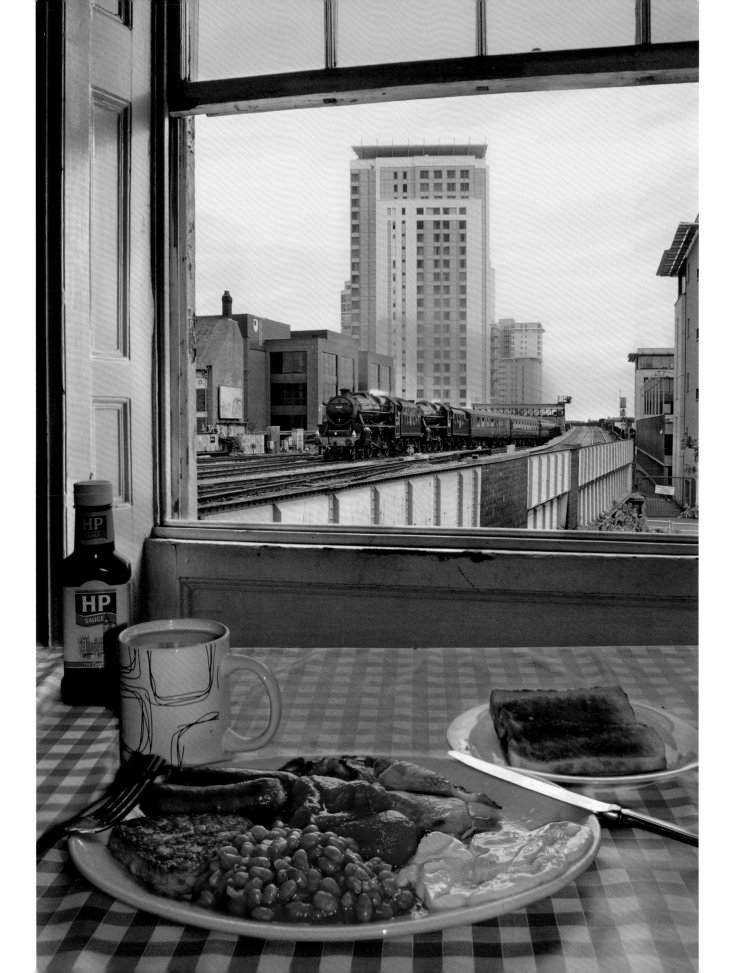

THE NETWORK RAIL 'LINES IN THE LANDSCAPE' AWARD

CHRIS HOWE ⋯⟩

Grindleford Station at dusk, Derbyshire, England

After an afternoon capturing autumn colour in Padley Gorge, hunger was singing in my belly and sent me to the famous station café. Although weighed down by the mighty meal, I wandered in the dusk and found myself on the station footbridge. The speeding trains and light in the western sky encouraged me to set the tripod once more. A few test shots showed it was worth waiting for another train. Whilst a six second exposure seemed about right for the station, I needed a second, faster exposure to hold in the sky detail. Then night stole the day.

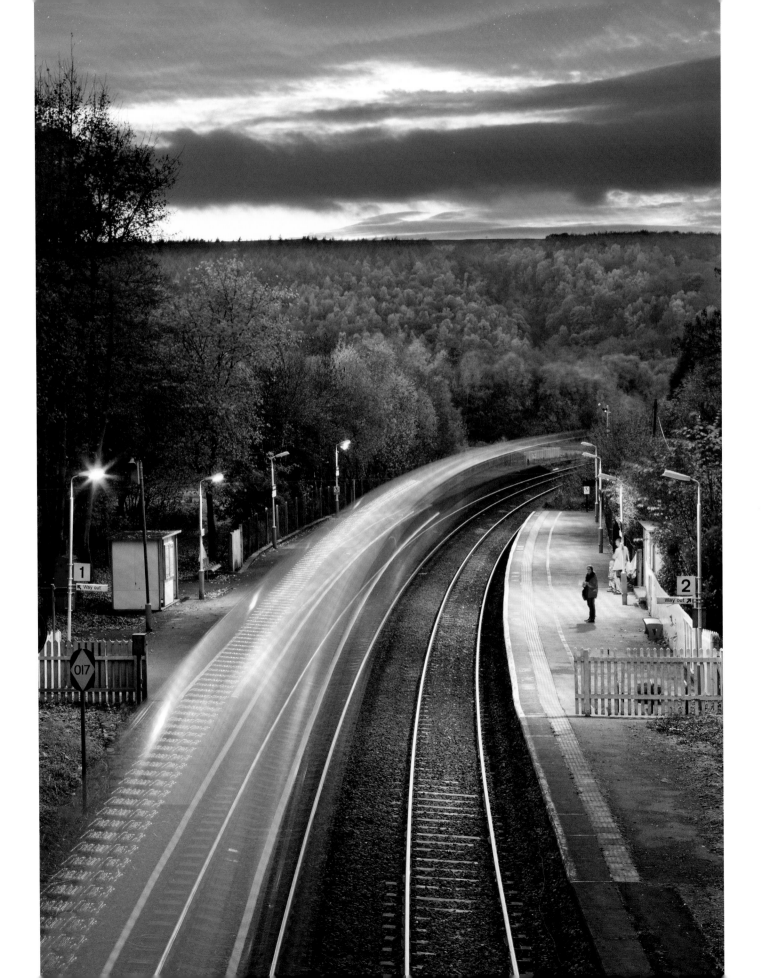

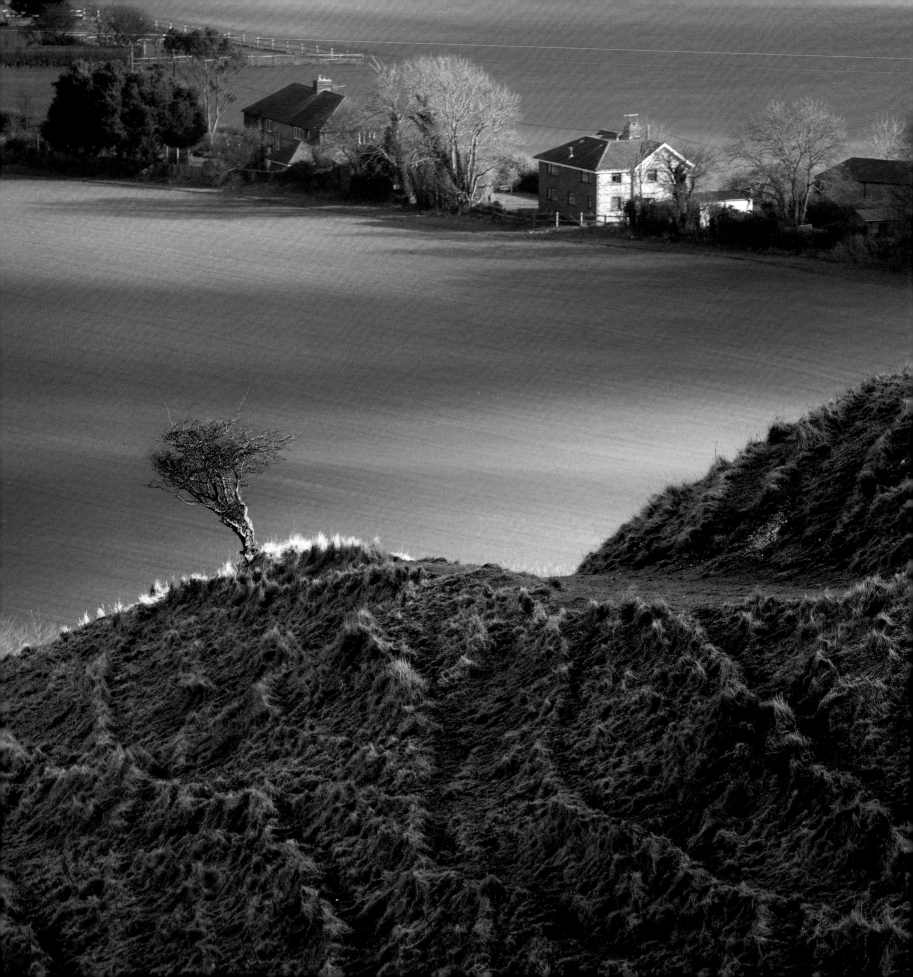

NATURAL ENGLAND'S 'LANDSCAPE ON YOUR DOORSTEP' AWARD

◀···· **SŁAWEK STASZCZUK**

South Downs near Kingston, East Sussex, England

It was an extremely windy, winter's day on the South Downs, which posed a challenge when taking photographs, especially with a long lens. The wind was chasing clouds across the sky incessantly and the consequent play of light and shadow on the ground allowed me to take some decent pictures even around noon, of which this is a good example. Later, when the sun was much lower and the wind had eased, I took more successful pictures in the area. It proved to be an exceptionally fruitful day.

CLASSIC VIEW
adult class

CLASSIC VIEW ADULT CLASS WINNER

DUDLEY WILLIAMS ⋯⋗

Sand Patterns, Isle of Eigg, Scotland

A freshwater run-off across the beach created these interesting patterns in the sand. The soft tones are provided by the late-winter dawn.

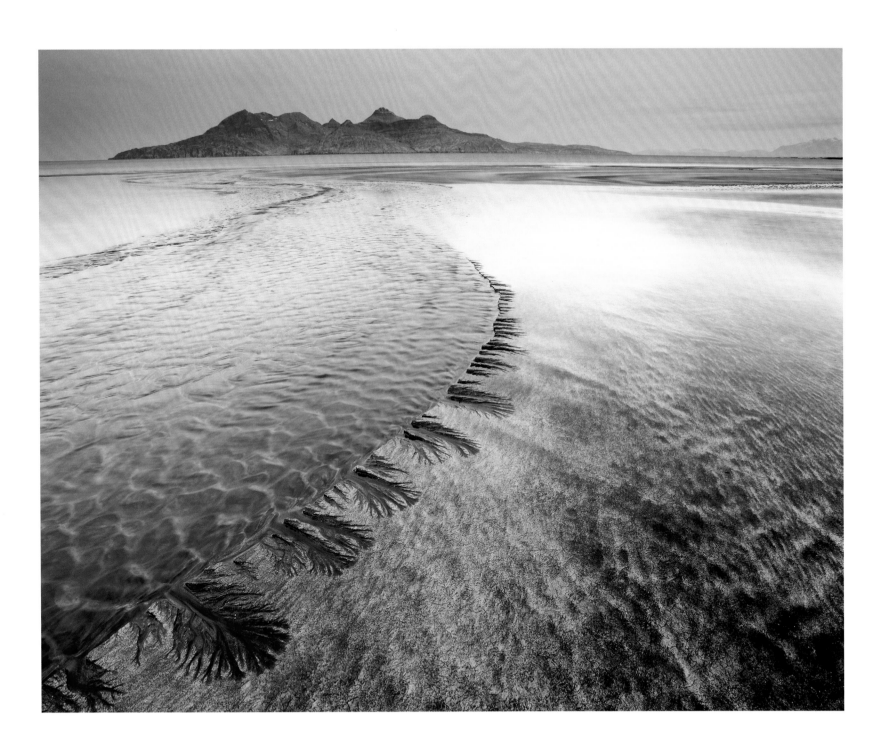

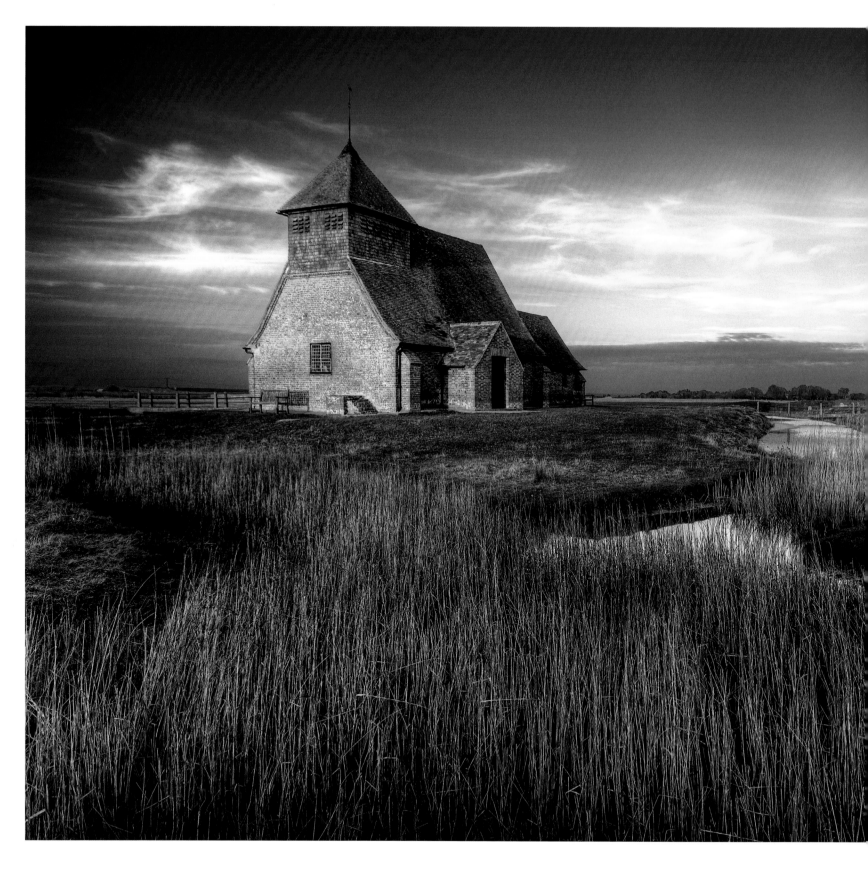

CLASSIC VIEW ADULT CLASS RUNNER-UP

MARSHALL PINSENT

Fairytale at Fairfield, Romney Marsh, Kent, England

This picture is of the church of St. Thomas a Becket at Fairfield on Romney Marsh, taken in late February. We'd been out all day, photographing in the area, and had left Fairfield until last, so we almost missed it. I usually like to take my time planning and considering the shot, but here we had to race across the marshes in the dying moments of a beautiful sunset. I had only a few minutes to decide on the best position and to set up before we lost the light. I have tried to capture the strong sense of history and magic about this place.

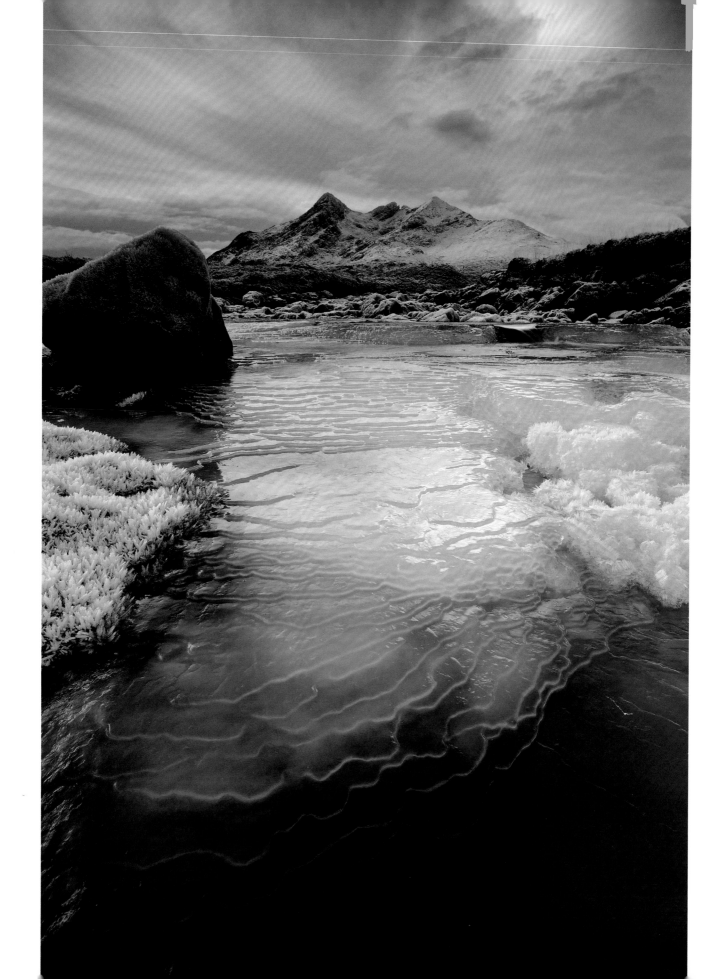

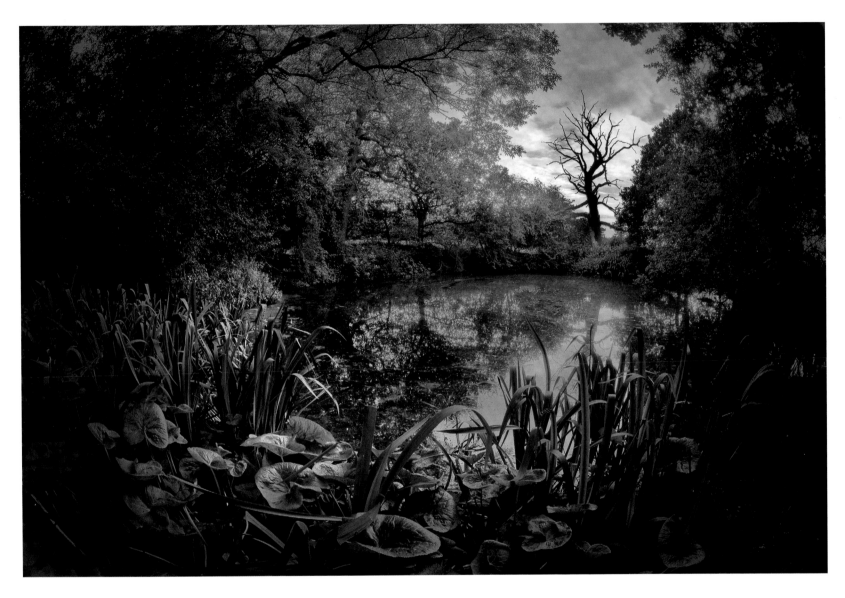

MARCUS McADAM HIGHLY COMMENDED

Ice steps, Sligachan, Isle of Skye, Scotland

The winter of 2009/2010 was colder than usual, and many of the rivers and waterfalls froze over. I was drawn to this scene because of the steps formed on the ice. It almost looks like they are lit with neon, leading up to the Cuillin mountains in the distance.

SERGEY LEKOMTSEV HIGHLY COMMENDED

Potters Bar, Hertfordshire, England

Hertfordshire has some great countryside to explore. This picture was taken at the edge of London on the cycle route called The Great North Way, which I use to cycle to work.

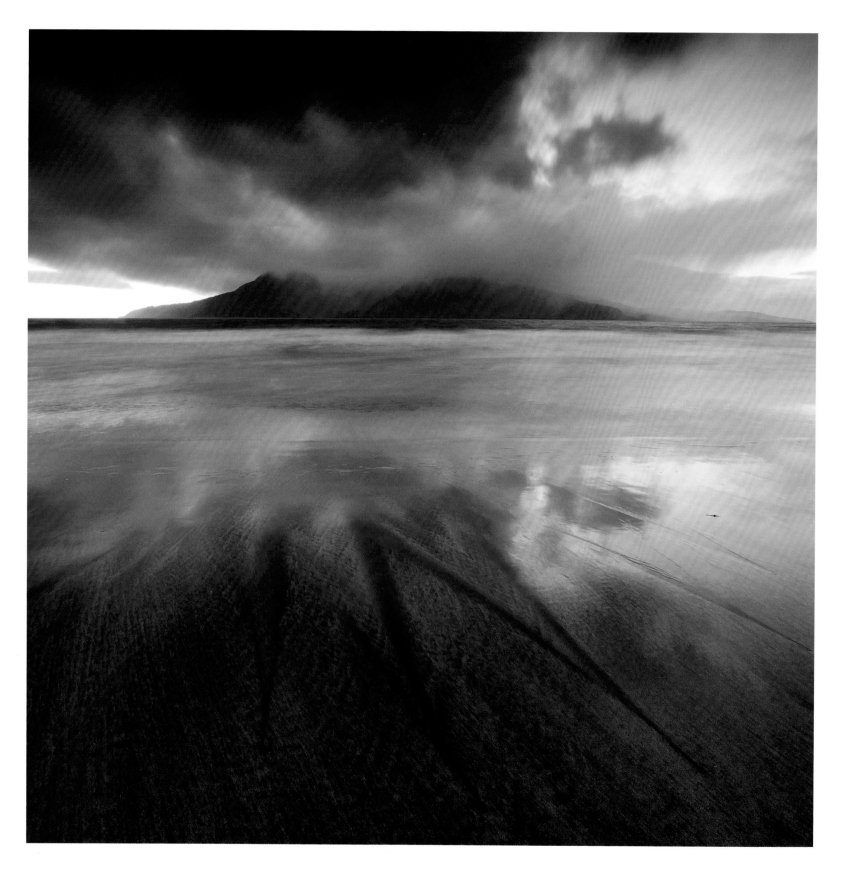

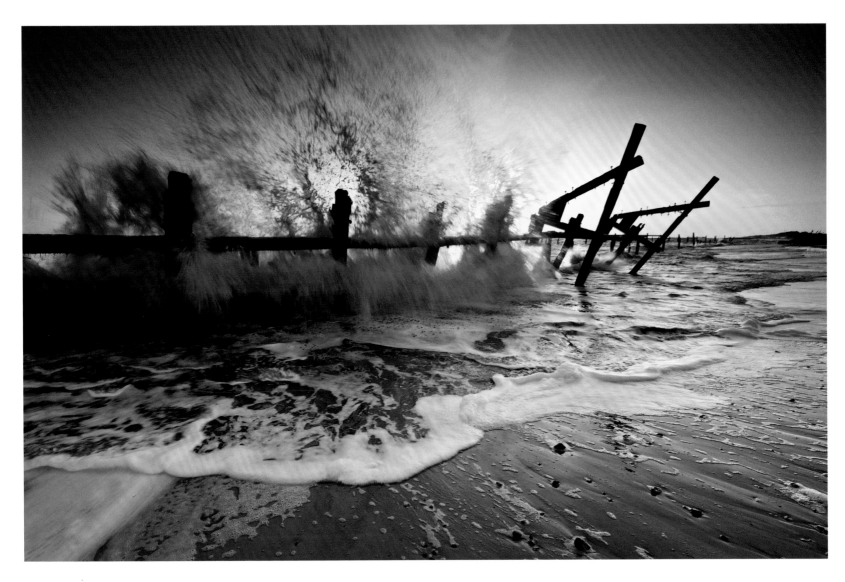

DUDLEY WILLIAMS

Eigg Star, Isle of Eigg, Scotland

This beach on Eigg has two sands of different colours that are arranged by the waves into patterns. The Isle of Rhum, swathed in menacing cloud, is across the water.

DAVE PECK

Happisburgh beach, Norfolk, England

Coastal erosion is a problem that affects several areas of the East Anglian coast. Happisburgh (pronounced Haze-borough) has suffered more than most. On the beach are three lines of defences, none of which have been successful in stemming the march of the sea. A two-hour drive to arrive well before a 6am sunrise saw some lovely pre-dawn light. Once the sun appeared on the horizon, I decided to use the sea thudding into the posts to hide its glare and backlight the spray. Several exposures were needed to get the composition I was looking for. I decided on a slightly longer exposure to give a sense of movement.

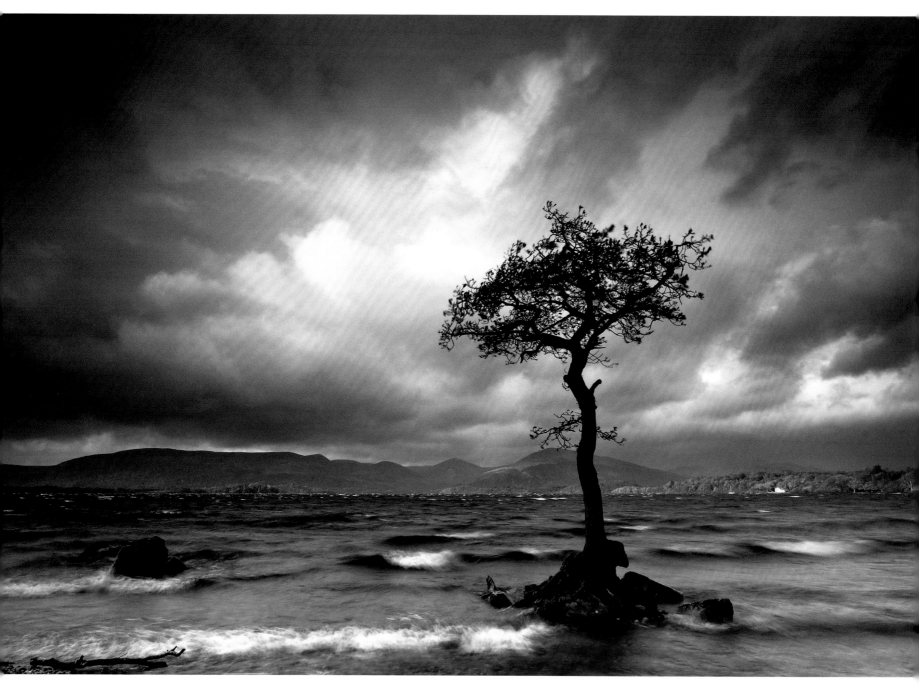

🌱 JEANETTE LAZENBY

The tree, Loch Lomond, Scotland

An image taken whilst I was sitting on the eastern shore of Loch Lomond on a winter's day, watching the sky and the light changing with the breeze.

JIM PARREN ⋯⟩

Mussels on slate, Trevone Beach, Cornwall, England

This was taken on a still evening in June. Of all the beaches in Cornwall this is the one I photograph most. The blue slate, shaped by the sea, comes alive as the sun drops. Here the mussels hug the protective contours of the rock.

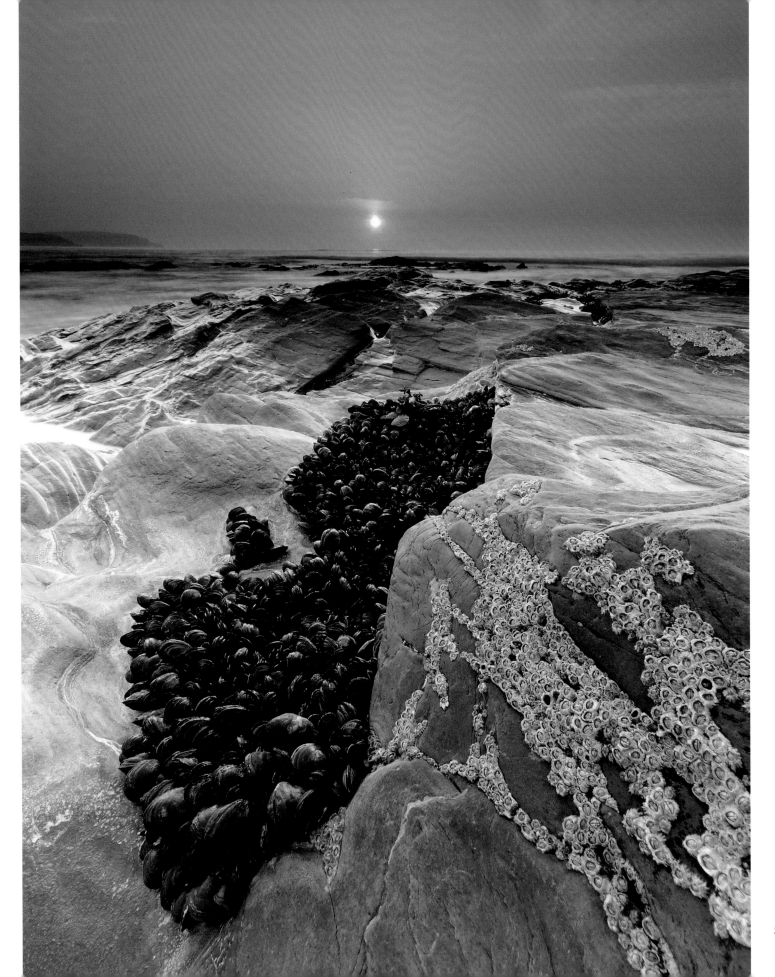

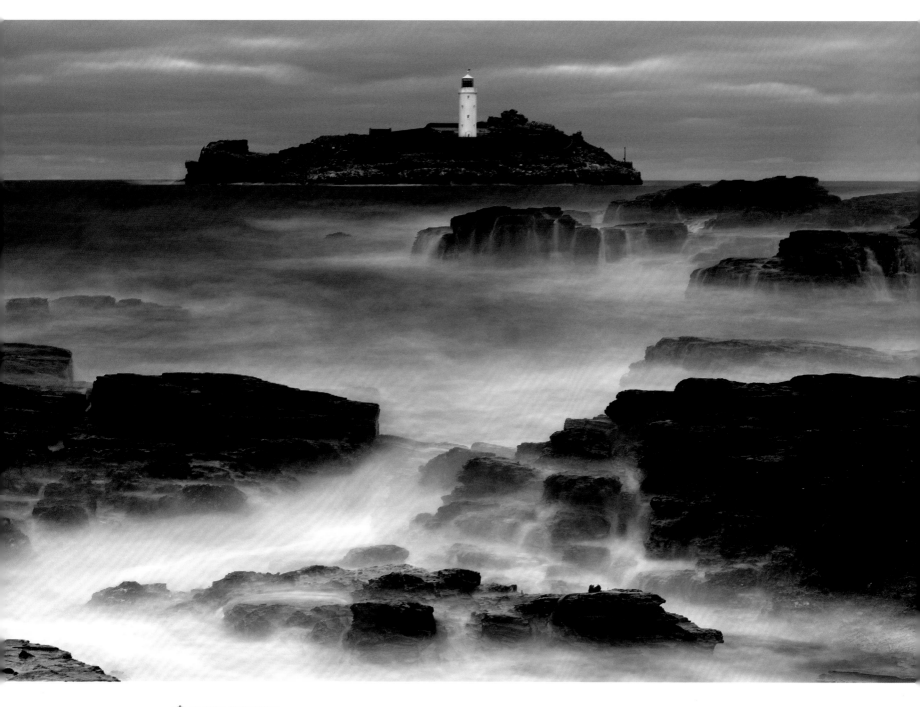

DAVID PULFORD

Dusk at Godrevy Lighthouse, Cornwall, England

This image was taken during a September week in Cornwall. The weather conditions did not look too promising with a predominantly overcast sky. However, the sea was lively and, using a long exposure for muted colours, an image with an ethereal atmosphere was the outcome.

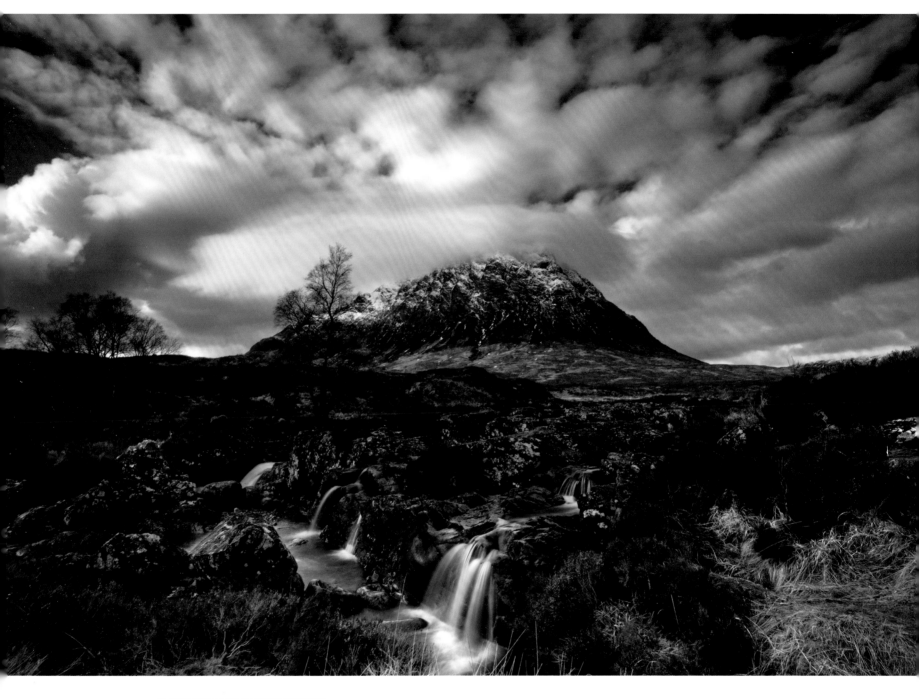

✝ **KRZYSZTOF NOWAKOWSKI**

Stob Dearg, Buachaille Etive Mor, Highlands, Scotland

Buachaille Etive Mor – an oasis of silence and wildlife. Captured on a February morning in undisturbed tranquillity. Only mysterious whispers among the trees and the murmur of a stream could be heard.

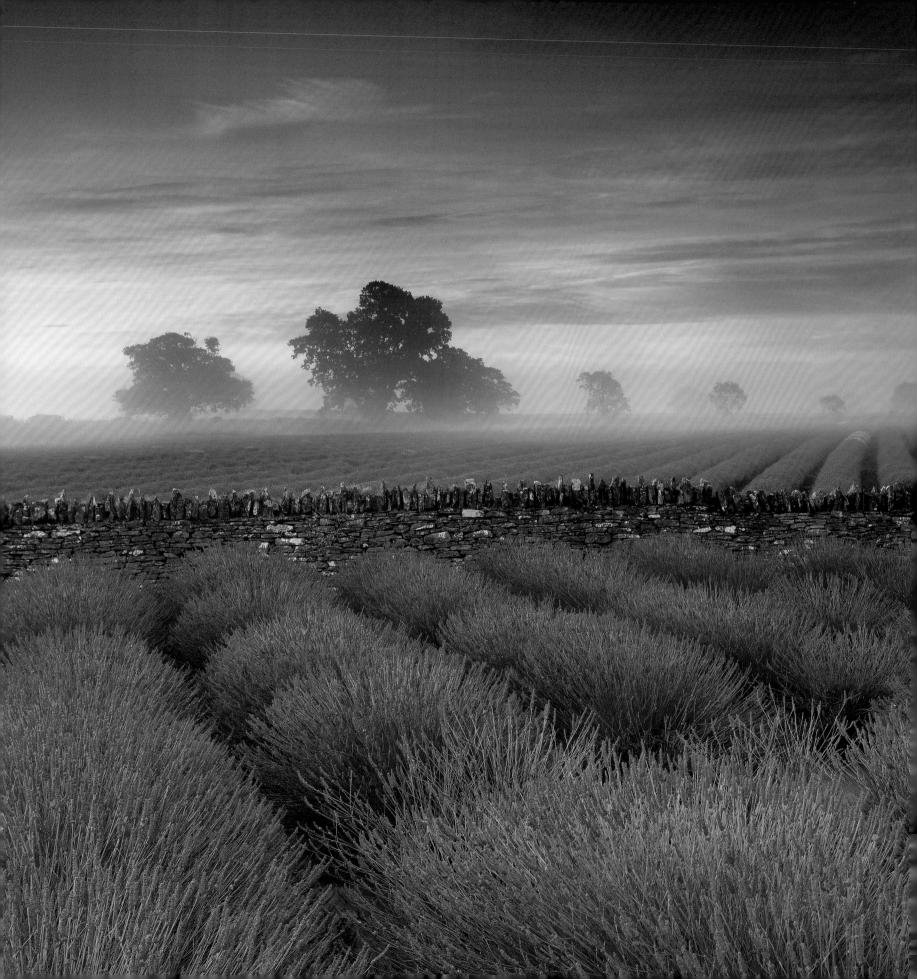

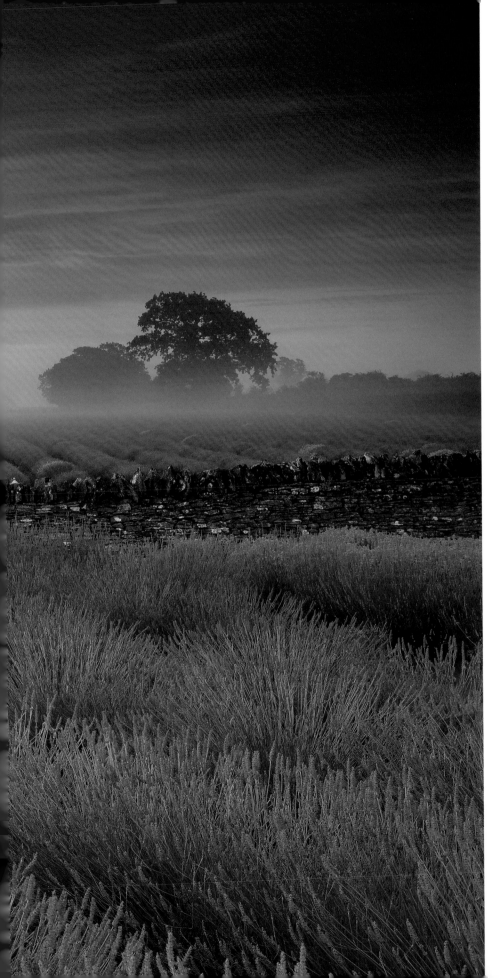

ANTONY SPENCER

Lavender field at dawn, Somerset, England

Mist rolls in over a fantastic field of lavender early on a summer morning at Faulkland in Somerset. I very nearly stayed in bed this particular morning. The sky was a blanket of grey cloud when I left but the closer I got to this field the more the conditions started to come together. The mist started to roll over the landscape shortly after I arrived and the colours just got better and better – definitely made getting up at 2.30am worthwhile!

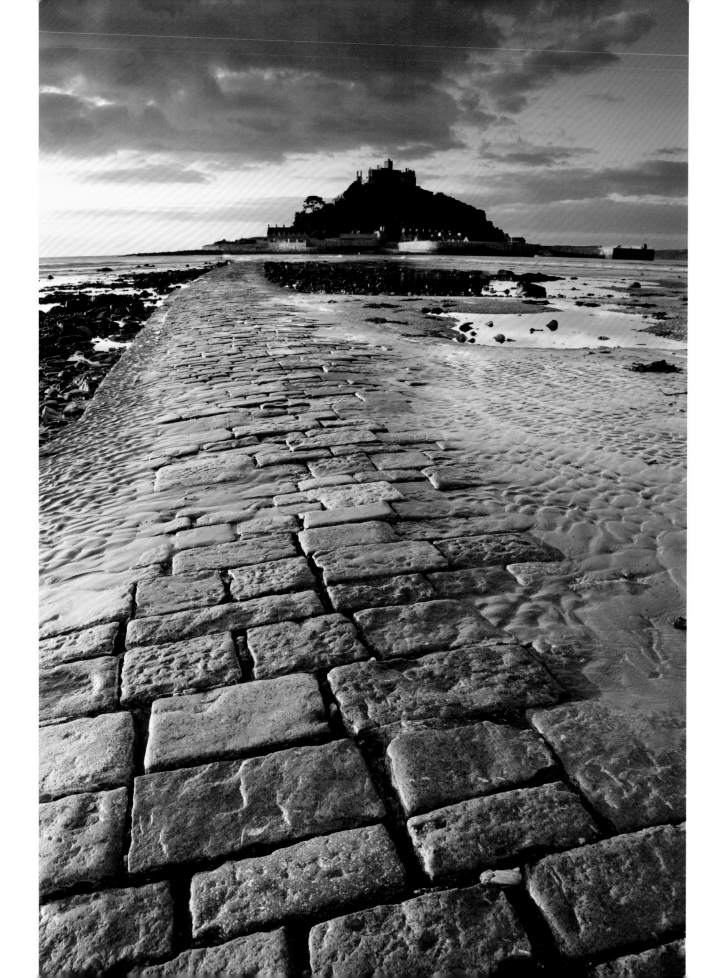

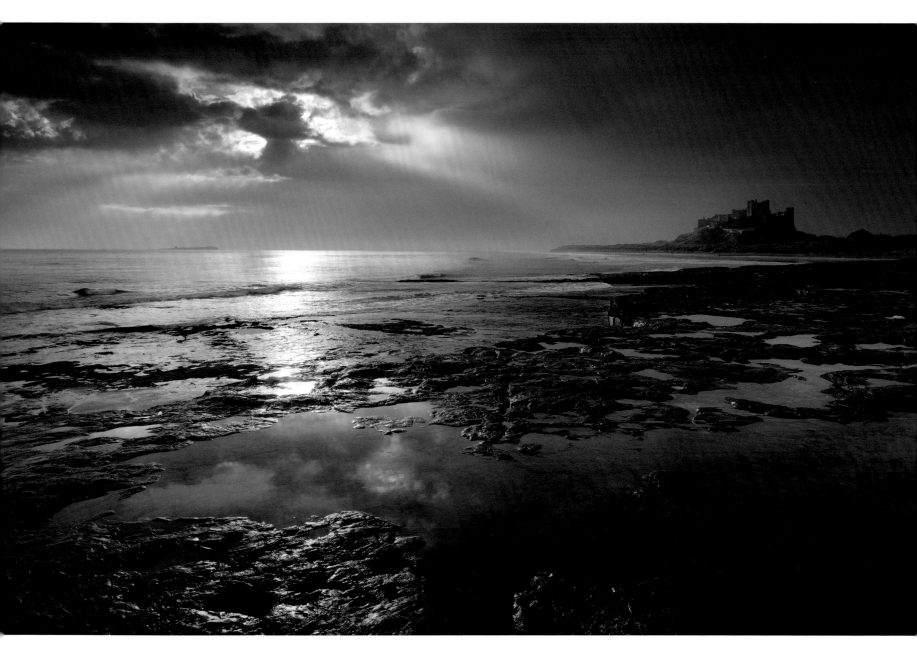

⟨·· MATT WHORLOW

St. Michael's Mount, Cornwall, England

Dawn is unquestionably my favourite time to visit and photograph St. Michael's Mount. With the short days in January, the sun rises over the sea to the left of the Mount, and if you're lucky, then for one glorious moment, the Mount is bathed in stunning golden light. The causeway runs out to the island but is only exposed from the sea at low tide. I had to wait nervously to see if the path appeared before sun cleared the horizon. Fortunately, the tide was moving swiftly, and I was able to get this shot with the cobbles, shining in the wonderful warm light, filling the foreground.

⟨· JOHN ROBINSON

Bamburgh Castle, Northumberland, England

I'd spent the past four mornings at this location without so much as a glimpse of a worthy image for my efforts, but that all changed on day four. Impetuous gusts saw heavy clouds skip past with pace and, to the south, a few small breaks in the clouds began to develop. I needed the sun, the castle and the cloud break all to line up and, at this point, the sky came alive; crepuscular rays moved across like spotlights, lighting up Bamburgh Castle in spectacular fashion! In those very brief seconds, I managed a mere six shots before the clouds engulfed the light again. Four days waiting for six seconds of light!

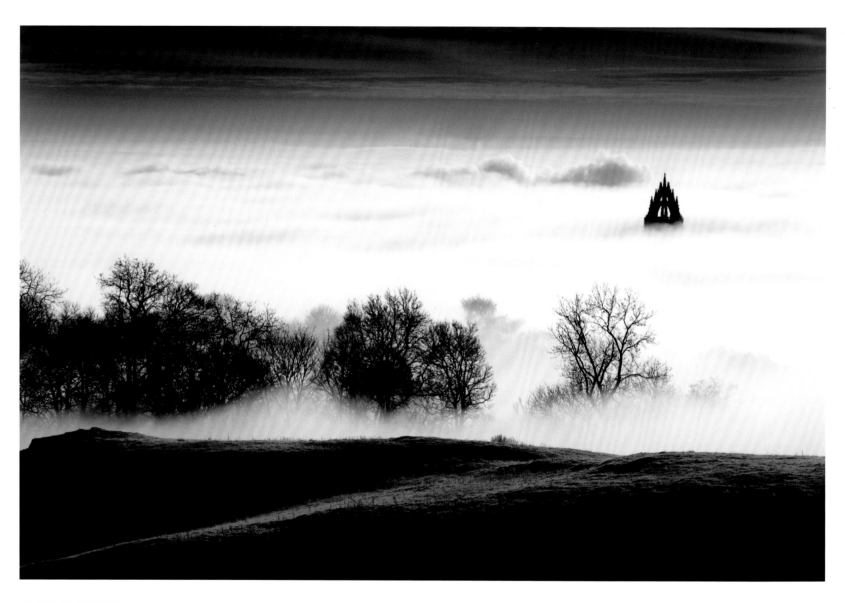

KEVIN SKINNER

Sea of clouds, Wallace Monument, Stirling, Scotland

No other pastime that I know gives you wee milestones of your journey to remind you of where you were and how you felt at any given time than photography. To be able to share that moment is just a joy. Standing on top of the Ochil Hills, immediately north of Stirling, the cloud inversion was almost complete over the entire Forth Valley. Only the trees that lapped the upper slopes of the Ochils and the magnificently awe-inspiring sight of the Wallace Monument peered above this breathtaking calm. I felt nothing more than an insignificant bystander watching this surreal scene spread out in front on me. I can still hear the silence and feel the calmness when I look at this image – a perfect moment.

ADAM EDWARDS ⋯⧐

Twilight mists, Perthshire, Scotland

I have always found something captivating about a misty forest. Perhaps it's the way they are so still and serene, or maybe it's the way they gradually fade into the unknown. This particular afternoon the mist rolled in quickly, getting thicker and thicker as time wore on. As twilight approached and visibility became severely reduced, I decided to head for nearby woods in search of some black and white shots to really convey the atmosphere of the day. This was my favourite image from the outing.

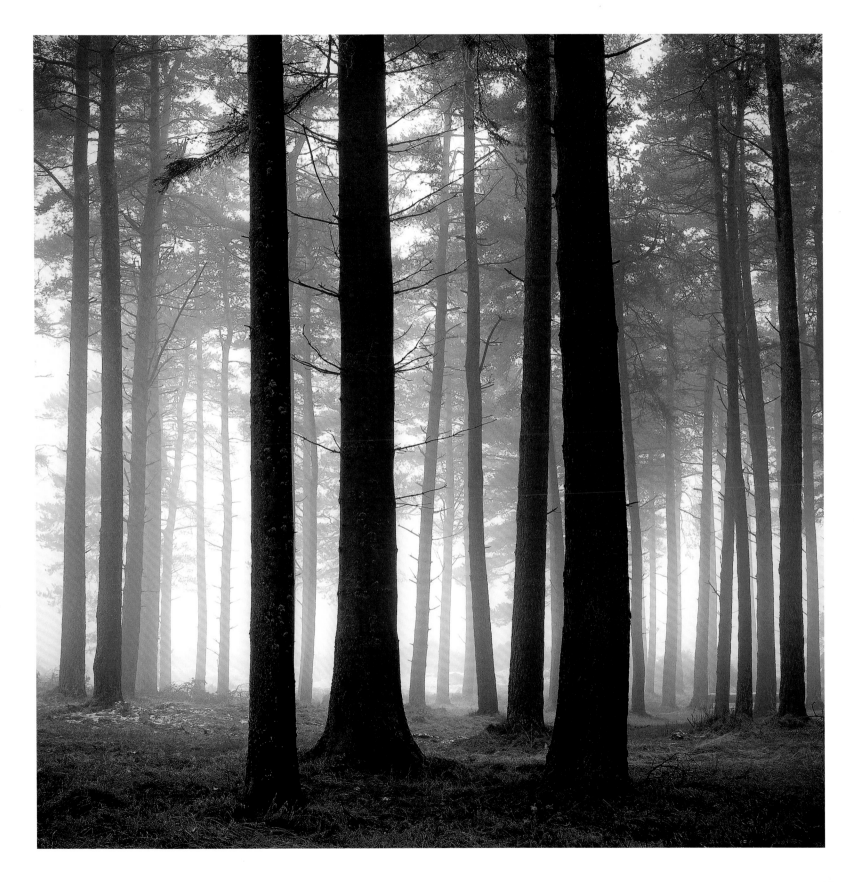

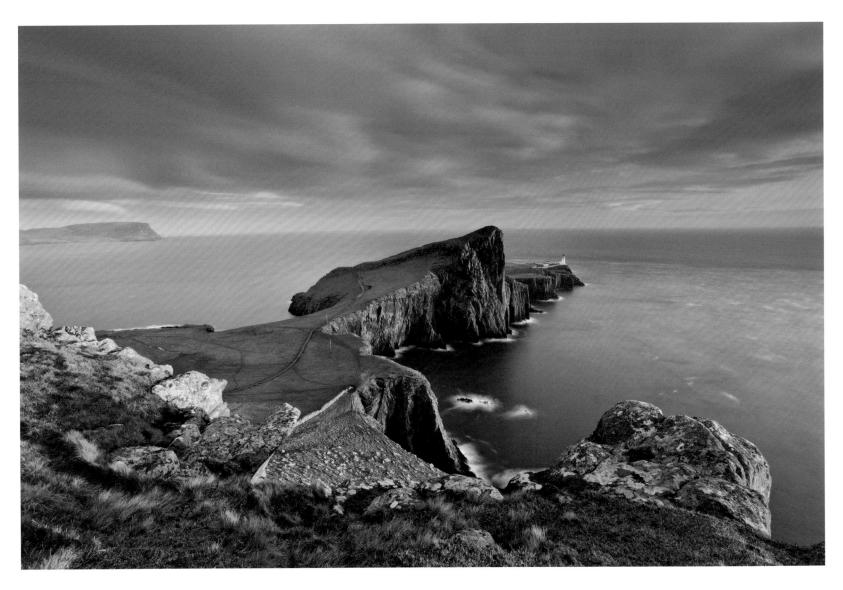

FORTUNATO GATTO

Neist Point Lighthouse at sunset, Isle of Skye, Scotland

Neist Point Lighthouse is located on the northwest of the Isle of Skye and towers over a vertiginous promontory into the Atlantic Ocean. This seascape is one of the most impressive I have ever admired. Right from the first moment I spotted it, I have dreamt about a picture that could portray its majesty. The beginning of the spring was marked by particularly variable weather, sometimes stormy and windy, but with interesting moments. Thanks to the incident light, the sun struck the cliffs with sidelight until the last light of the sunset. All the requirements were met. I walked to the desired location quite early, set the tripod, sat by the edge of the cliff and waited. The sunset was wonderful for colours and intensity. It was what I had pre-visualized. One year from my first visit and after many attempts, a real 'ocean of light' was taking place in front of my astonished eyes.

PETER RIBBECK

Hunterston view, near West Kilbride, Scotland

This area of the west coast of Scotland has beautiful views looking across the Firth of Clyde to the Isle of Arran and the Cumbraes. It is a hidden gem that very few photographers venture to. The coastline is rugged with fascinating prehistoric-looking rock formations that I was determined to capture in the best possible conditions. I have often passed this place noticing what, to me, looks like a creature's face in the rock.

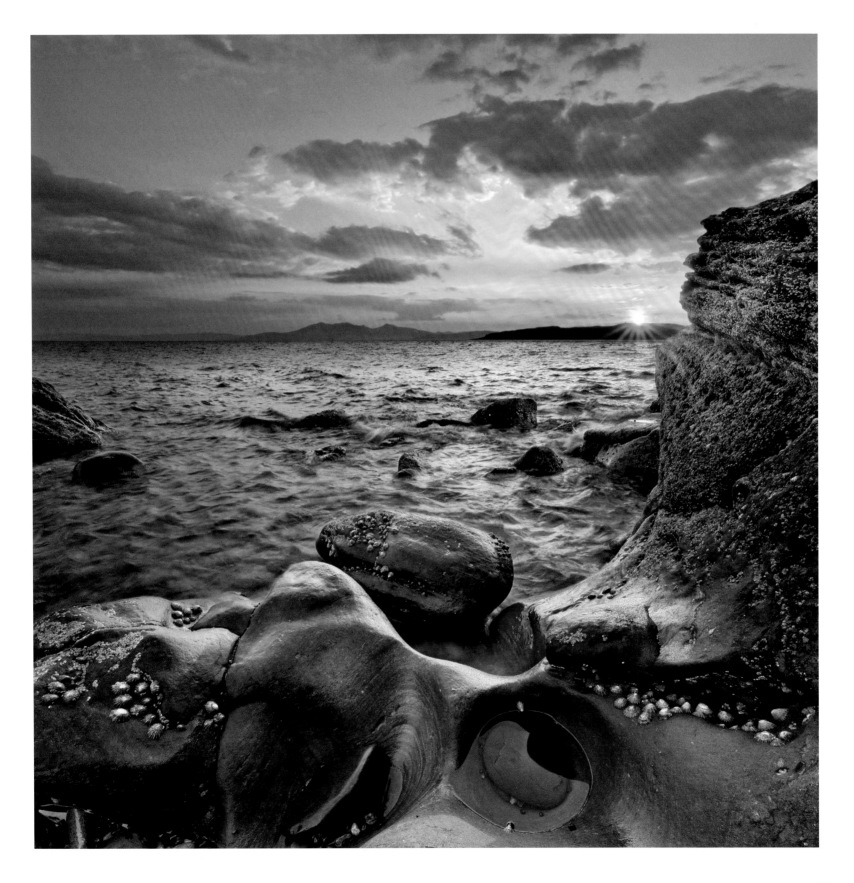

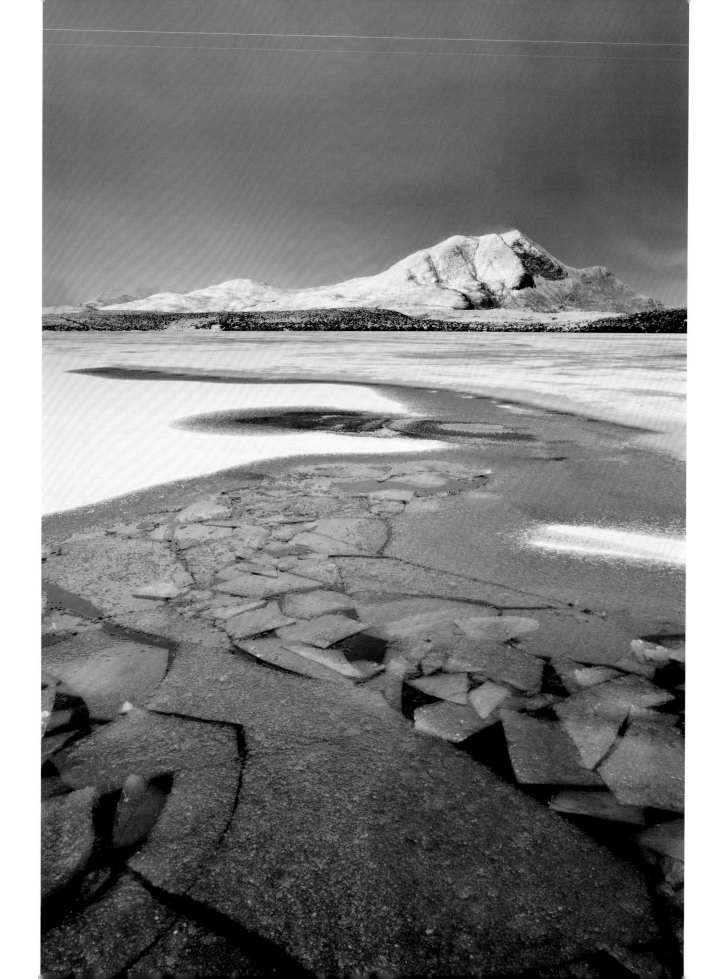

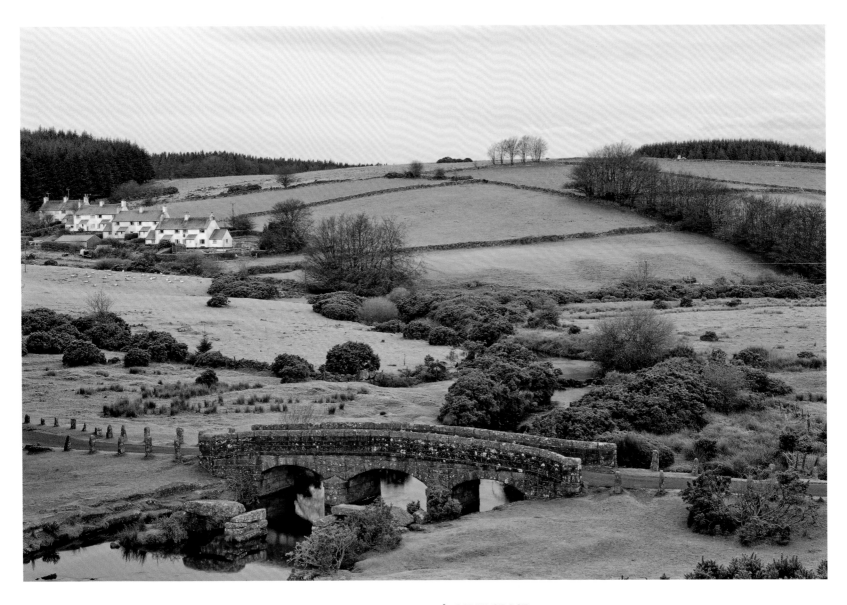

FORTUNATO GATTO

Winter dawn at Lochan an Ais, Sutherland, Scotland

I remember that late January morning very well. It was characterised by wild strong winds, snowstorms and temperatures below zero. Waiting for the right light conditions, I stood for about an hour and a half in the small, icy loch, wearing my wellington boots. The real challenge, though, was to find a composition to guide the eye towards the lit background. The uniformly frozen lake did not offer an interesting foreground, so I decided to create a guideline by breaking the ice in front of me using the tripod.

COLIN GRACE

Bridges across the Dart at Bellever, Devon, England

The early morning sun and the deep overnight frost lend an overall pastel feel to this scene of the two bridges spanning the East Dart River at Bellever on Dartmoor. This is one of my favourite spots on the moors and I like to visit at least once every season if I can. This particular Sunday morning was one of the coldest I have experienced on Dartmoor but the peace and tranquillity that I experienced was well worth it.

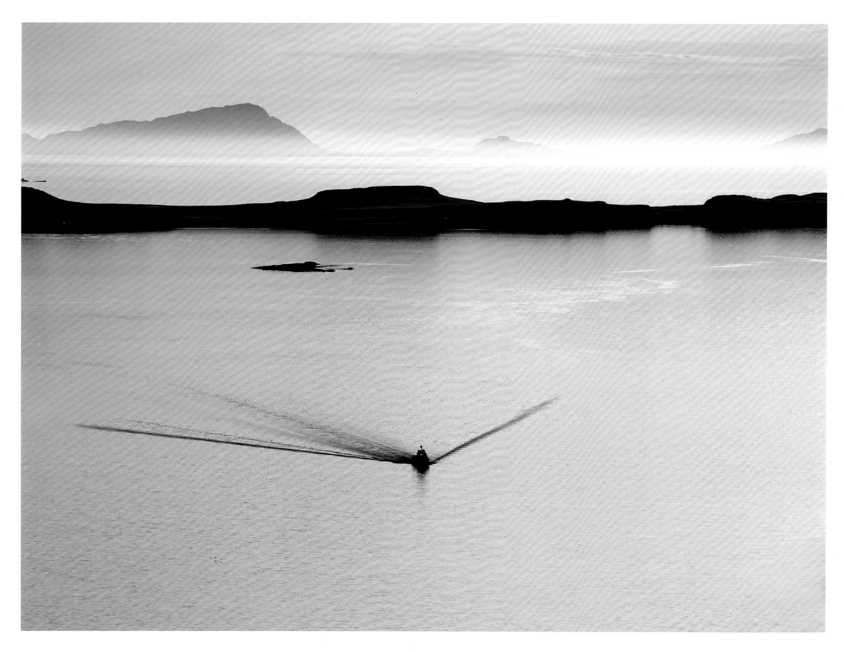

⊤ JON PEAR

Coming home, Stein, Isle of Skye, Scotland

Living on the Isle of Skye gives me some fantastic opportunities to photograph the landscape. However, many planned photography excursions can result in disappointment. This particular evening, my wife Linda and I were driving to Trumpan on the Waternish Peninsula to try and photograph the sunset when we got a glimpse of this boat coming into harbour. I waited until I thought the boat was in exactly the right position and then pressed the shutter. I took several more images but none of the others somehow seemed to be quite so 'right'.

DAMIAN SHIELDS ⋯⟩

St. Michael's Mount, Cornwall, England

This shot of St. Michael's Mount near Marazion was taken during a recent holiday. With warmth and colour, I wanted to create a simple image that captured the beauty and peaceful calm of that location at that time of day.

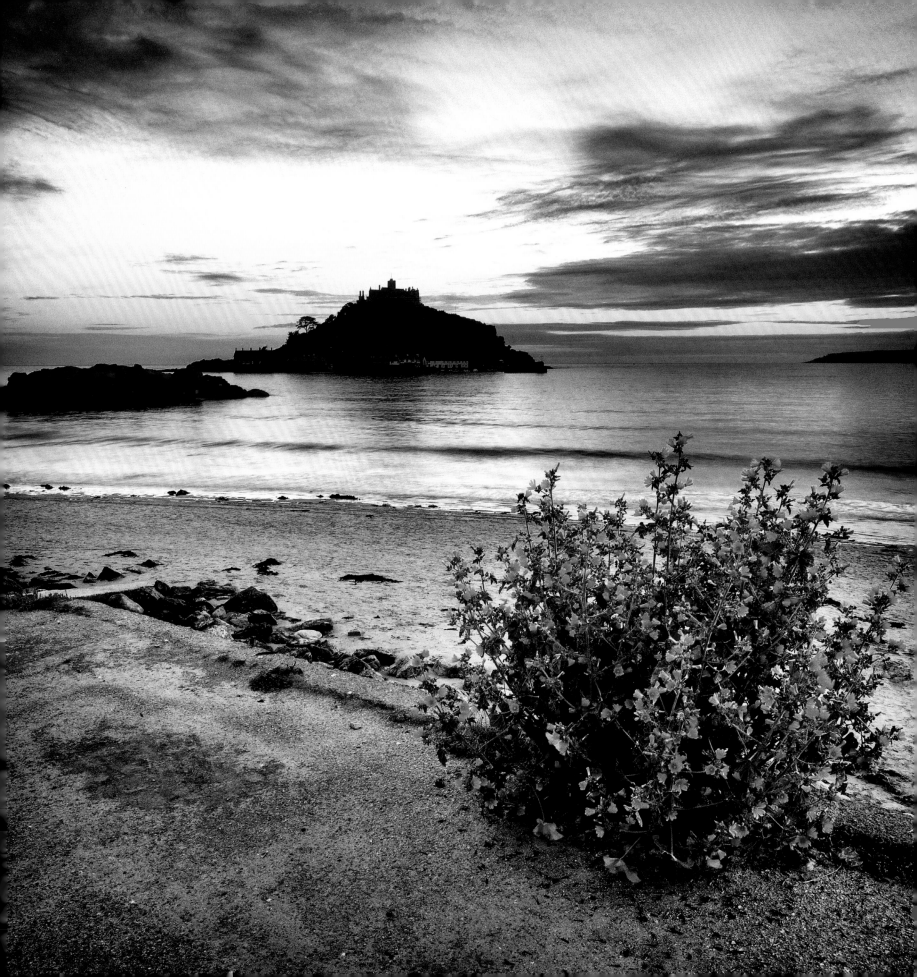

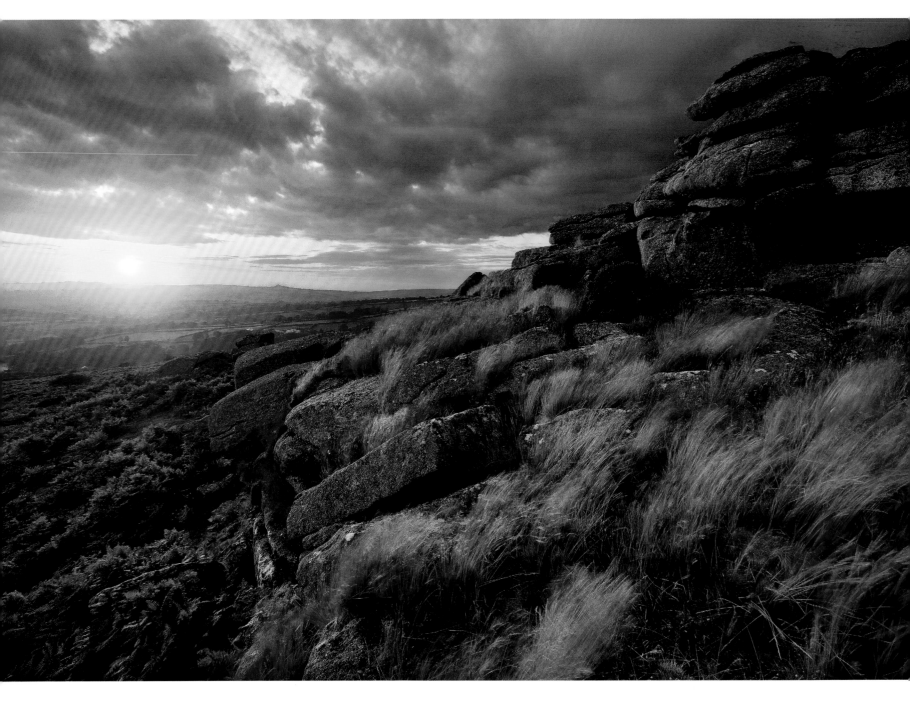

ALEX NAIL

Pew Tor, Dartmoor, Devon, England

This summer day was like all the rest in the two weeks previous, with drizzle throughout the morning and afternoon. Towards sunset, the drizzle stopped and I headed out, camera in hand, in the hope of a photo. The gap on the horizon was exciting; after all the rain the skies were very clear. I cycled to this spot at Pew Tor on Dartmoor and was in position just as the light was at its peak. The golden grasses turned red under the light of the setting sun. Brief moments like these make landscape photography quite thrilling.

50

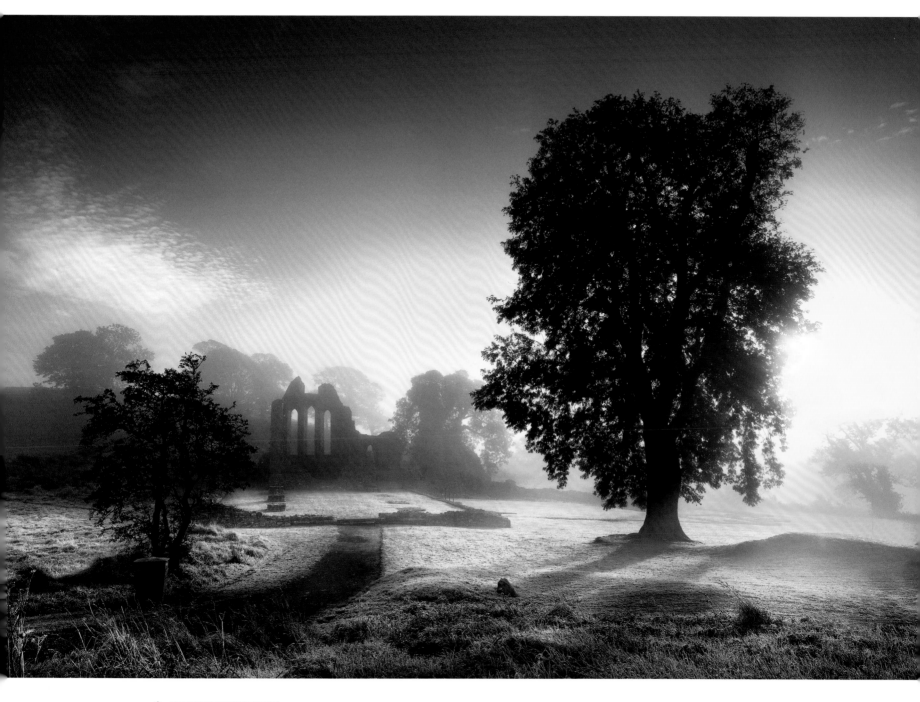

✝ STEPHEN EMERSON

Enchanted Abbey, Downpatrick, Co. Down, Northern Ireland

The impressive ruins of Inch Abbey are near to where St Patrick himself is said to be buried. They are in a beautiful location beside the River Quoile, with distant views towards de Courcy's Cathedral town of Downpatrick. I captured this on a foggy morning and, as the sun started to filter through, the golden tones shrouded the scene adding a mystical mood to the ruins.

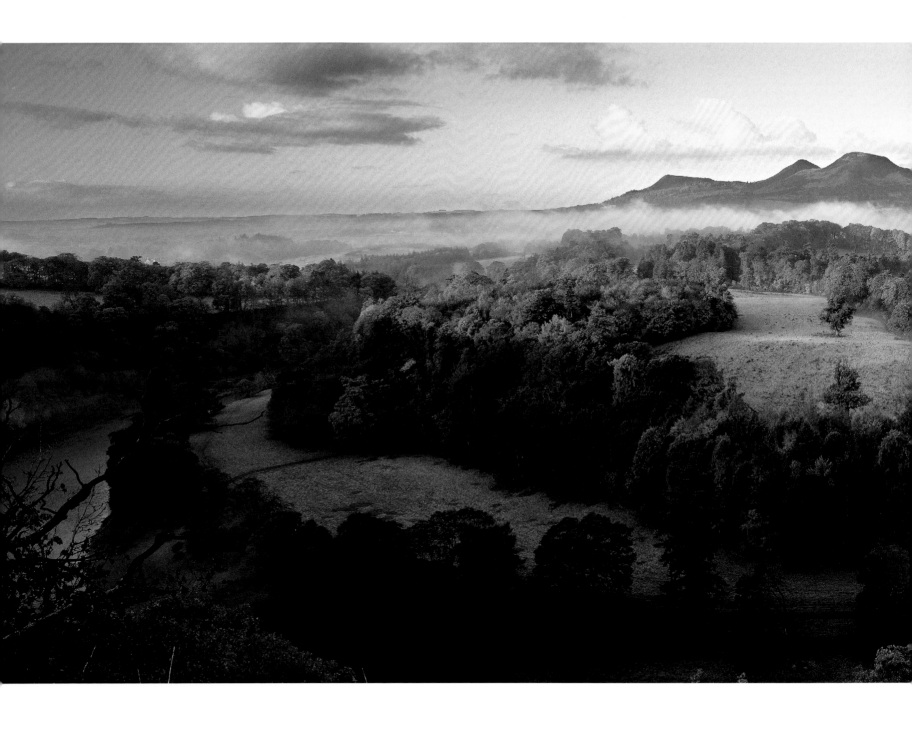

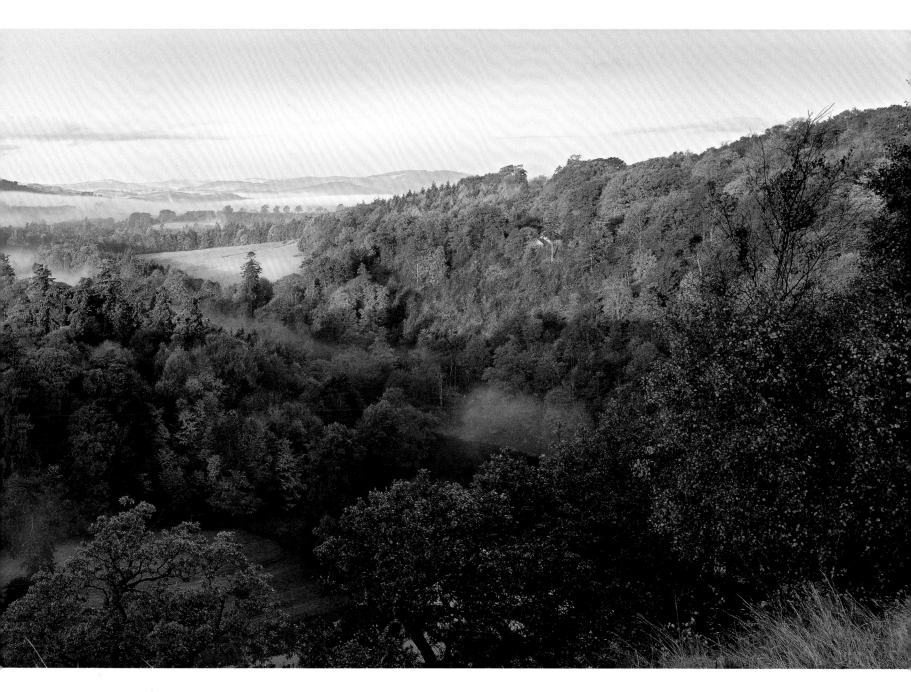

☂ CHRIS CLOSE

Scott's View in the Borders, Scotland

This image was taken at sunrise at Scott's View, which is east of Melrose in the Scottish Borders. Overlooking the River Tweed, the view is named after Sir Walter Scott, of whom it was, reputedly, a favourite. The distinctive three peaks of the Eildon Hills are in the distance.

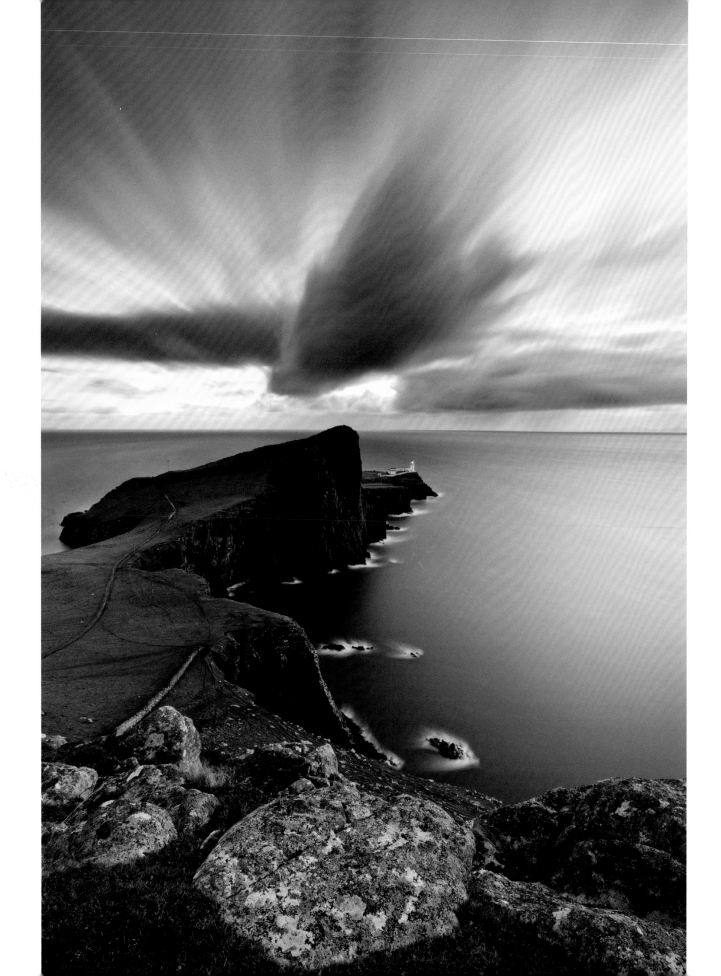

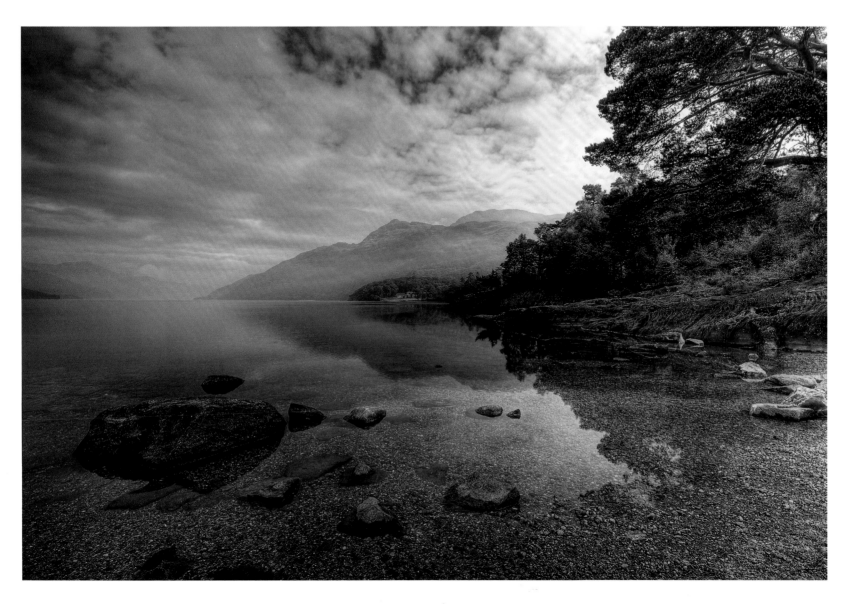

EMMANUEL COUPE

Neist Point at dusk, Isle of Skye, Scotland

This scene was shot after sunset and the long exposure, in combination with the equally strong winds, created this bird-like shape in the clouds, made the roaring ocean appear peaceful and shaped a white contour around the base of the cliffs. Since the sun had set only minutes earlier, there was enough warm colour to spread across the sky. This place is unique because it marries contrasting natural elements together in a grand scene. By 'contrasting', I refer to the forever moving ocean and sky meeting the solid-standing giant cliffs and rocks.

KARL WILLIAMS

Rowardennan, Loch Lomond, Scotland

It was early morning and, having spent the preceding hour taking some long-exposure dawn shots further up the loch, I was on the way back to the car when I spotted this view – the conditions were perfect for the classic 'grab' shot. Two minutes later a breeze had sprung up and the reflections were gone!

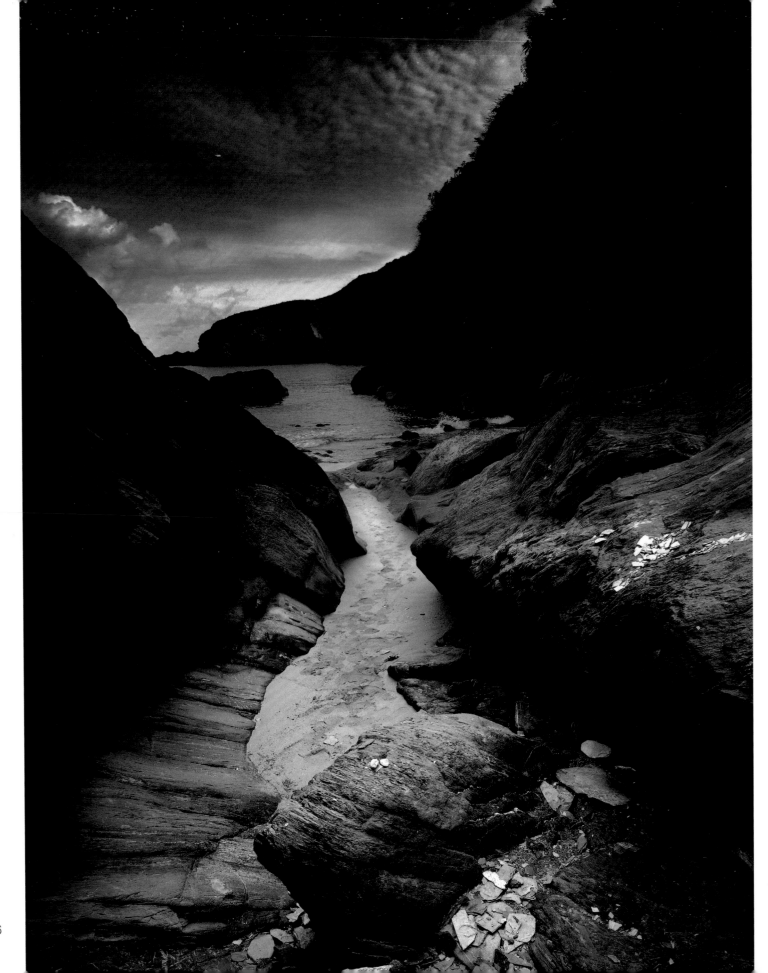

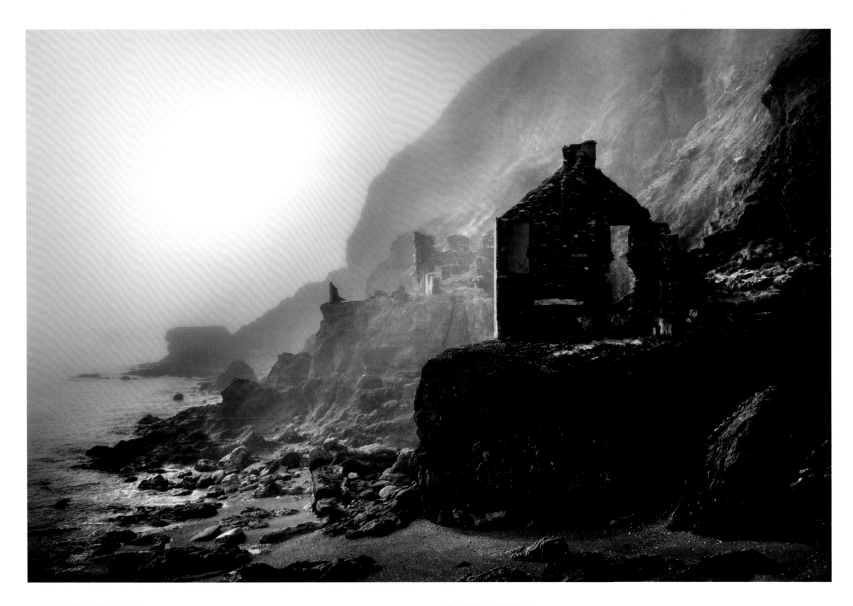

DAMIAN SHIELDS

Man Sands, Devon, England

Man Sands is a fairly remote beach in Devon that I visited with my family one late summer. A short walk to the right of the flat sands led me to these towering jagged cliffs and outpourings of natural slate with an amazing texture and shimmering metallic sheen that were a gift to my eyes. With this shot I was interested in the relationships of line, texture and pattern in each element (sky, water, sand and slate).

PAUL KNIGHT

Hallsands, Devon, England

Dredging took place just offshore from the village of Hallsands in the 1890s. By 1917 the sea had encroached leaving just one house intact. Hallsands can only be reached by boat now, although there is a viewing platform nearby.

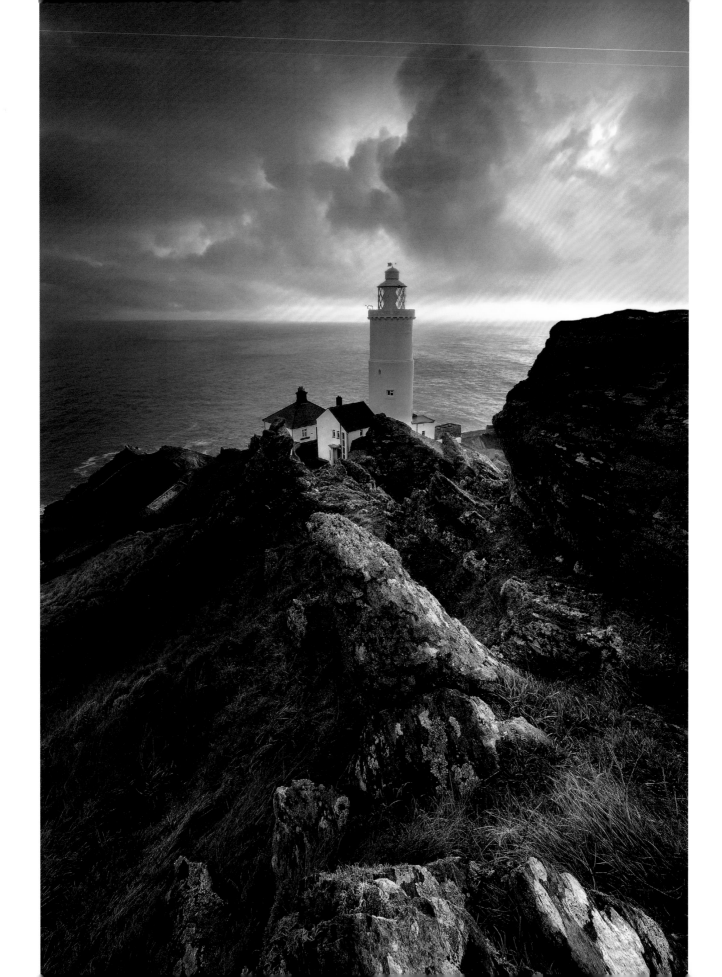

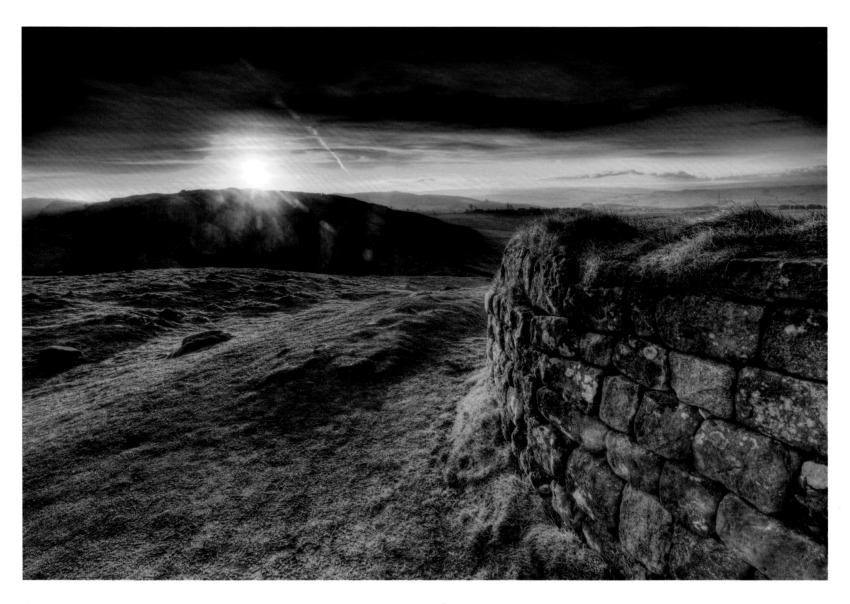

PAUL FORGHAM

Sunrise at Start Point, Devon, England

I'd wanted to photograph this location for some time and finally had the opportunity on a cold January morning. Start Point is one of the most exposed peninsulas on the English coast, stretching almost a mile into the sea. The weather wasn't looking promising at first, with distant fog and heavy cloud, but as the sunrise unfurled I was treated to a quite spectacular show. The fog quickly cleared as the sun blazed a laser-like trail across the horizon, illuminating the sky in an almost biblical fashion, while bathing the rocks and grasses in wonderful light and rich colours.

WAYNE BRITTLE

Winter Dawn over Hadrian's Wall, Northumberland, England

Such a stunning location, which I never get tired of visiting. The local forecast for this particular morning predicted that it could be a bright and frosty start to the day, so my camera was set up well before sunrise just waiting to capture my moment. I used a blend of exposures and I really like the detail that this technique brings out in the image, especially in the stonework.

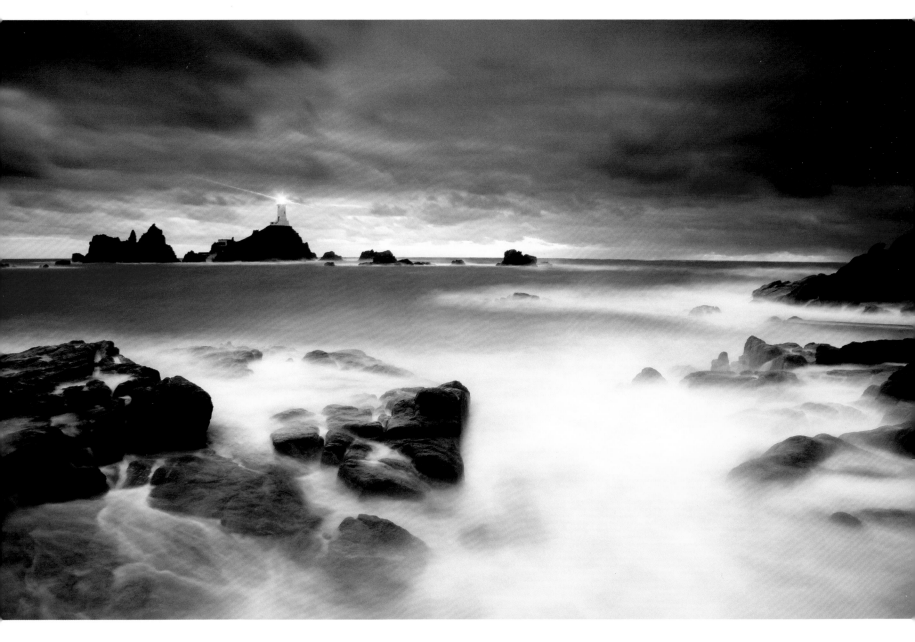

⚜ PAUL SANSOME

La Corbière, St. Brelade, Jersey, Channel Islands

I was in Jersey for one week and was keen to photograph the lighthouse at La Corbière in high seas. I visited the location several times in disappointing conditions and then, on the last day, I was excited by the potential of the windier weather. The low light conditions meant that a long exposure was needed. This created the ethereal feel of the breaking waves and also ensured that the light of the lighthouse would be on.

NICOLA HARKNESS ⋯⟩

Smoo Cave, Durness, Scotland

The waterfall of Smoo Burn seen through the dim light of the second chamber of the cave – a combined sea and freshwater cave in the far north of Sutherland.

Judge's choice David Watchus

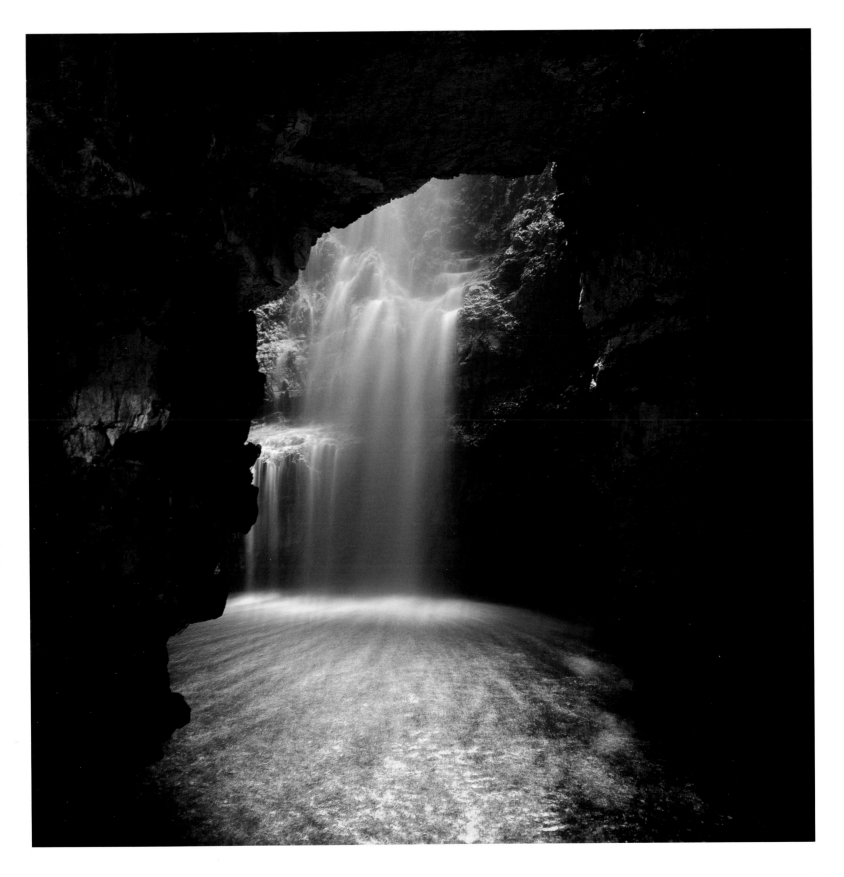

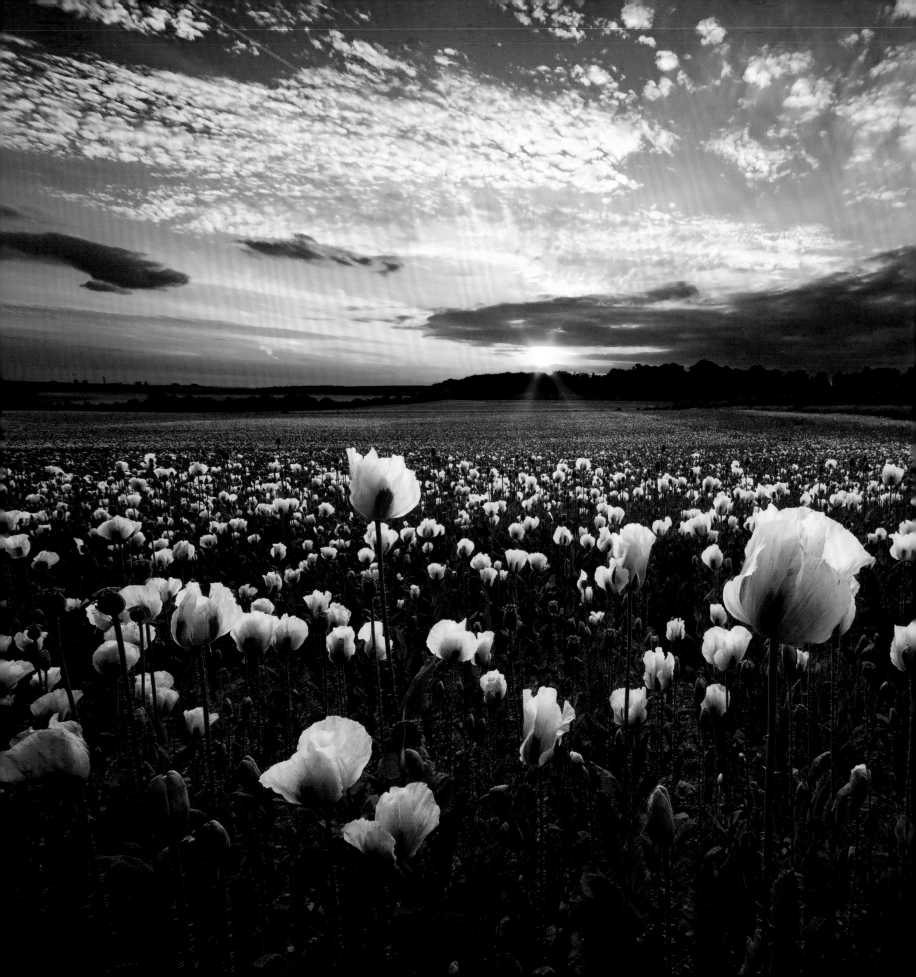

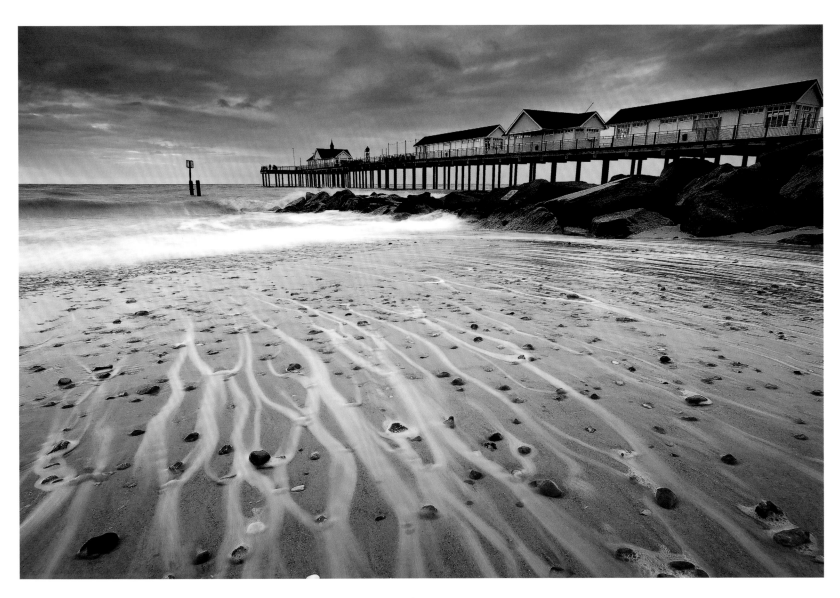

ADAM EDWARDS

Summer solstice poppies, Oxfordshire, England

Midsummer in England is a beautiful time for wildflowers, as the countryside comes to life with all manner of brightly coloured flora. I had scouted out this location for the first time the previous evening, arriving just slightly too late to make the most of a rather tasty sunset. Although I managed some nice shots of the afterglow, I vowed to return the following day at the summer solstice to try again. On my second visit I arrived in slightly better time and was able to capture the last of the day's light as it flooded across the field, lending the poppies a gentle glow before the sun disappeared below the horizon.

MARTIN CHAMBERLAIN

Ebbing tide at dawn, Southwold Pier, Suffolk, England

Southwold's pier dates back to 1900 and has been restored over recent years to become one of the finest piers in Britain. Getting out of a warm bed at five in the morning to photograph it isn't the easiest thing in the world, particularly when it's cold and the clouds appear dense enough to guarantee that the sun will stay hidden for the day. But as I set up my tripod and waited for my watch to tell me the sun had risen, the cloud cover thinned and small patches of blue appeared in the east. I noticed that the pier buildings were slowly turning from a cold blue hue to subtle amber. The underside of the clouds had caught the first light, and the sand glowed through the wash of the tide. For one minute I was rewarded with near perfect light. Just enough time to try a few combinations of slow shutter speeds and retreating waves.

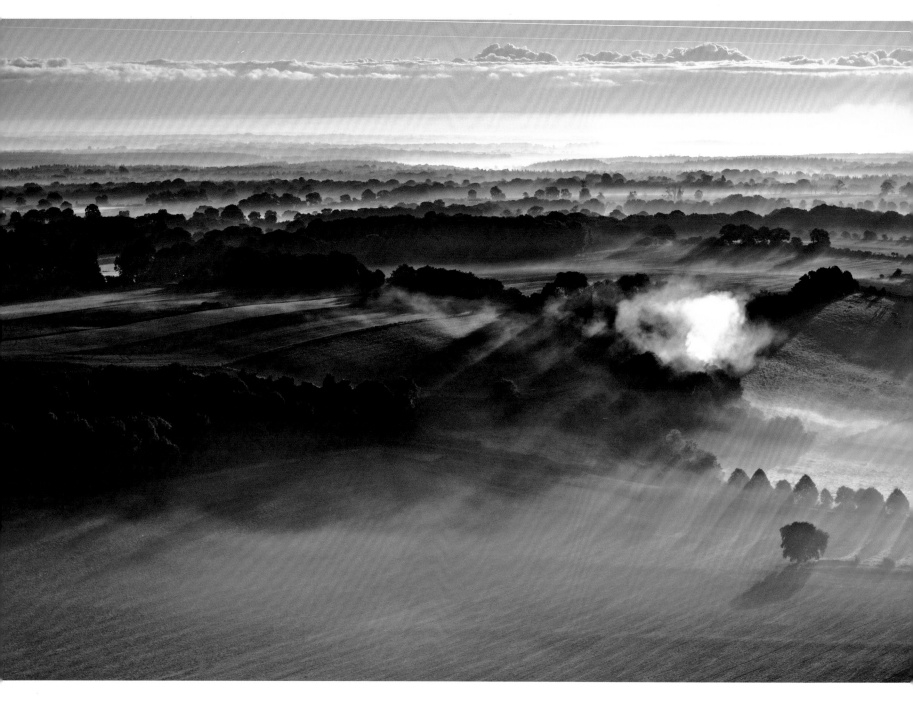

✝ JIM GROVER

Sunrise over the Vale of Pewsey, Wiltshire, England

Martinsell Hill is the site of an Iron Age hillfort and provides panoramic views over Pewsey Vale. On several occasions, I've climbed up the hill in pre-dawn darkness to capture the rising sun, not knowing what the ensuing sunrise might bring. I've been disappointed on many occasions, even if it's still a wonderfully tranquil place to enjoy a thermos of hot coffee! But on this August morning I was rewarded with the rays of the low rising sun streaming through a light mist that hung over the vale below, casting long tree shadows. A puff of smoke, from a farmer burning the corn stubble, added to the misty mood.

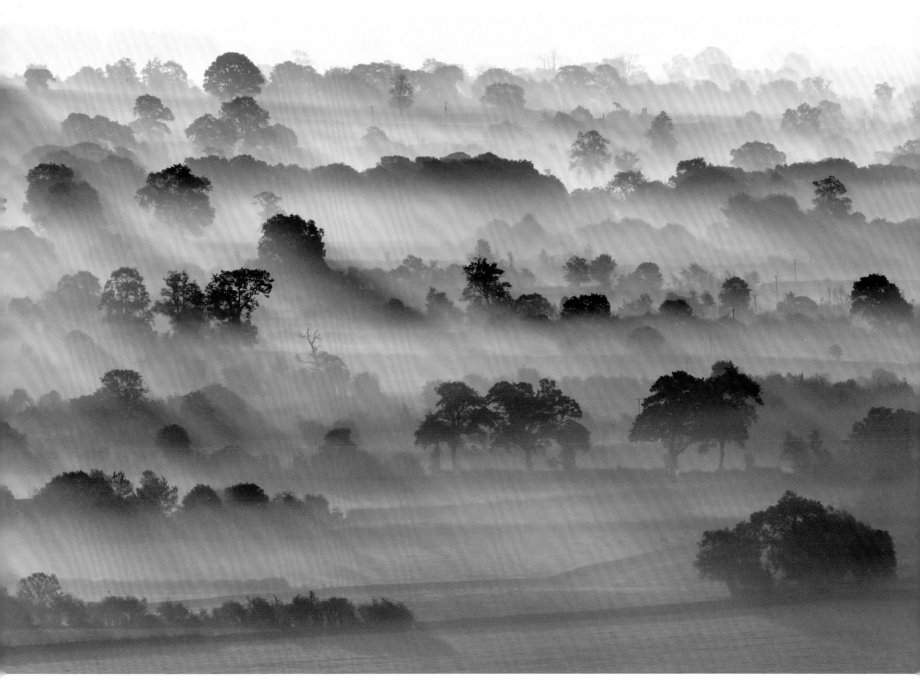

🌱 DAVID CLAPP

Dawn over the Somerset Levels, England

A trip to Glastonbury Tor to shoot mist across the Somerset Levels seemed doomed by cloud with hardly any mist at all. As the sun rose and the air warmed so the mist thickened in the valley proving once again that I should stop moaning when I have no idea of the outcome. Shot with a long lens, the telescopic effect flattens a few miles of fields into these distinctive rows, enhanced by light rain of a very different kind.

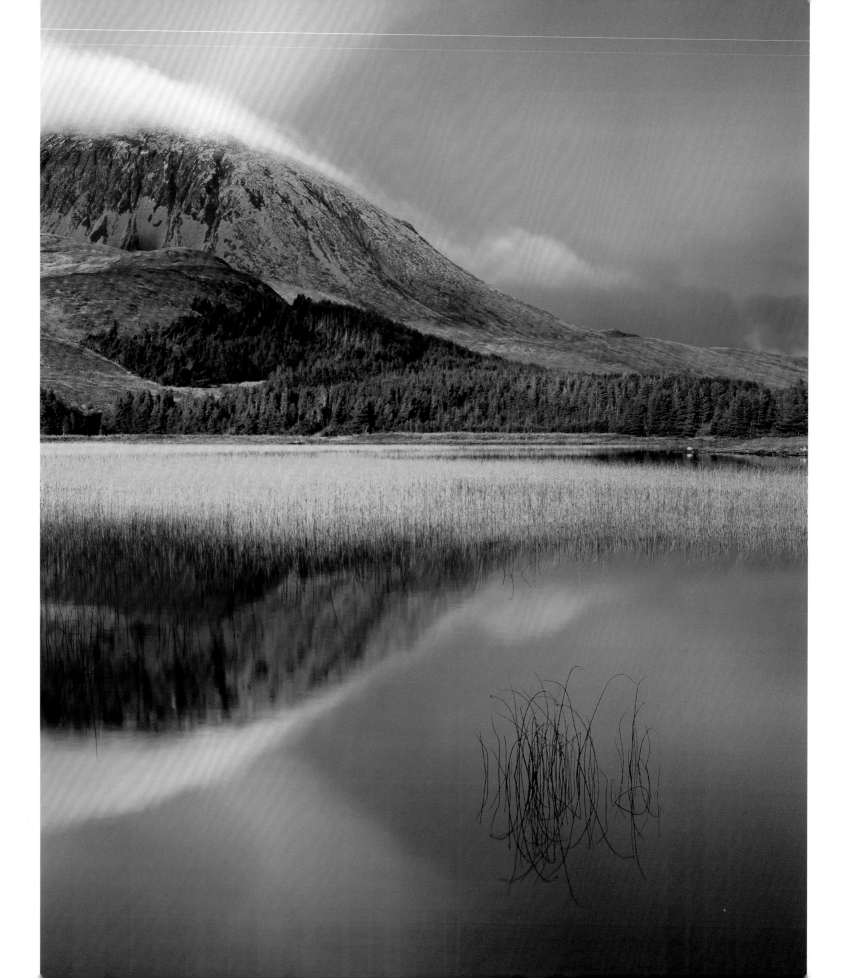

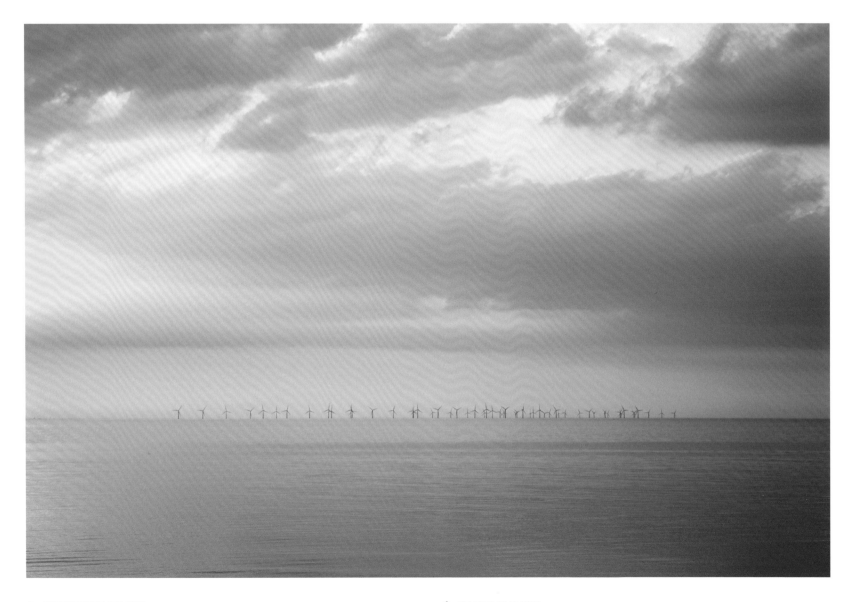

DIMITRI VASILIOU

Loch Cill Chriosd and Beinn na Caillich, Isle of Skye, Scotland

As a regular visitor to the Isle of Skye, I had tried to take similar pictures before. However, the reeds never came out with that golden colour when the low sun was on them. I decided that it might be a 'digital thing' so gave it a try with Fuji Velvia medium format film and I am pleased I did. The low sun had turned the reeds to pure gold and Velvia managed to capture the beauty of it.

GRAHAM DUNN

Offshore wind farm from north Norfolk, England

Whilst photographing the north Norfolk coast I noticed this wind farm, often thought of as a bit of an eyesore, becoming enveloped in the stunning colours that surrounded the setting sun. I love hinting at man's impact on the landscape in my photography and I thought this would make an interesting and intriguing composition. Though enormous in our eyes, this image shows how small the turbines are when compared to the size and scale of nature around them, whose power they hope to harness.

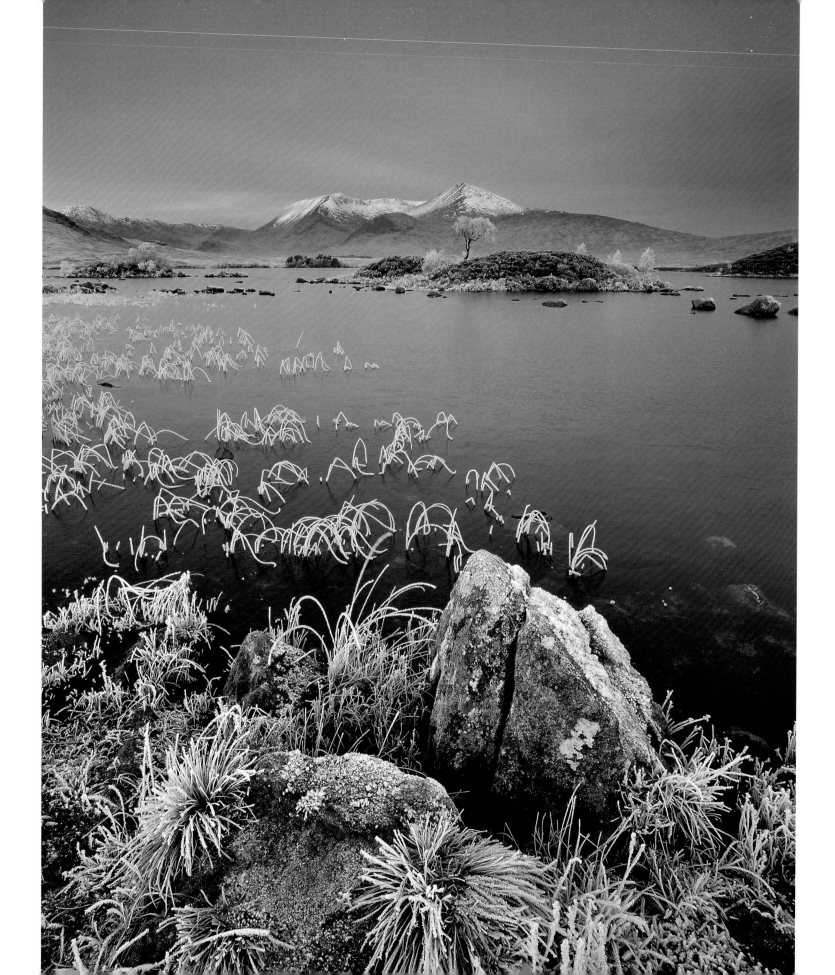

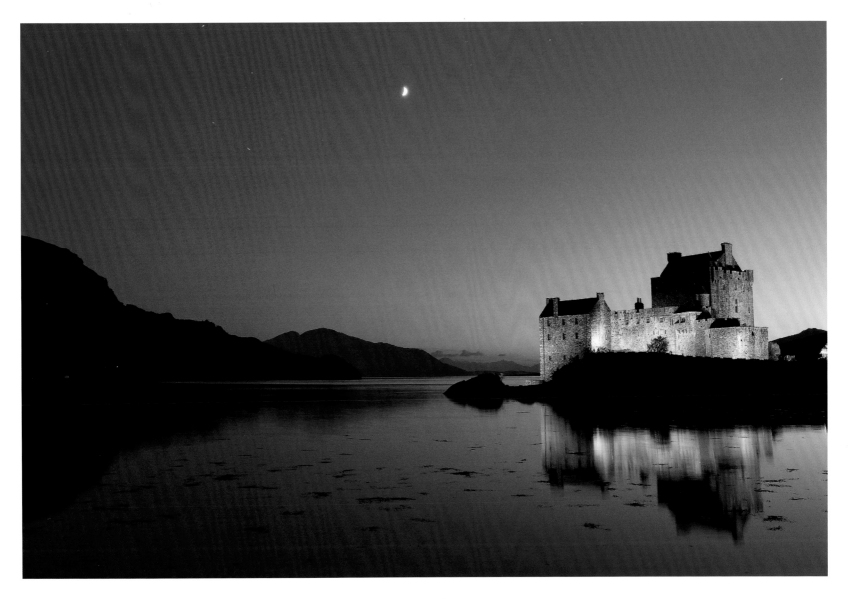

NEIL MacGREGOR

Winter dawn, Rannoch Moor, Scotland

The weather forecast predicted a cold, clear December night with sub-zero temperatures. Next morning, I found myself on Rannoch Moor with a small group of Kirkintilloch Camera Club members. In the dark at 6.45am we set up cameras and tripods, sipped coffee from flasks and waited for the light... A prolonged spell of cold weather had frozen the loch and hoarfrost coated the vegetation and trees of the moor. The stage was set and as dawn broke the sky turned a deep shade of blue. Unfortunately a cloudbank in the east occluded the rising sun, so no direct light fell on the distant Blackmount hills. However, for a brief moment, some thin cloud above the mountains was lit by the rays of the sun giving some warm colour to the cold, blue scene.

ALESSIO BOZZO

Eilean Donan Castle, Scotland

Eilean Donan Castle and Loch Duich during a calm, short night in early June. The crescent moon casts a gentle light on the quiet landscape.

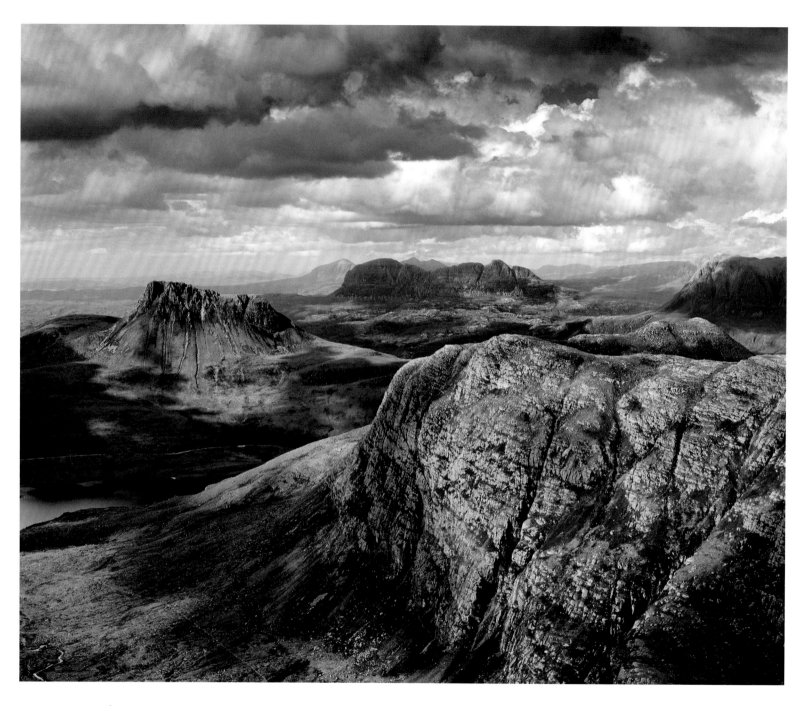

⚜ GLENN HARPER

Stac Pollaidh and Suilven, Scotland

I drove south from Lochinver on the 'wee mad road' to Achiltibuie, through the beautiful and dramatic Sutherland landscape and kept going almost to the end before parking near the bridge and taking the track up to the Fiddler. It is a suspense-filled walk, as each small ridge you conquer reveals yet another until finally you are rewarded with this magnificent view.

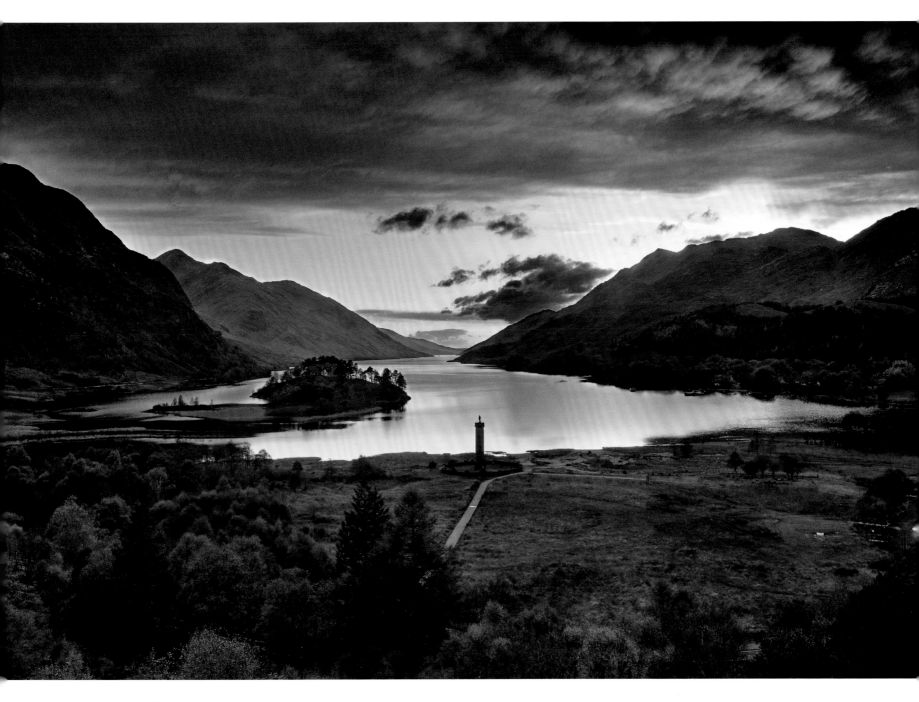

✝ IAN THORNE

Glenfinnan Monument and Loch Shiel, Scotland

Autumnal sunset, looking towards Loch Shiel, with the Glenfinnan Monument in the centre and St. Finan's Isle at the head of the loch. The monument marks the point where the standard was raised to start the doomed 1745 Jacobite rebellion.

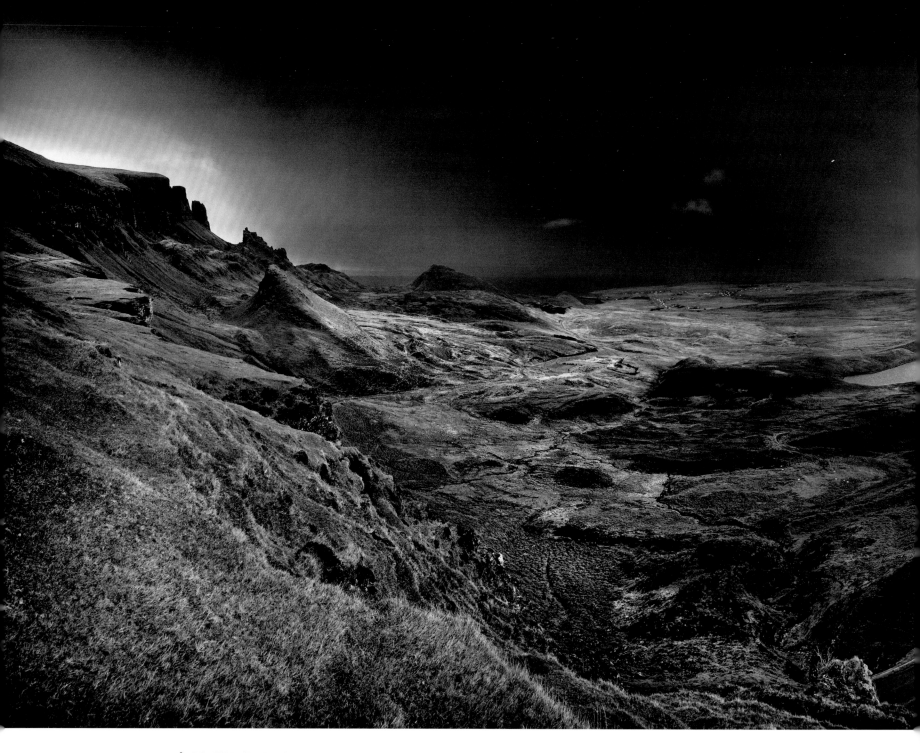

DAMIAN SHIELDS

The Quiraing, Isle of Skye, Scotland

The Quiraing is an area I had dreamt of visiting for a long time, having had my imagination stirred by countless interpretations of its majesty by other photographers. This panorama was captured on my first visit to Skye and I have tried to communicate the sense of sheer space and atmosphere I felt on reaching this vantage point.

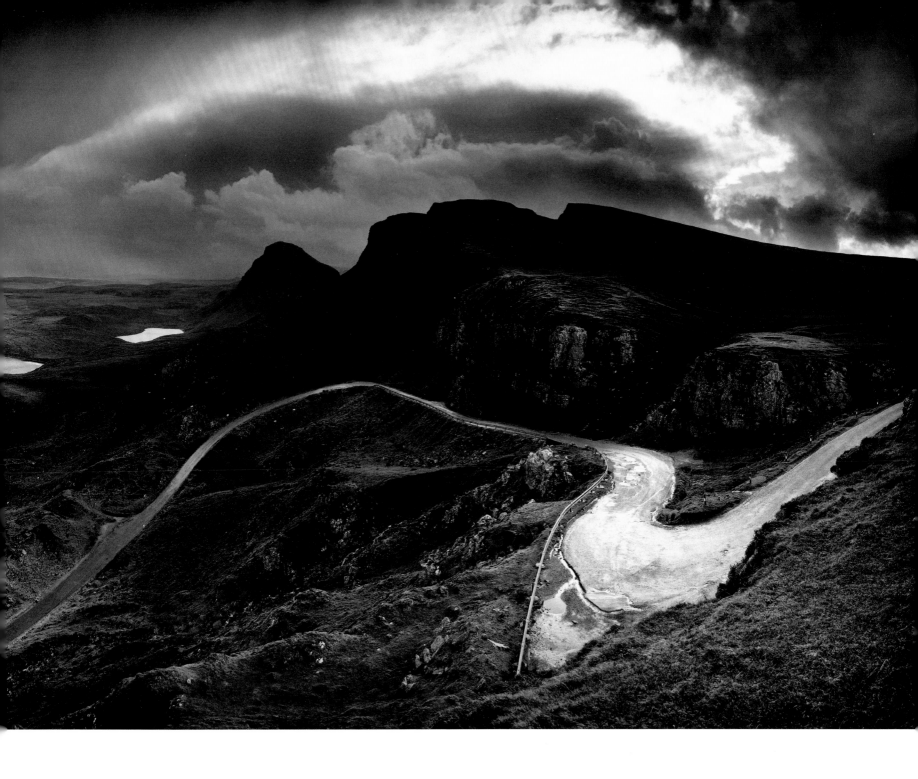

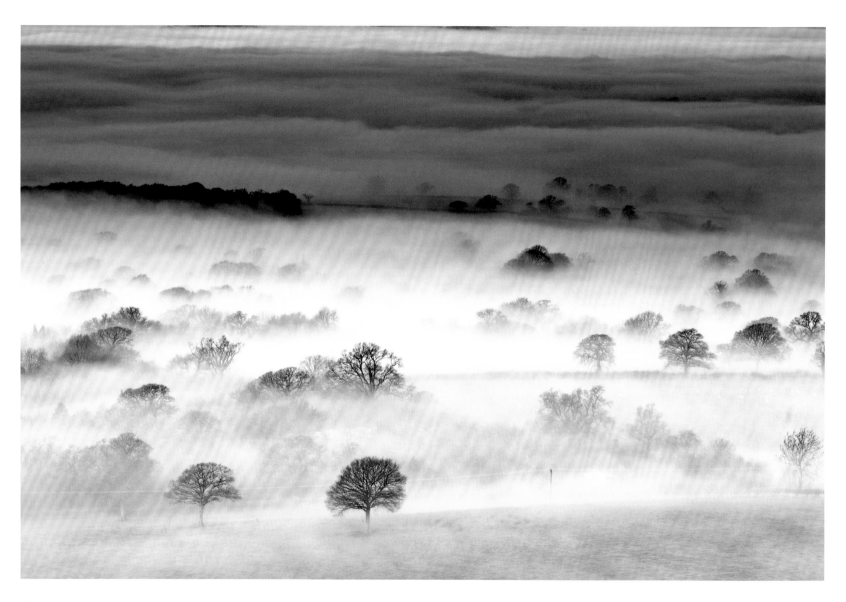

ANTHONY BLAKE

The Blackmore Vale from Bulbarrow Hill, Dorset, England

On this misty November morning, the villages of Ibberton and Woolland are close by but hidden by the mist. A farm worker's caravan can just be seen through the haze. This ethereal scene is typical for the time of year, with the early morning mist slowly burning away as the sun starts to rise. With a small time window of opportunity and a desire to pick out the temporary layers that had formed around the trees, I opted to use a medium telephoto lens which compressed the trees and emphasized the three-dimensional feel of the scene. The mist did the rest.

MARTIN EDGE ⋯⋗

Misty sunrise on the River Frome, Wareham, Dorset, England

I was in situ well before sunrise but a flat, dull sky without a hint of promise dashed my hopes. I waited past sunrise – still nothing. I thought of leaving when out of the mist a watery sun broke through. Luckily, I'd already composed my idea into a strong diagonal with the reflections of the masts leading the eye along the river and out towards the sea. Within minutes this serene moment was over but my early start had been well worthwhile.

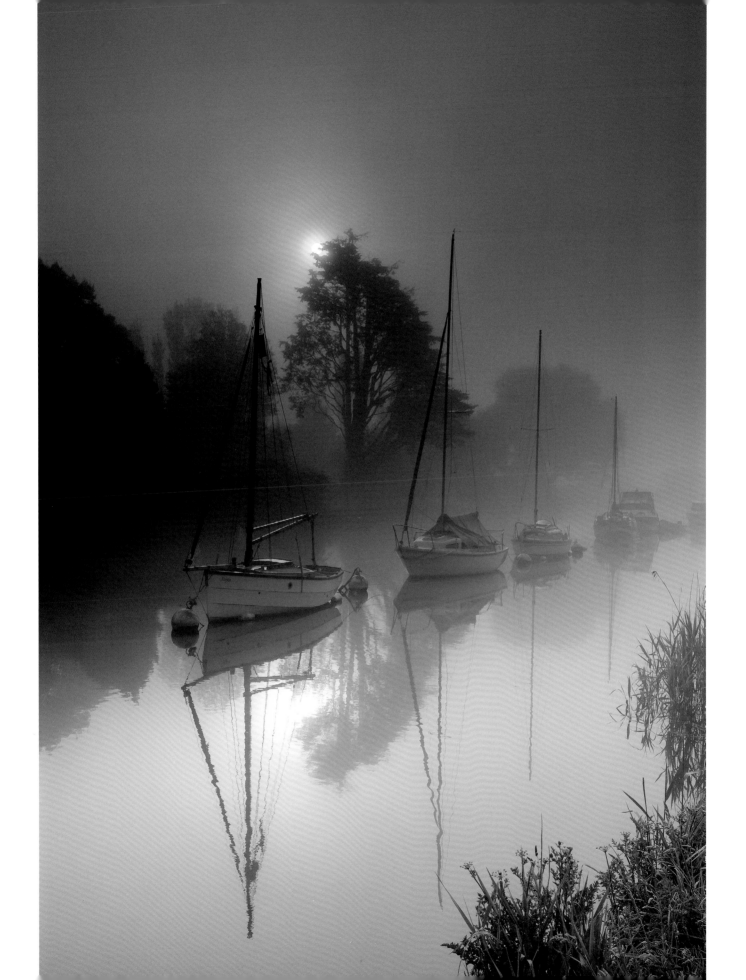

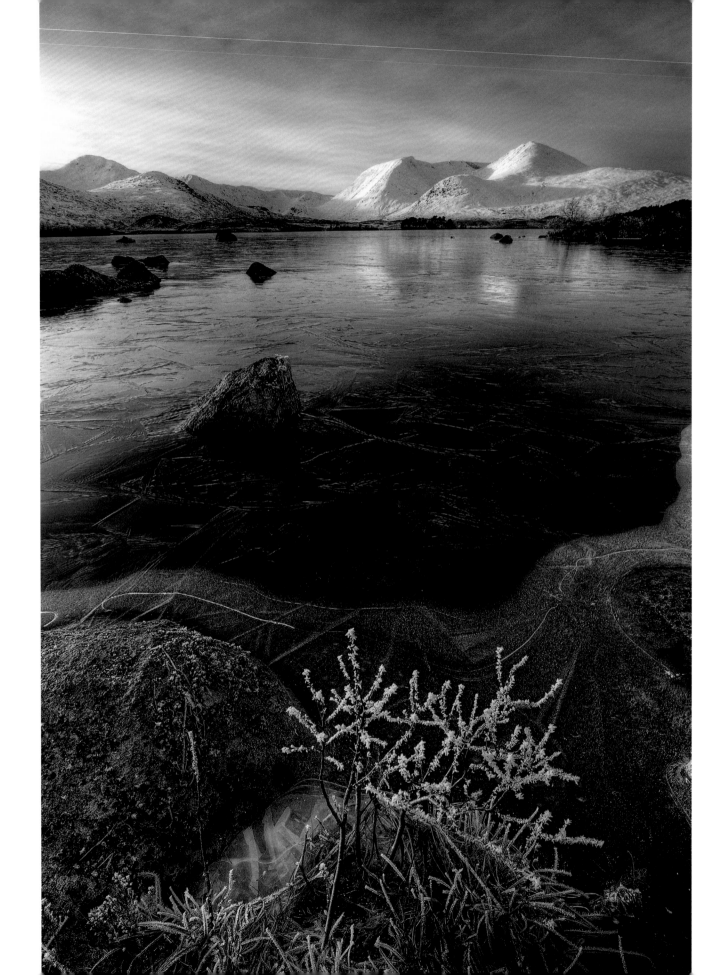

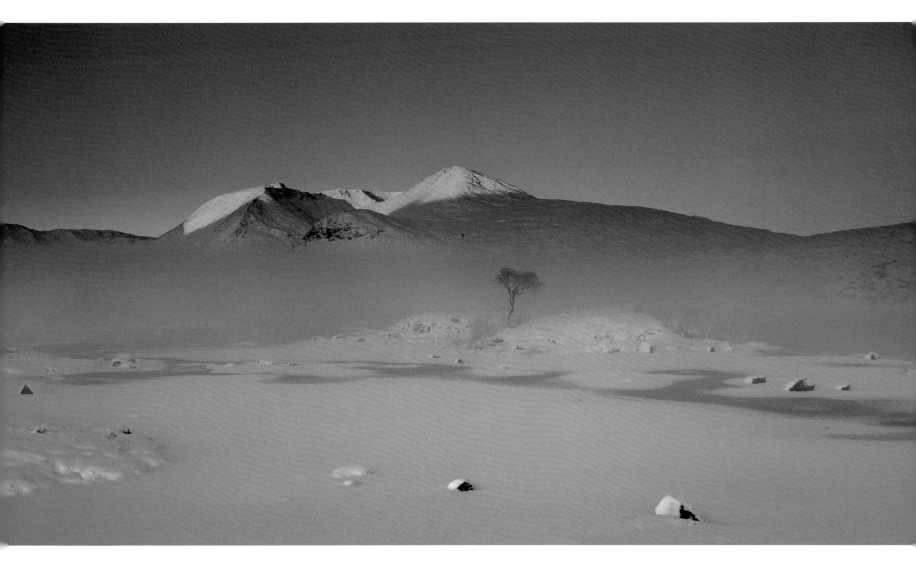

THOMAS GRAHAM

Lochan na h-Achlaise, Rannoch Moor, Scotland

One of those days we all dream of with snow, ice and the light to work the wonders of Lochan na h-Achlaise with Black Mount in the distance. I loved the way the frost was still showing on the small bush and tried get down real low to get the whole feeling of that day into the shot.

THOMAS GORMAN

Lochan na h-Achlaise, Rannoch Moor, Scotland

I travelled for over three hours on this extremely cold winter's morning to reach Lochan na h-Achlaise. My car's thermometer read −16°c as I stepped out of it pre-dawn. I had pre-planned my visit to this location and was glad that there were not many people about to see me doing star jumps in an effort to stay warm. As the sunlight crept over the hills behind me and started to illuminate the peaks of the Black Mount I knew the time had arrived. I captured a couple of photographs before the glare of the morning sun was fully upon me and the glory of that initial sunrise glow was gone. I returned to my car to find that I was stuck in the snow. I am very grateful for the assistance I received from some fellow photographers who managed to help push my car out of the snowdrift.

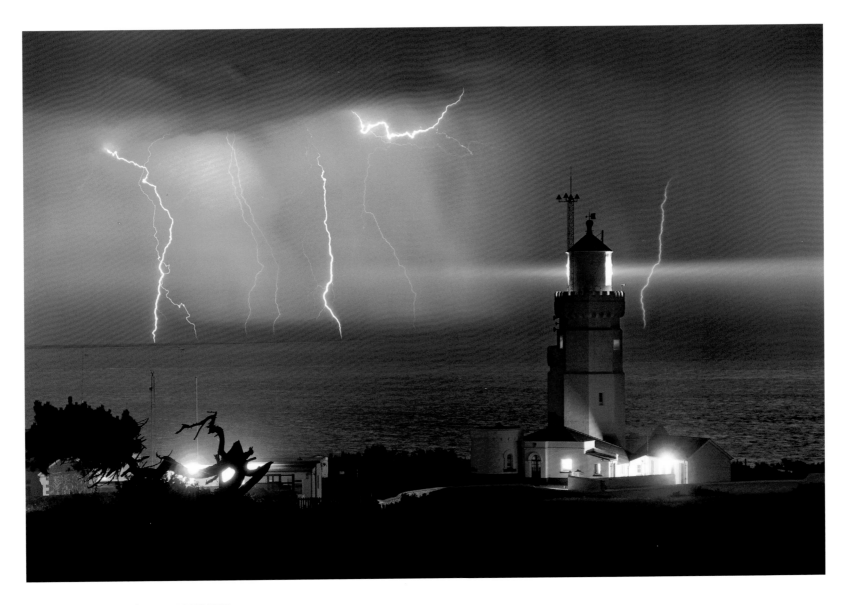

✝ JAMIE RUSSELL

Lightning over St. Catherine's Lighthouse, Isle of Wight, England

St. Catherine's Lighthouse is a well-photographed spot on the Isle of Wight but, as a lightning photographer, I have been waiting for many years to capture a storm at this location. You may think that the horizon appears to tilt, but on closer inspection you can see that it's the approaching torrential rain from the front edge of the storm cloud. A long exposure is usually required to capture night time lightning, as in this case where the multiple strikes were captured over a period of 26 seconds, and a wide aperture was used as the lightning was behind the rain curtain, making it somewhat fainter than usual.

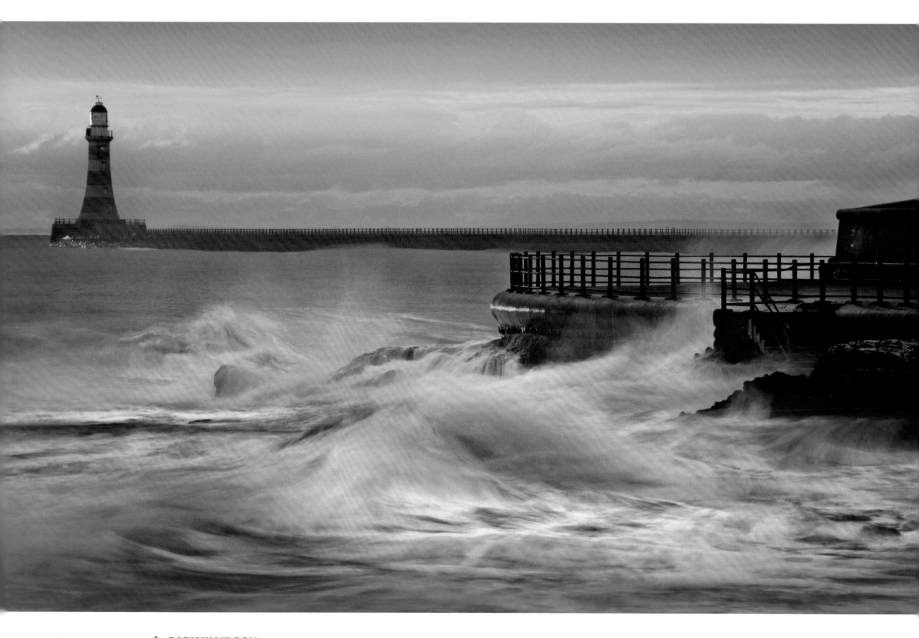

ⵟ **GARY WAIDSON**

Roker light over Parson's Rocks, Sunderland, England

When people first see this picture, most assume I've done something odd to the colour.
In truth this scene was much as you see it now. I had work in the area, so on a cold, windy
January morning, I found myself out along the seafront after breakfast, hoping to see the
sunrise. In the pre-dawn light, the colours were cool and muted. Warmer, pastel shades of
dawn crept into the sky as the sun started to break between the sea and the clouds. Then,
just for a few seconds, the light glinted off the wet stonework and the low clouds lit up. The
water still reflected the higher blue sky while a long exposure captured the waves, pounding
onto the rocks and the moment was etched into my memory and my memory card too.

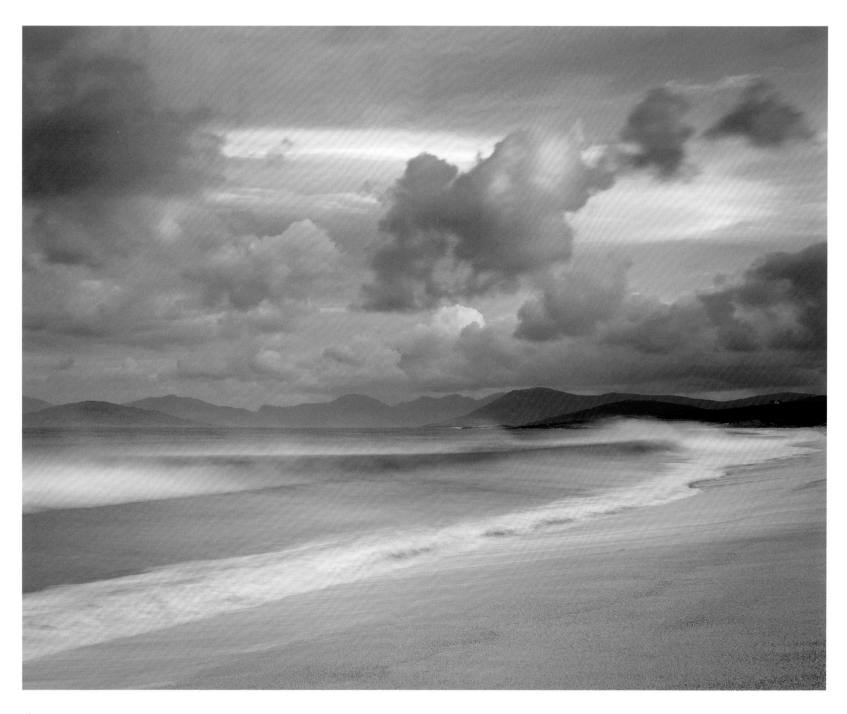

✝ DUDLEY WILLIAMS

Scarista surf, Isle of Harris, Scotland

Turquoise waves roll onto a pristine, deserted beach in this beautiful corner of the Outer Hebrides. A strong wind blows the crests off the waves and tugs the clouds. The winter morning provides the soft tones and a slow shutter gives life to the sea.

DAVID KENDAL ⋯⊹

Seilebost in winter, Isle of Harris, Scotland

A very cold morning on the Isle of Harris. Taken at first light, overnight snow on the distant peaks was a welcome bonus. Despite the bitterly cold weather, I experienced a special sense of calm on the beach that morning and it is a feeling that I will never forget. I knew the lack of colour in the sky would allow the subtle pastel tones in the scene to take centre stage and, due to the low light, a long exposure was required on this occasion.

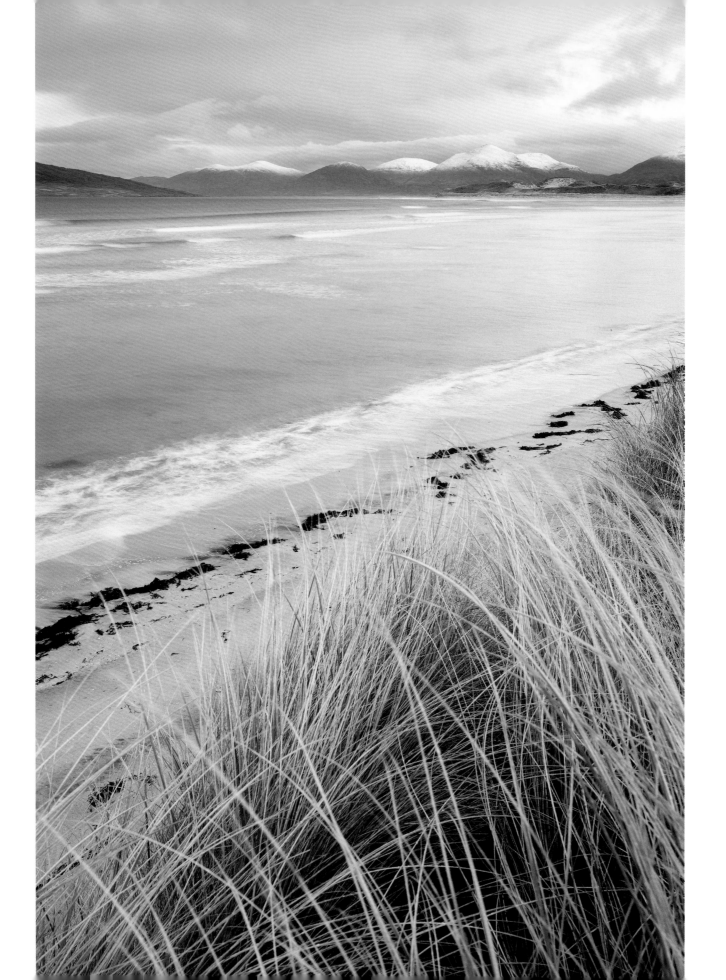

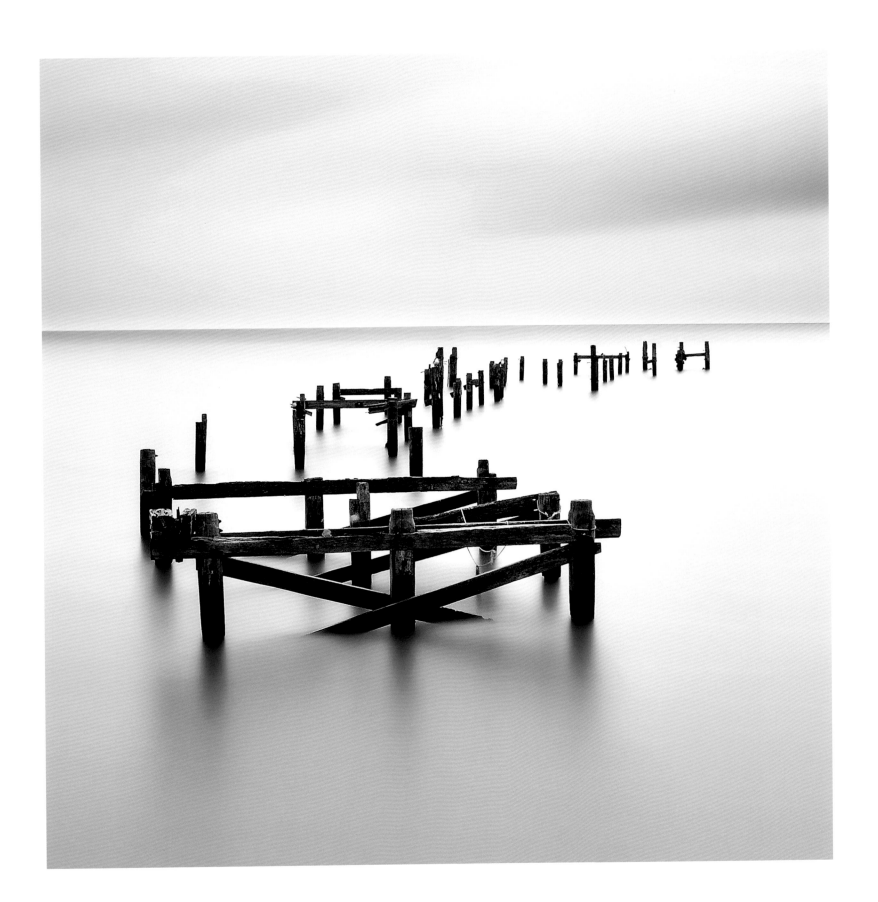

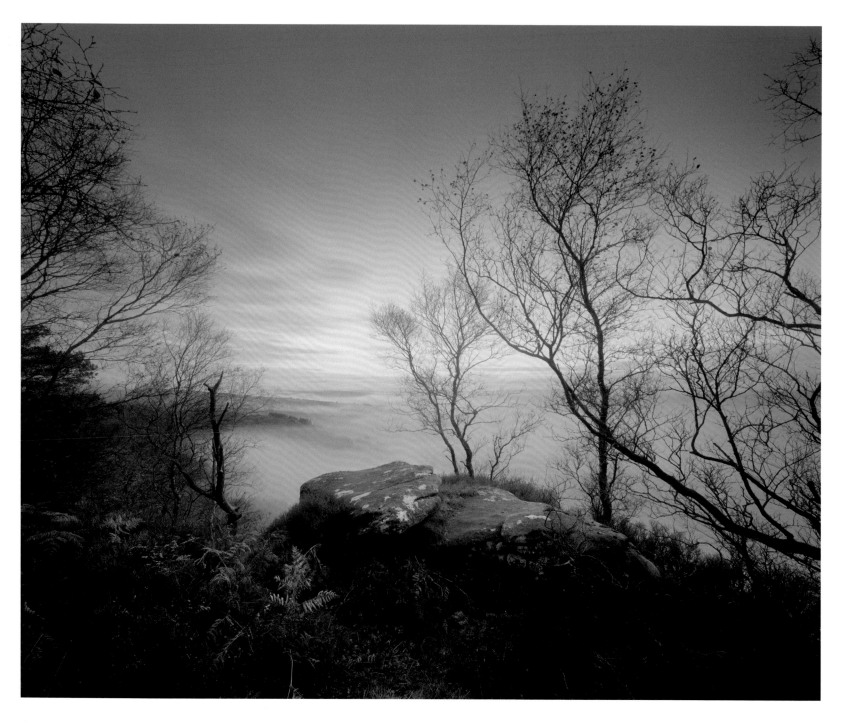

ROB CHERRY

All that remains – Old pier, Swanage, Dorset, England

A very popular shot for anyone visiting Swanage. This was my first attempt at the old pier remains on a rainy afternoon. The cloud cover really helped to create a calm mood in this image and placed the emphasis on the structure.

TRISTAN CAMPBELL

Misty dawn, Nidderdale, North Yorkshire, England

The subtle, late autumn colours and ethereal mist created a haunting atmosphere on this cold October morning.

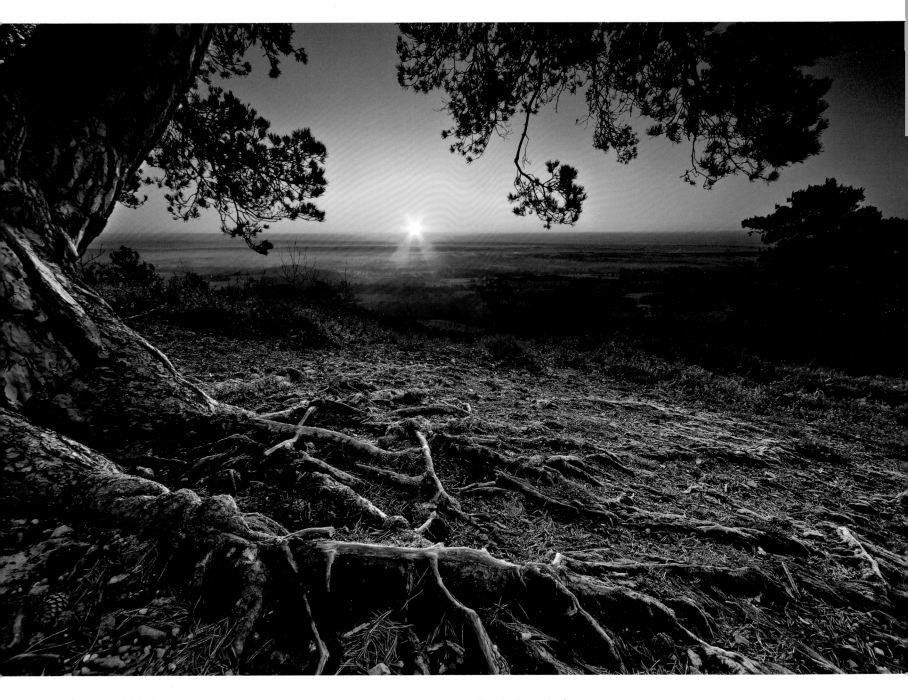

ADRIAN HALL

...and a journey began, Surrey Hills, England

Looking south from the Surrey Hills at one of southern England's highest points. For me this image makes me feel like leaving Hobbiton and striding forth from Middle Earth to start a new adventure on a new day as the mists roll in and the sun rises over the horizon.

STEVE SHARP ···⫶

The Dales Way near Grassington, North Yorkshire, England

A distant snowstorm approaches the limestone pavement above Grassington on the Dales Way. Minutes later, everywhere was a whiteout, making for a very long journey home.

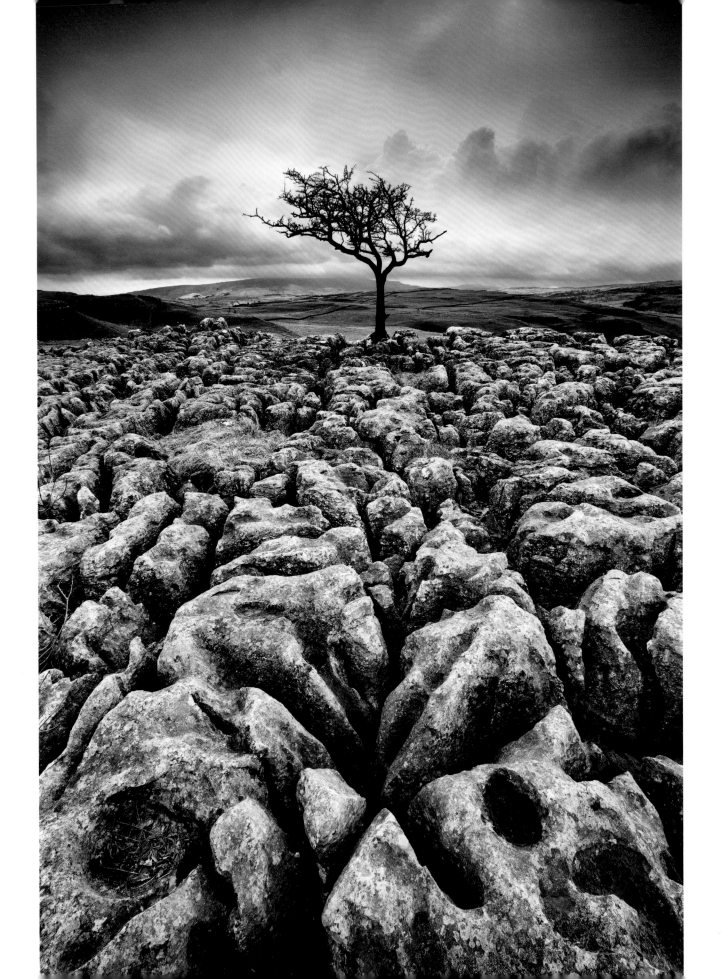

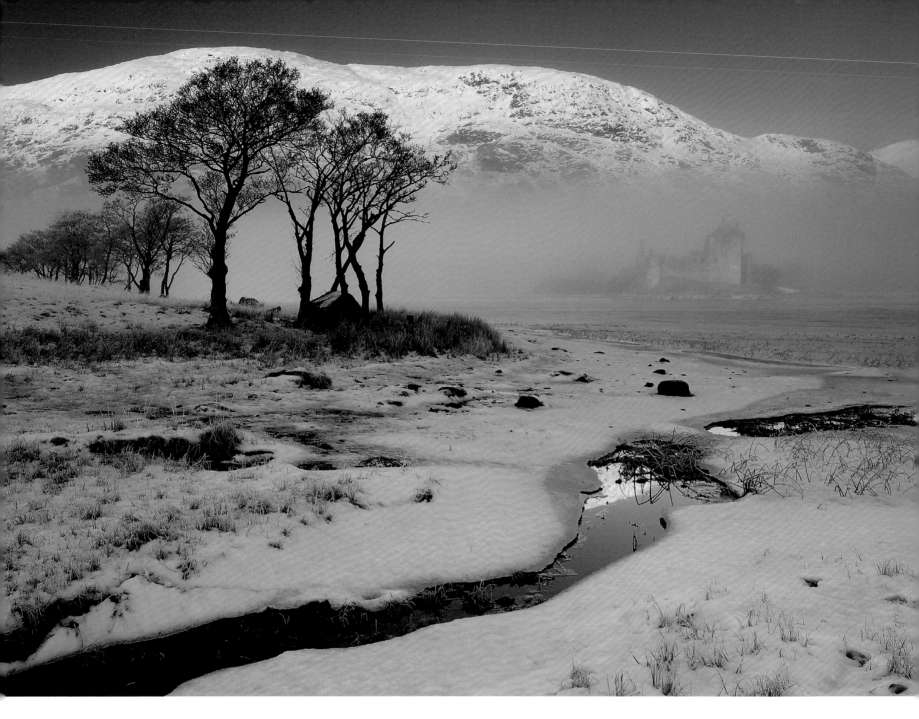

🕂 **BRIAN CLARK**

Through the mist, Loch Awe, Argyll, Scotland

This composition was planned during an afternoon visit to Loch Awe with a view to making the image at dawn the following day. The early morning, however, brought thick mist that obscured everything. On this occasion, a lengthy wait proved worthwhile and eventually the outline of Kilchurn Castle appeared, creating this somewhat ethereal scene.

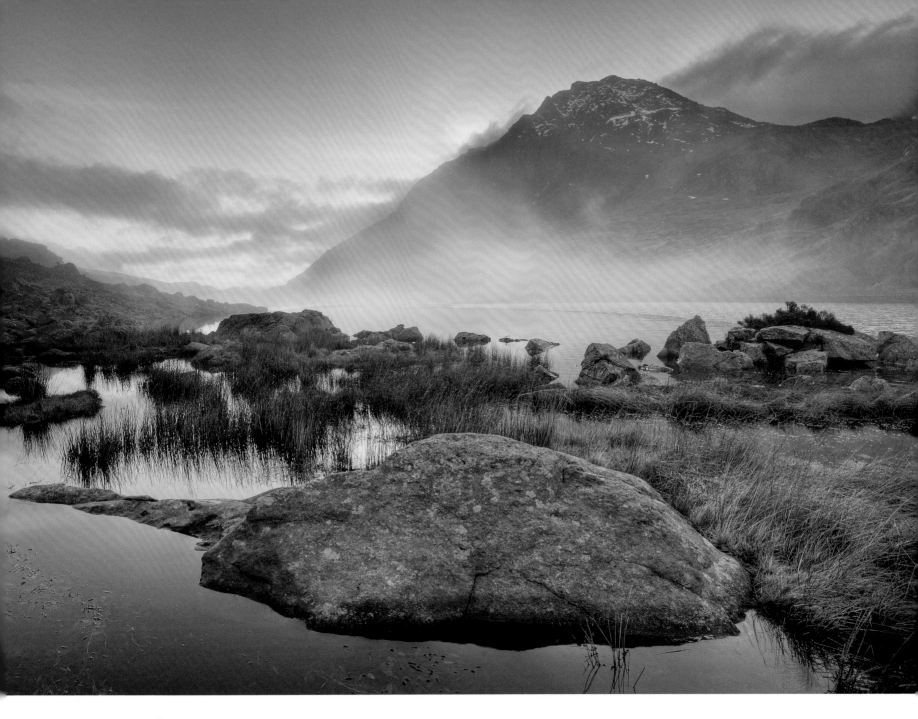

GRAHAM COLLING

Lynn Ogwen and Tryfan, Snowdonia, Wales

On a whim I drove for over one hundred miles, starting out at 4.30 in the morning, from my home near Birmingham to Snowdonia to take photographs on a very chilly, early February morning. I'm not blessed by scenery of this magnitude near my home and try to get out to our National Parks as often as possible. I love this area, especially the natural amphitheatre of the Glyderau surrounding Llyn Idwal. By happy chance, I decided to cross the Afon Ogwen at its outfall from the lake and take some shots up the valley. The mist started to form as the sun rose behind Tryfan. Within minutes a thick blanket of mist had obliterated the scene.

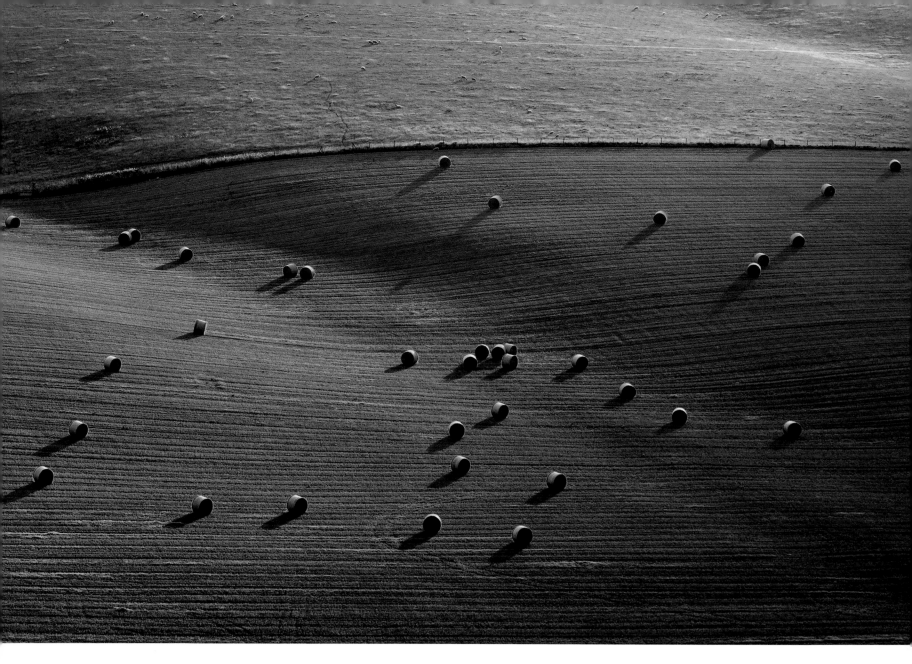

ŚLAWEK STASZCZUK

Hills near Saltdean, East Sussex, England

I set off before sunrise hoping to catch some low, sculpting light on the undulating slopes strewn with bales. But a thick layer of clouds over the horizon obscured the sun and so the sun was already quite high in the sky by the time it finally emerged from behind them. Fortunately, some passing clouds came to my aid and diffused the light enough to let me take a few decent pictures.

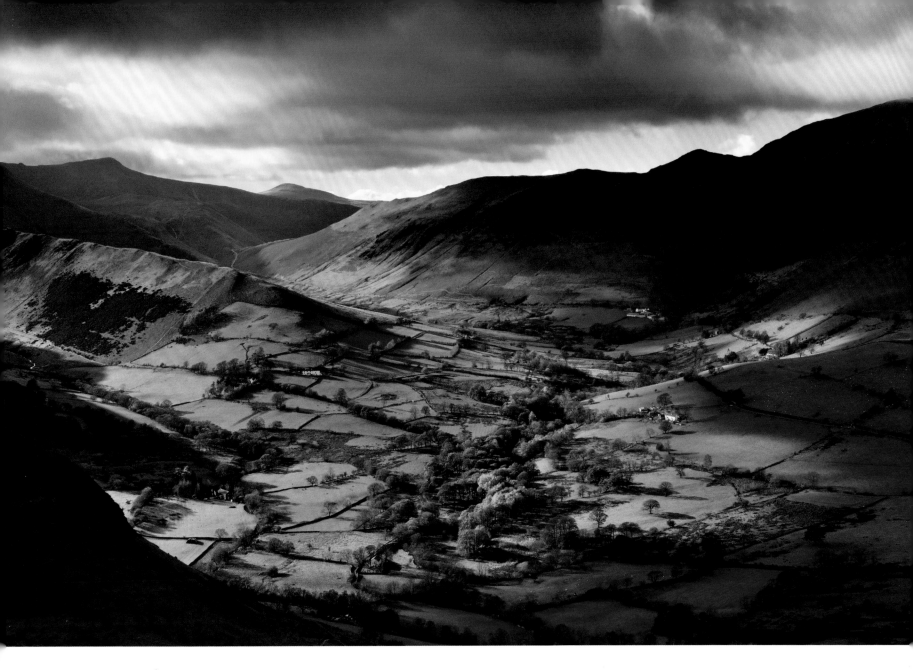

ADAM BURTON

Valley of light, Newlands Valley, Cumbria, England

For most of my time as a landscape photographer I have been a wide-angle addict, searching for big bold foregrounds to include in my shots, usually at the edges of lakes or beaches. In the past year, however, my style has changed quite radically. I have developed a passion for getting higher and capturing images looking down over big landscapes. This image of Newlands Valley, in the Lake District National Park, is a classic example of the direction my photography is now taking me. I simply love landscape photographs where I can roam around and explore, noticing new little details upon each viewing. But a big view on its own is usually not enough; something extra is needed to initially capture and then hold the attention. In this image that extra something came from the dramatic light, painting fields of the lush, green countryside, while leaving other areas in deep, dark shadow.

CLASSIC VIEW
youth class

CLASSIC VIEW YOUTH CLASS WINNER

WILLIAM LEE ···}

Seahouses, Northumberland, England

One of a few abandoned shacks that lie dormant in the small town of Seahouses on the Northumberland coast.

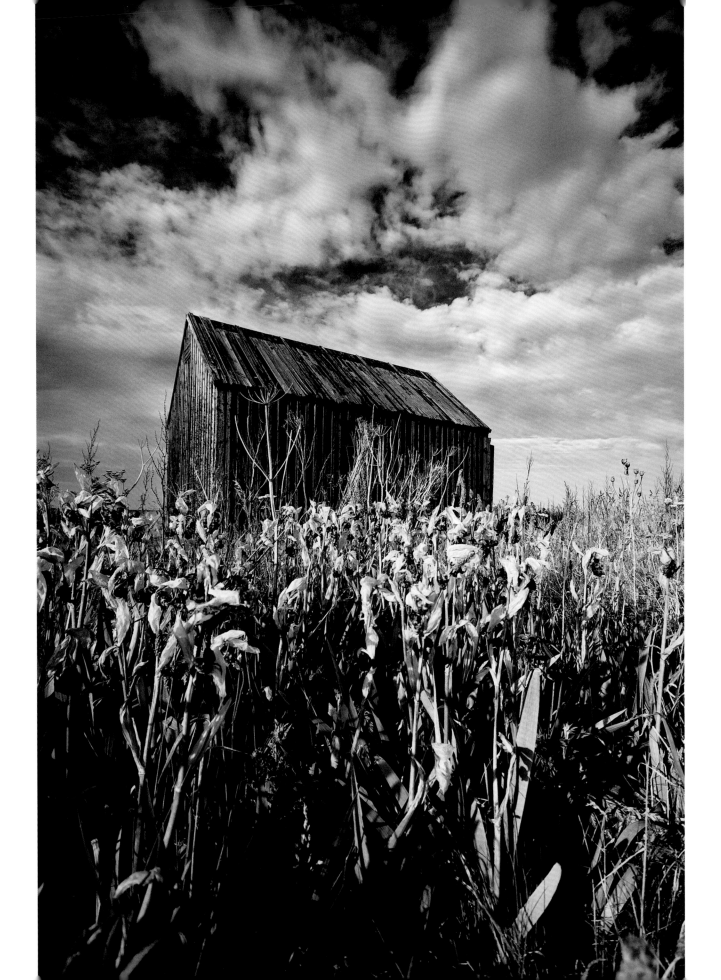

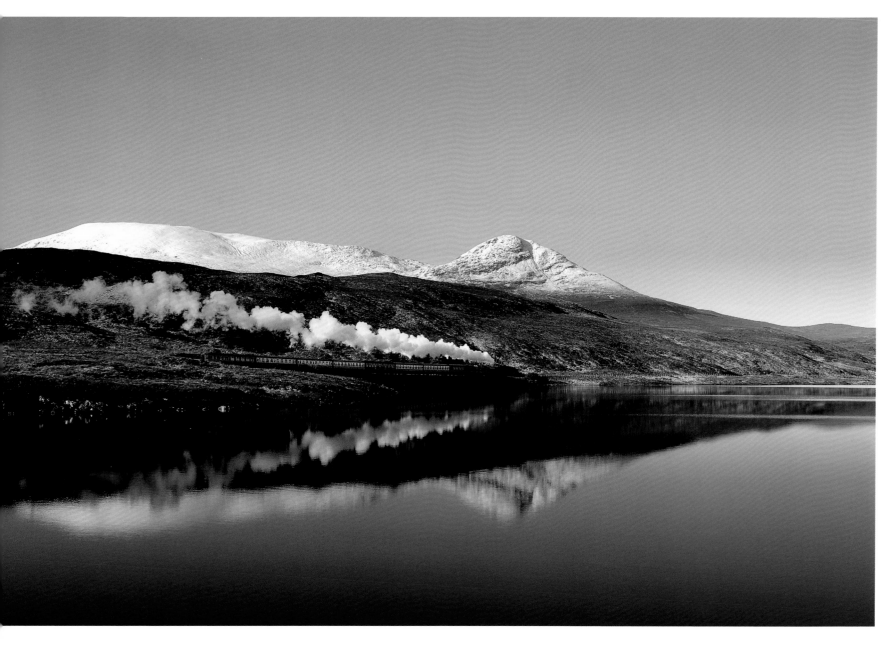

✝ TALIESIN COOMBES

Reflections, Strath Bran, Scotland

One of my favourite railway lines is the dramatically scenic line from Inverness to the Kyle of Lochalsh. It rarely sees steam and, recently, only once a year in April. I was so pleased when the conditions were almost perfect for steam photography - cold, bright and still. This is the North Briton Railtour passing along Loch a' Chuilinn with the 848-metre, snow-covered Sgurr a' Choire-rainich in the background, all perfectly reflected in the loch.

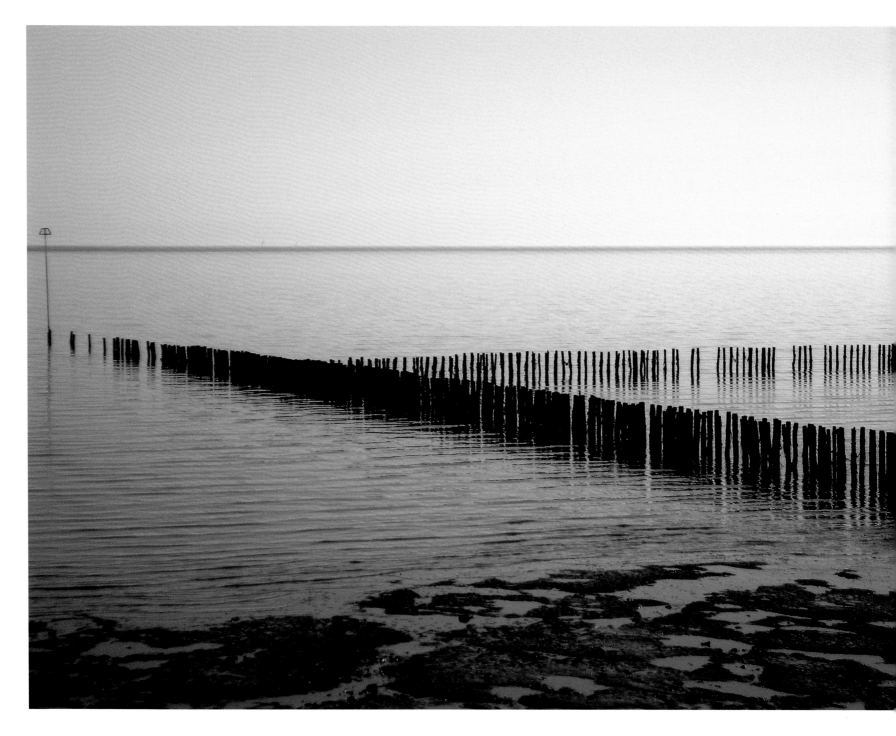

ALIXANNE HUCKER

Mersea horizon, Essex, England

Once upon a point – Sea defences in Mersea, the most easterly inhabited island in the UK.

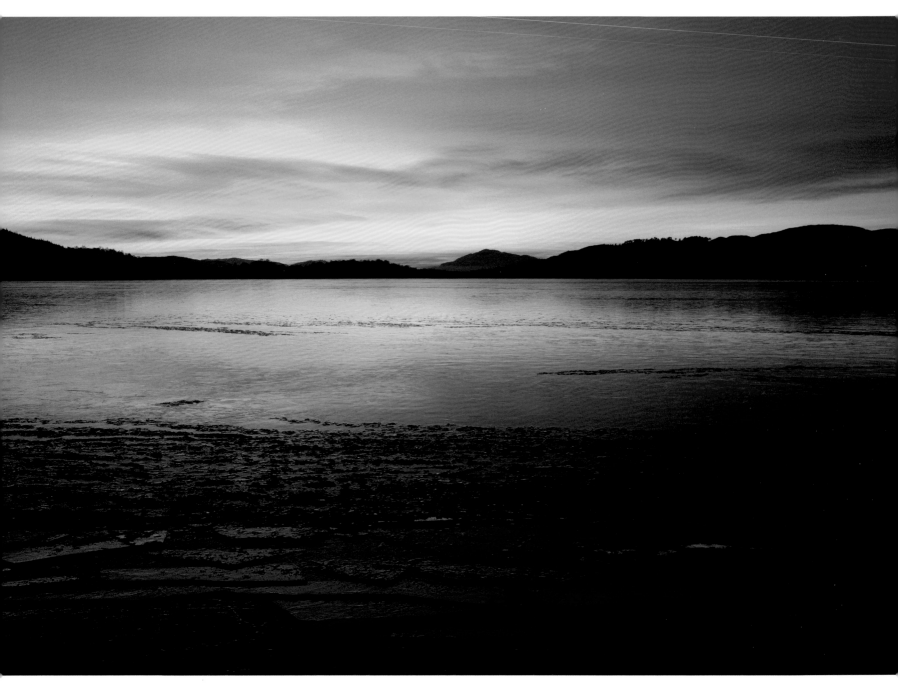

⚕ SAM CAIRNS

Winter sunset, Scotland

Winter is my favourite season for photography. Ice forms on water and snow falls on the ground, as temperatures plummet. All this leads to fantastic winter scenes and this was one of them. I could see the colours beginning to burst into the sky and, from then on, I knew I could get some good pictures. I photographed this scene using the ice as the foreground and making sure I included all the brilliant colours that had emerged in the sky. This was one of winter's magical moments!

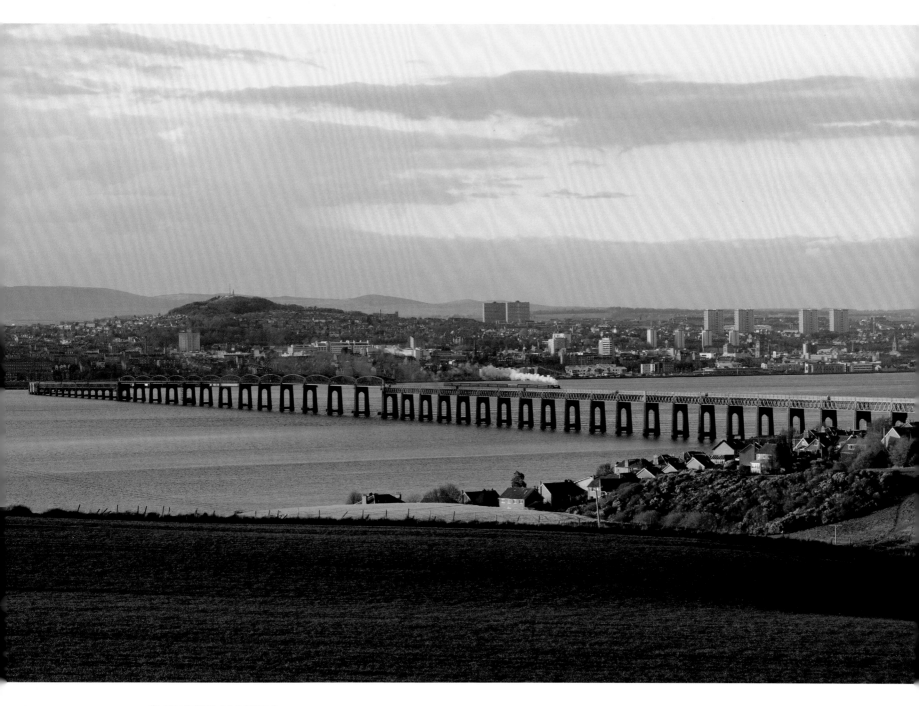

⚡ TALIESIN COOMBES

Tay Bridge, Dundee, Scotland

After a mixed day of weather, following a steam-hauled rail tour southbound from Inverness, it was wonderful to sit on the hillside overlooking this beautiful panorama. With the River Tay below and the City of Dundee as the backdrop, all bathed in a soft golden evening light, I waited for The Great Britain II Railtour to cross over the famous Tay Bridge. Fortunately, the sun managed to last just until this moment before a band of clouds passed in front of the sun and the remainder of the journey across the bridge was in shadow.

LIVING THE VIEW
adult class

LIVING THE VIEW ADULT CLASS WINNER

JON BROOK ···⟩

Heather burning on the Lancashire/Yorkshire
border, England

Heather becomes tall and woody with age and becomes a poor
source of food for moorland wildlife, particularly grouse. During
spring and autumn each year, heather burning takes place
throughout the upland areas of the British Isles to encourage the
natural regeneration of the plants. The heather is burnt in strips
approximately 30 metres wide. This gives a sufficient area for the
plant's new growth, which over the next few years will provide
food for the grouse during the breeding season. The areas of old
heather that are left provide cover from predators for the nesting
grouse and their young. This photograph is of the gamekeeper
from the Fourstones Estate controlling the last burn of the day.

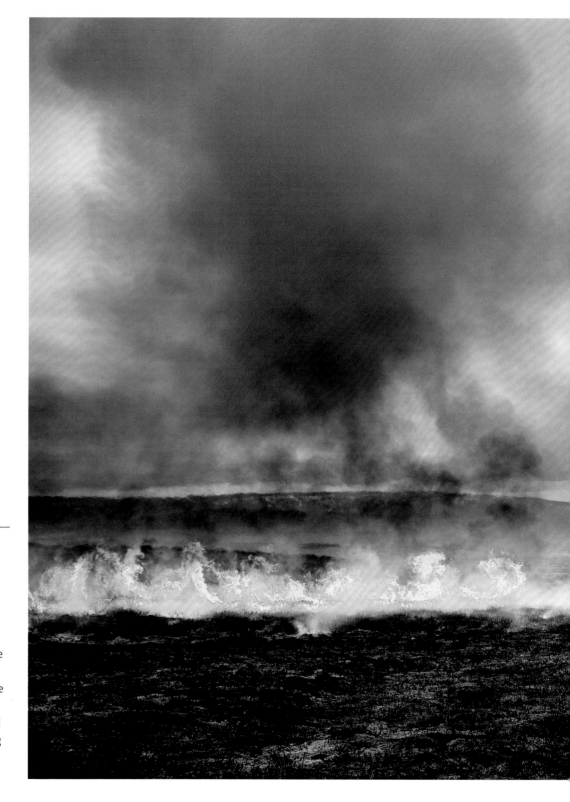

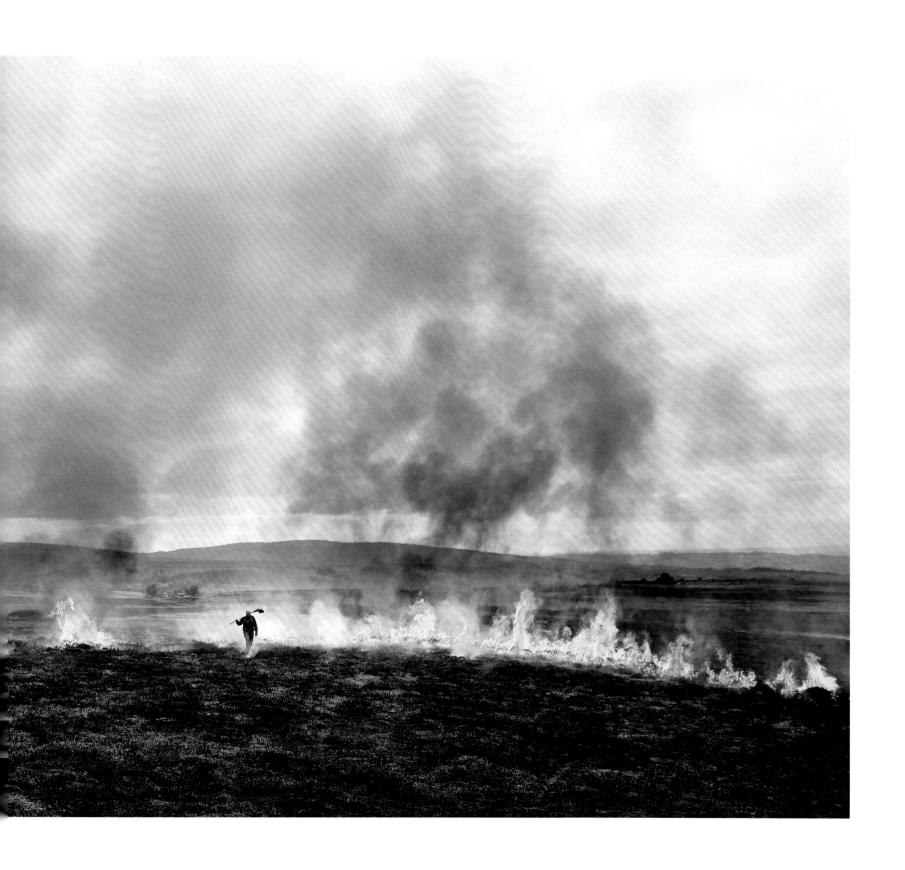

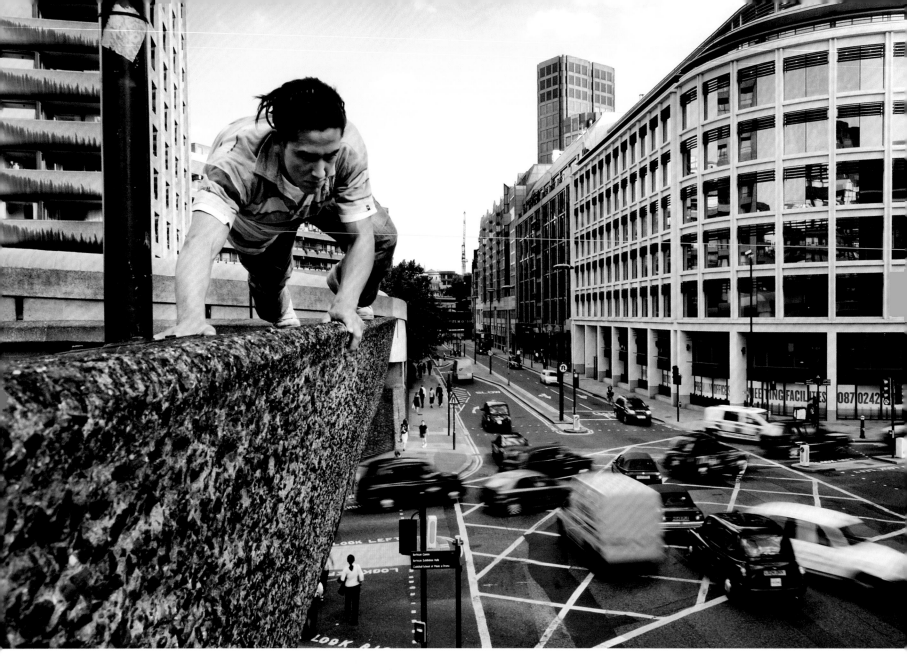

LIVING THE VIEW ADULT CLASS RUNNER-UP

✝ JONATHAN LUCAS

Crossings, Barbican, London, England

Daniel Ilabaca performs a cat crawl on the wall opposite Barbican Underground station. Using a slow shutter speed, I wanted to catch the motion of traffic below Daniel to create a sense of chaos. An experienced traceur, Daniel often surveys his environment with calm confidence – a mark of someone who fully understands his domain and his capabilities within it. I wanted to capture an essence of this assuredness amidst the urban terrain in which he is habitually immersed.

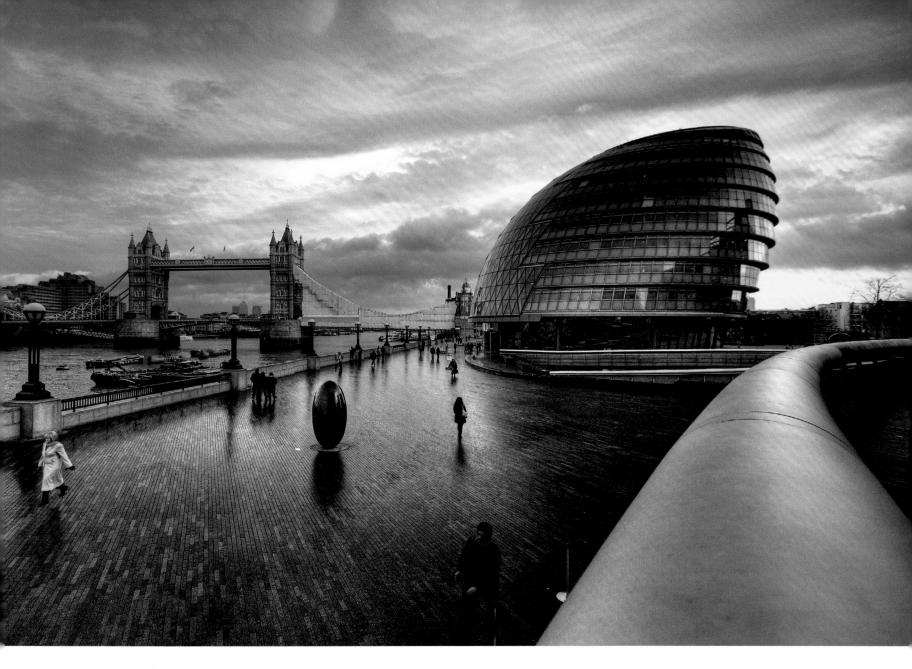

⁂ **WILFRIED BANCHEREAU**

City Hall, London, England

As the winter sun was setting, the light was fantastic. My Gorillapod (flexible tripod) really helped me out with the composition. I decided to merge three different exposures to bring out all the colours and details of the scene.

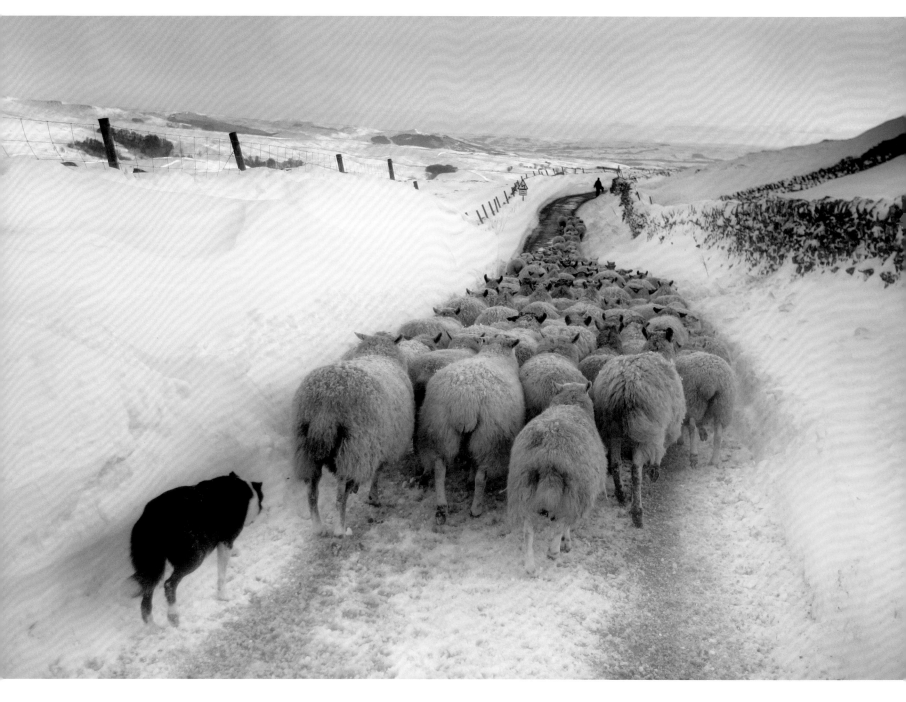

STEPHEN GARNETT HIGHLY COMMENDED

Malham Moor in winter, North Yorkshire, England

During one of the worst winters in many years, a lone farmer and his sheepdog drive a flock of sheep down from the snow-covered hills of Malham Moor, in the Yorkshire Dales, to the less harsh conditions of the lower ground.

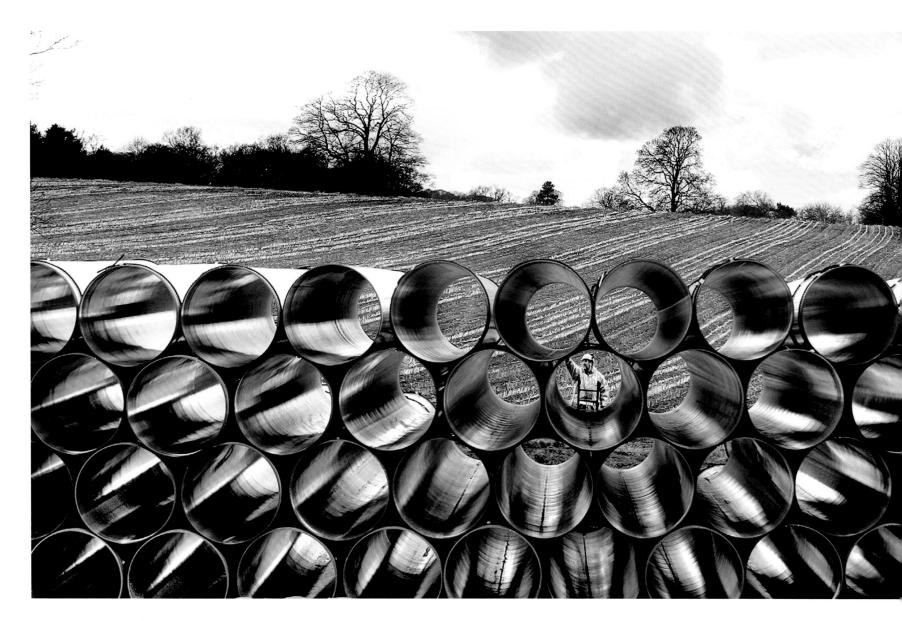

STEPHEN GARNETT

Steel gas pipes, near Skipton, North Yorkshire, England

A workman views this stack of steel pipes stored in a field just outside Skipton. They are ready to be used in a major gas pipeline project running from the north east of England to the west coast.

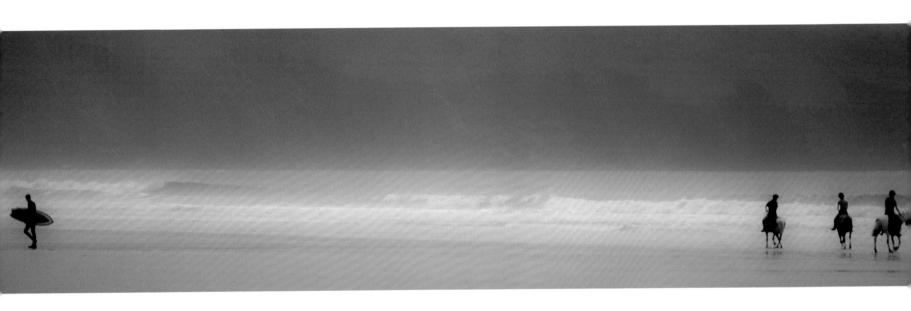

⚛ DAVID WILLIAMSON

Woolacombe Beach, Devon, England

I was walking south along Woolacombe Beach, in May, with a pal I hadn't seen in a long while. We were catching up on old times, when he alerted me to the horses on the beach. They were galloping away to my right and I had to run in order to get within a reasonable range. Then the surfer came onto the scene and stopped to chat to the riders. As he walked away from the girls, I instinctively knew that I had a special scene unfolding. As a landscape photographer, I'm not used to reacting quite so quickly but, on this occasion, it worked.

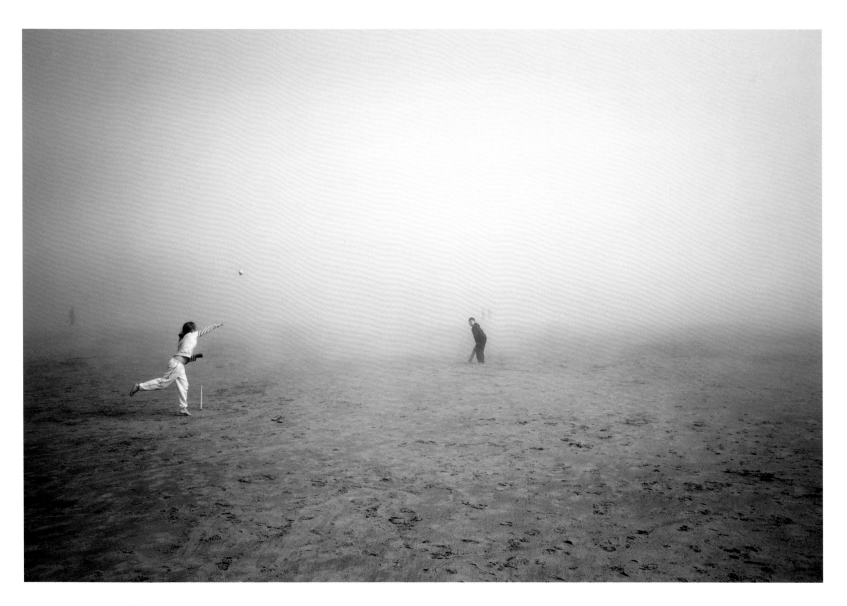

✝ CEDRIC DELVES

Folkestone beach, Kent, England

A particularly hot, spring day on the beach at Folkestone. Inland heat draws damp, cold air in, off the Channel, to make dense fog along the immediate coastline. Even so, people continue down to the coast and, of course, fog will fail to stop play.

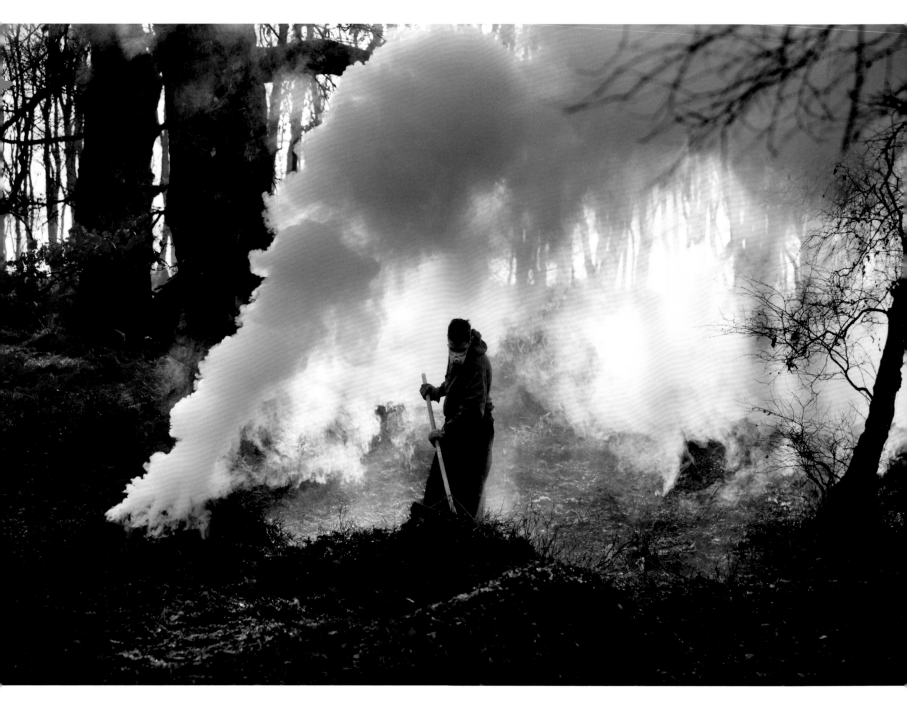

ANDREW FOX

Cannock Chase, Staffordshire, England

A ranger on Cannock Chase burns piles of bilberries in a bid to halt the progress of Phytophthora disease. The disease, which is thought to have been brought in to the UK on container plants from the Far East, destroys plants and trees. Brocton Coppice on the Chase is home to oak trees, some of which are around 600 years old.

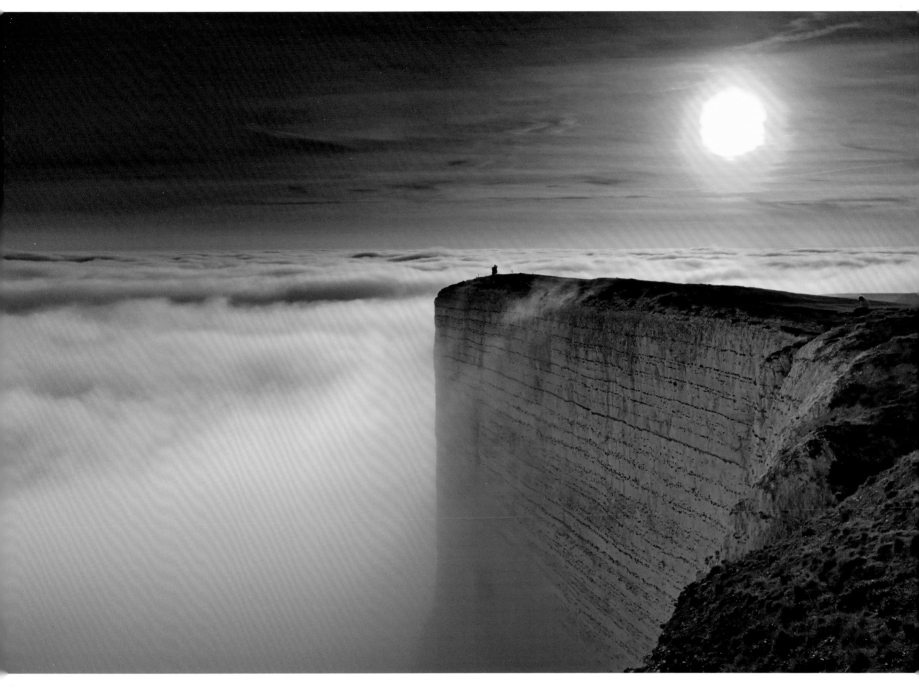

✝ RHYS DAVIES

Beachy Head, East Sussex, England

Most visitors left for the day when the sea mist began to roll in. Those that stayed were treated to a truly magical view as the breeze dropped and the mist settled below cliff-top level.

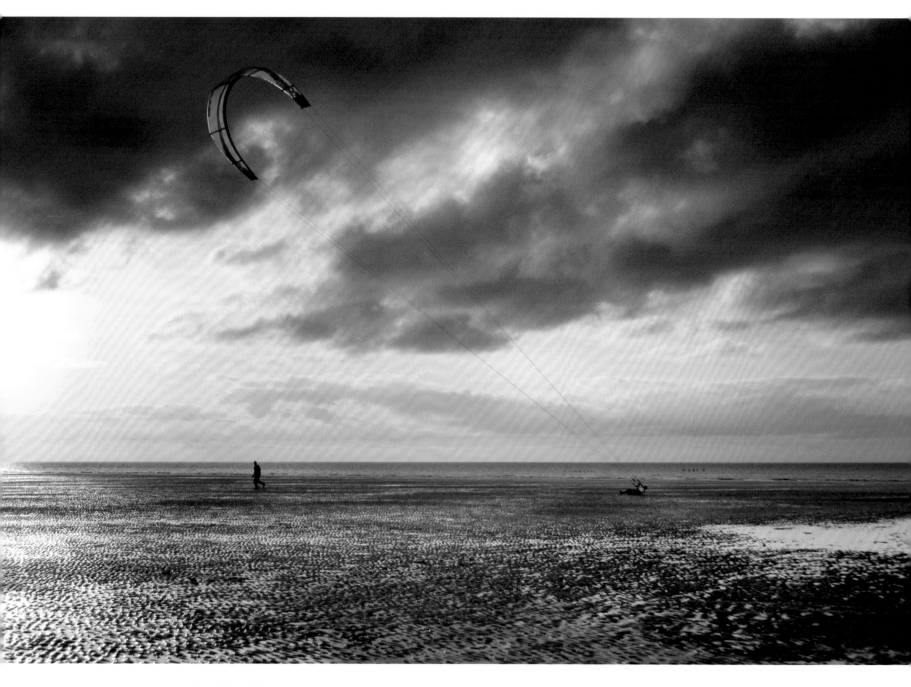

✝ **ANDREW DUNN**

Power kiting, Hunstanton, Norfolk, England

Two friends battle to keep control of a power kite, which was a bit of a handful, on Hunstanton beach in Norfolk.

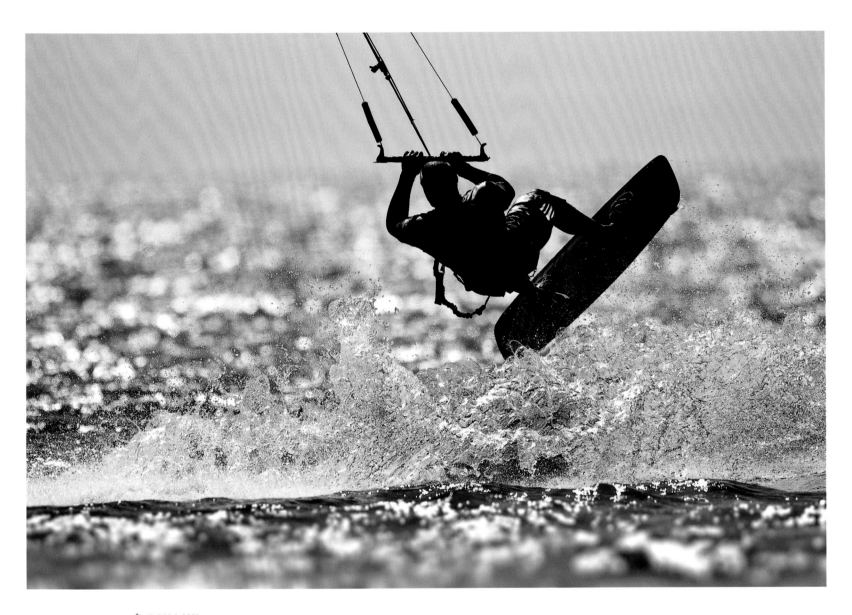

✝ DAN LAW

Kite surfer, Hunstanton, Norfolk, England

Hunstanton is a mecca for east coast kite surfers and is one of a few locations on the east coast with a west-facing coastline, allowing for sunsets over the Wash.

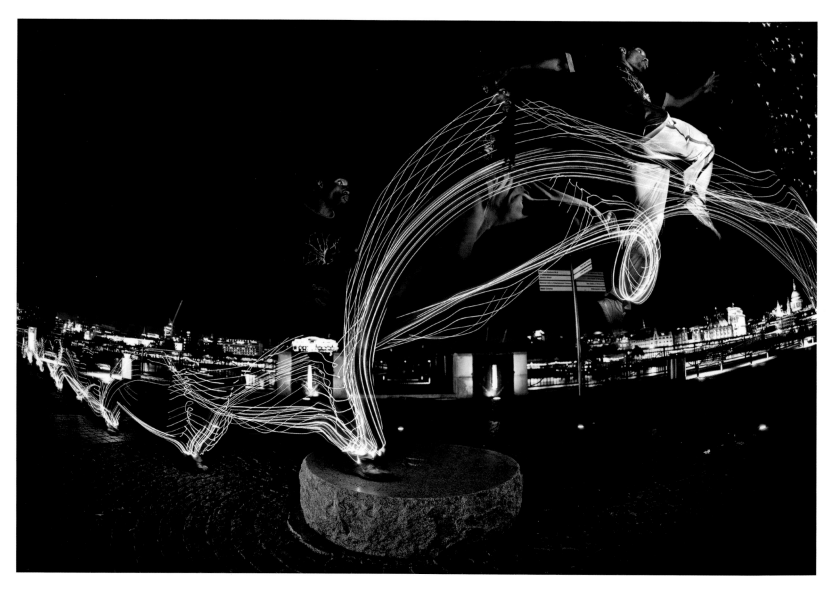

JONATHAN LUCAS

Origins, Sébastien Foucan leaves his mark in London's skyline, England

Using special LED lights attached to his limbs, Seb's graceful flow across the Thames river path was presented in its entirety as I fired a flash manually during his movement. My aim was to show how a freerunner can utilise the dimensions of both space and time to create an artistic integration within the landscape. While the moment itself may have been fleetingly short, the image remains a permanent record of where Sébastien travelled and the motions he created to get there.

BOB McCALLION ┈┈┈

Braving the elements, The Dark Hedges, Co Antrim, Northern Ireland

On a bitterly cold morning in February, I arose early and arrived at these ancient Beech trees to be confronted by a brooding, almost surreal, landscape. An overnight sprinkling of snow lay on the branches and a heavy mist rendered a scene like something from a fairy tale. All morning the mist waxed and waned but eventually the end of the road became visible. Losing patience for someone (or something!) to appear, I set the self -timer on the camera and included myself in the frame, before the mist closed in again and the moment was lost forever. On days like these, without a care in the world and wrapped in a warm coat, I can't think of a nicer place to walk.

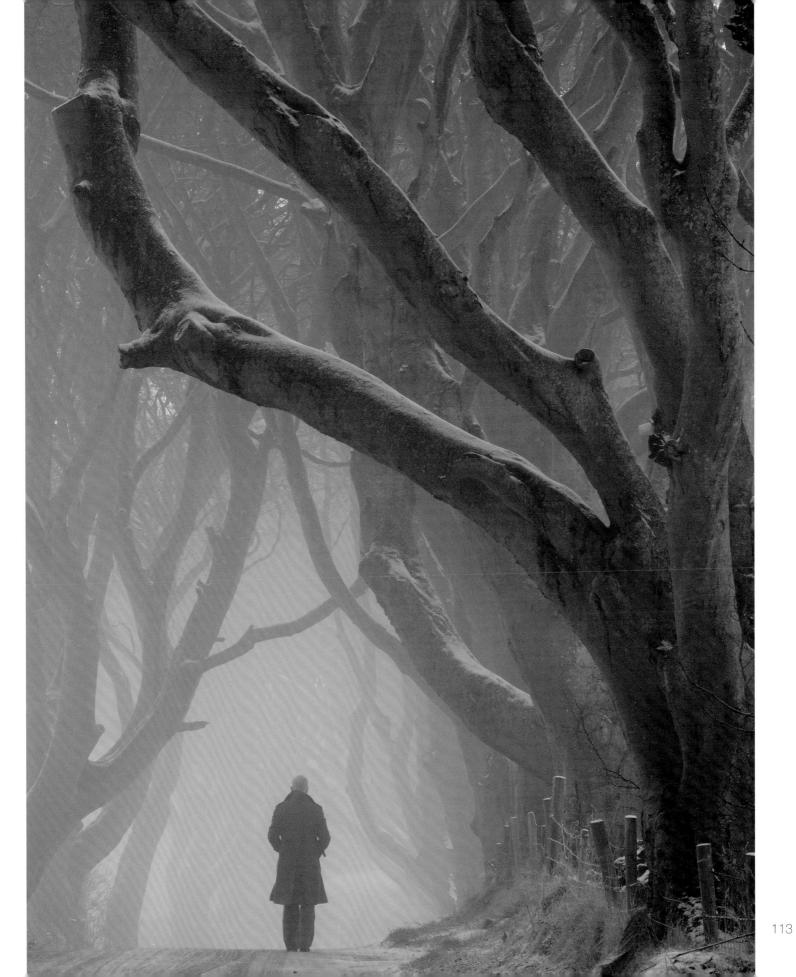

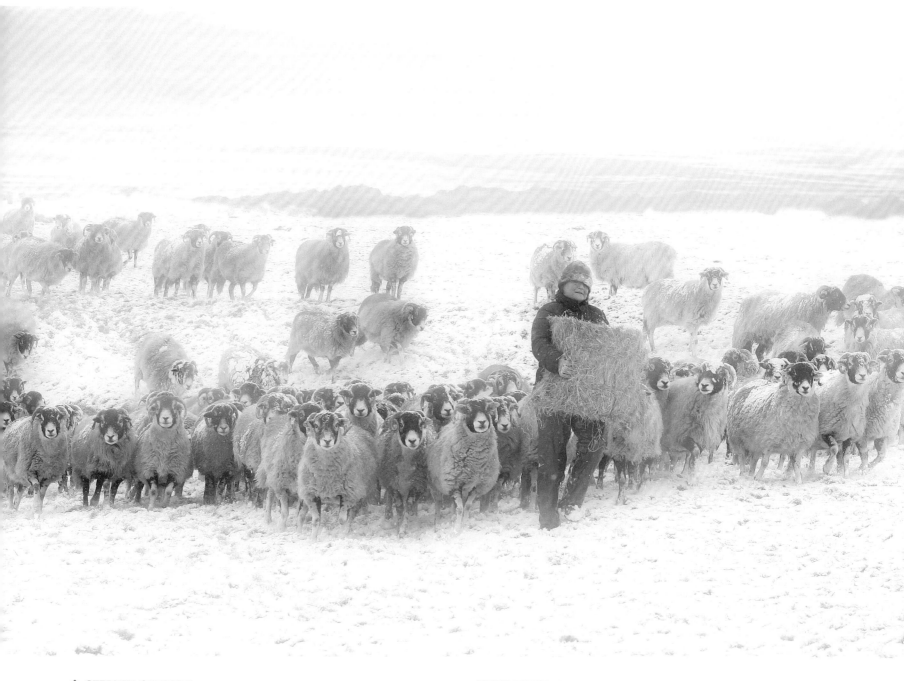

STEPHEN GARNETT

Feeding the flock, Yorkshire Dales, England

Hill farmers in the Yorkshire Dales often have to work in the harshest conditions. Here a shepherdess battles through the snow and mist above Helwith Bridge, near Settle, to make sure her flock is fed.

KEITH EVERY ⋯⟩

Winter walk, Richmond Park, London, England

Taken on one of the coldest days I can remember for a long time. Richmond Park looked like a winter wonderland. The hoar frost remained nearly all day – a rare occurrence in the London area.

KRZYSZTOF LIGEZA

Ants, Brecon Beacons, Wales

Water reflections have been always a subject of my fascination – that non-existent, mirrored world, where the known meets unknown and the real meets unreal. I was lucky enough to see this phenomenon again during a trip to the Brecon Beacons. The mountain grass there can be yellow/orange at a certain time of year and this can create the impression of being on some abstract desert. Especially if seen from a certain distance – everything looks different. So I was not sure if I was watching two travellers on the way home or ants on the way to an unreal anthill...

ROBERT BIRKBY

Calderdale woodland, West Yorkshire, England

The woodland around Calderdale provides some stunning photo opportunities in the autumn. I had taken a few shots on this Sunday morning in early November. The images looked good with the sunlight filtering through the trees but something seemed to be lacking. A couple then walked into view so I quickly took another shot. Although distant, they seemed to add scale to the scene making the photograph complete.

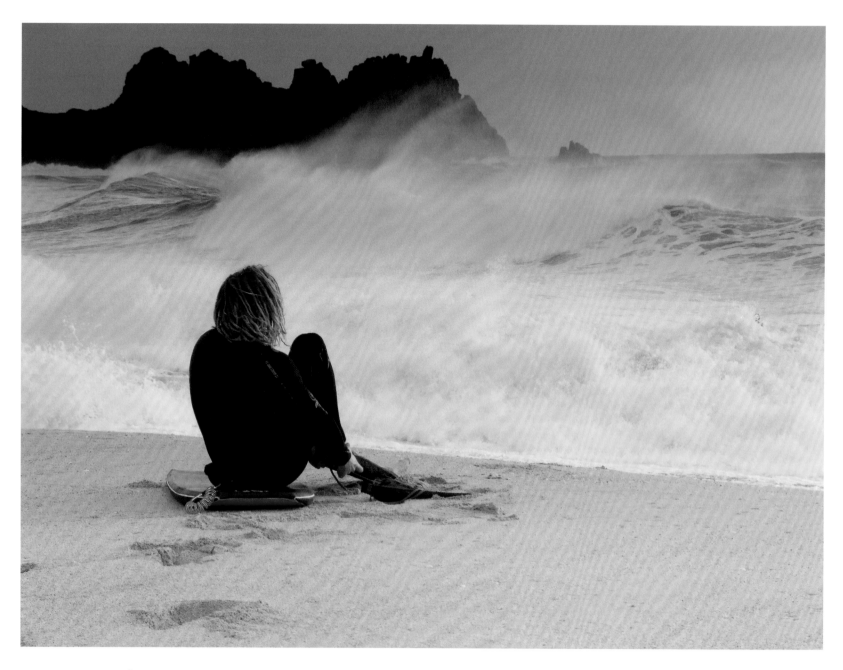

JACQUIE WILKES

Anticipation, Porthcurno, Cornwall, England

The state of the surf at Porthcurno near Land's End in Cornwall can't be seen until the brow of the path is reached and the beautiful isolated beach appears below you. The sand is made of crushed shell and the light always shines green through the waves. On this December day I arrived to find the beach deserted apart from three intrepid surfers. The wind was whipping the spume into white horses, and I was able to get a quick shot as the body boarder raced to prepare himself for the water. We were both in our element.

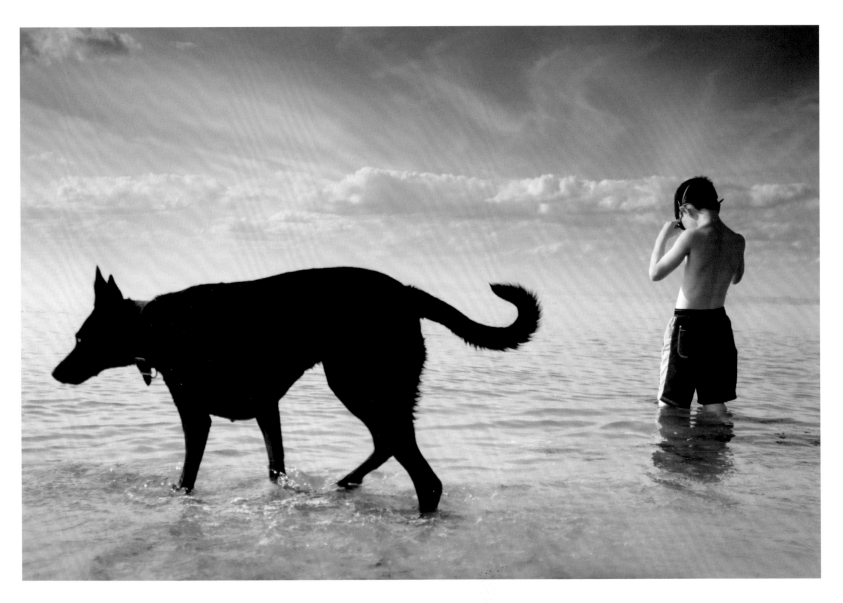

CHRIS FRIEL

Boy and dog, Whitstable, Kent, England

I was taking pictures of my son swimming in the sea at Whitstable when the dog ran through the frame.

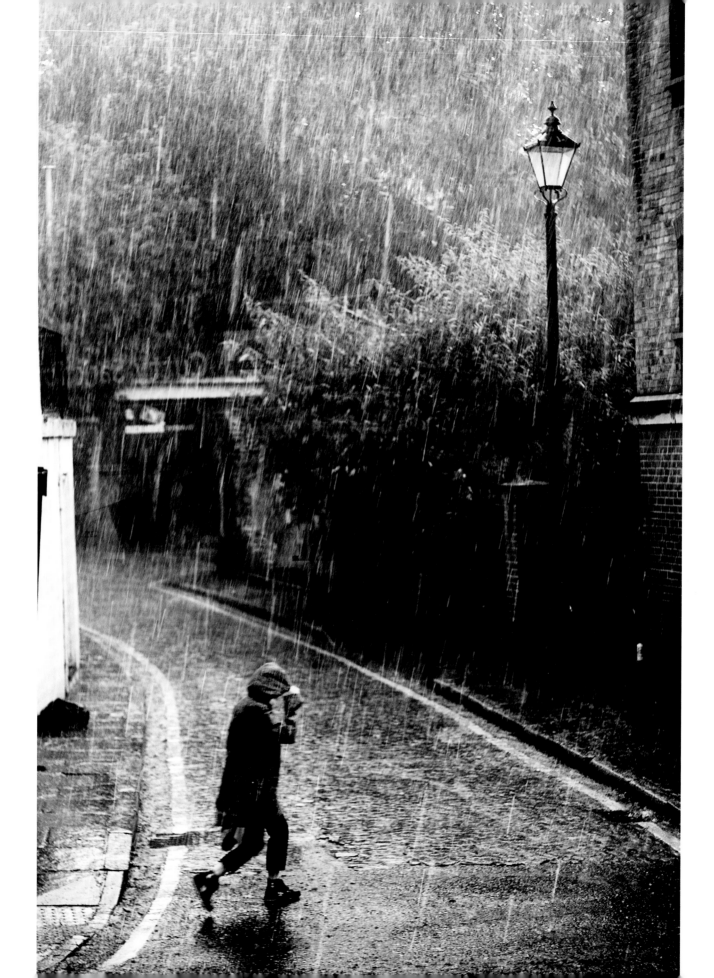

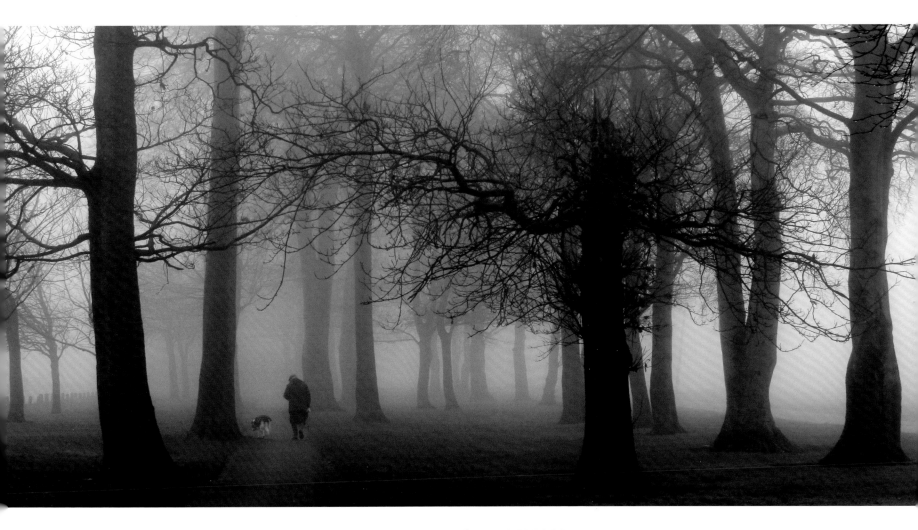

TATIANA ZIGAR

Rainy summer's day, Greenwich, London, England

Rain is always a mysterious phenomenon for me – a time for thinking, a time to stop for a moment and look around. It's quite hard to capture rain. You need to work to find a good observation point where your camera will be safe from drops, to compose the image and finally wait for the rain and a story. I was going to Greenwich Festival when suddenly rain started! I arrived at the nearest subway and there it was – the perfect viewpoint for shooting. The view was straight to a nice narrow street and the rain was pouring! I just could not miss that unexpected luck and took the shot.

CHRIS CONWAY

Walk in the mist, Sherdley Park, St. Helens, Merseyside, England

A man and his dog walking through the mist in Sherdley Park, just a few miles from where I live. It's a place I always head to when conditions are like these – you can't beat it!

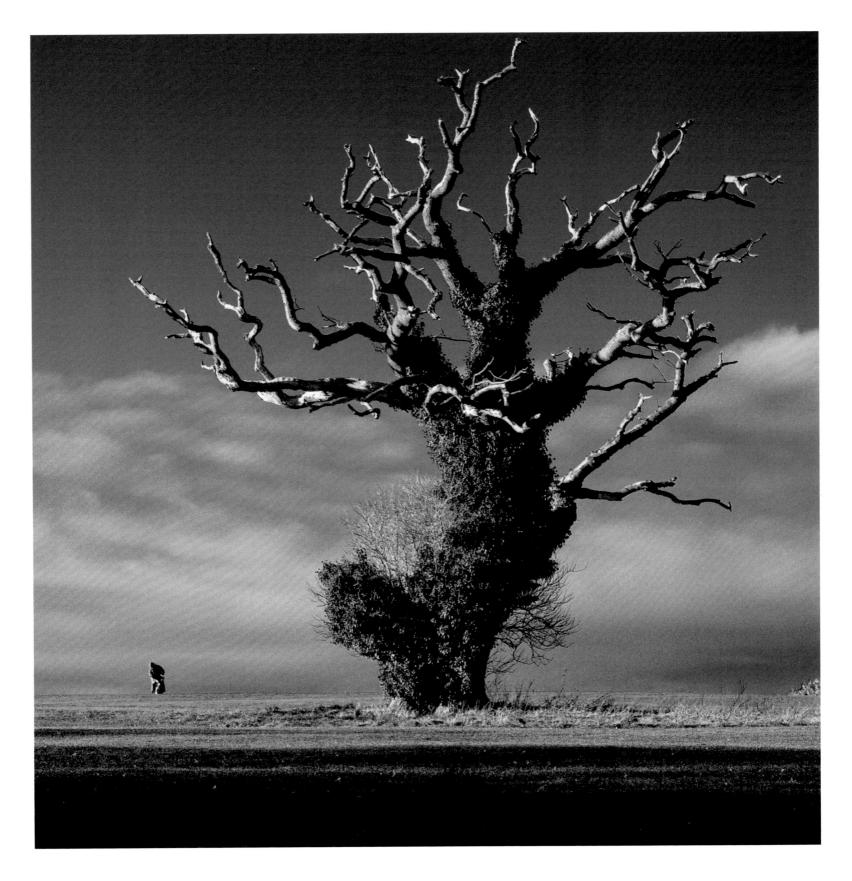

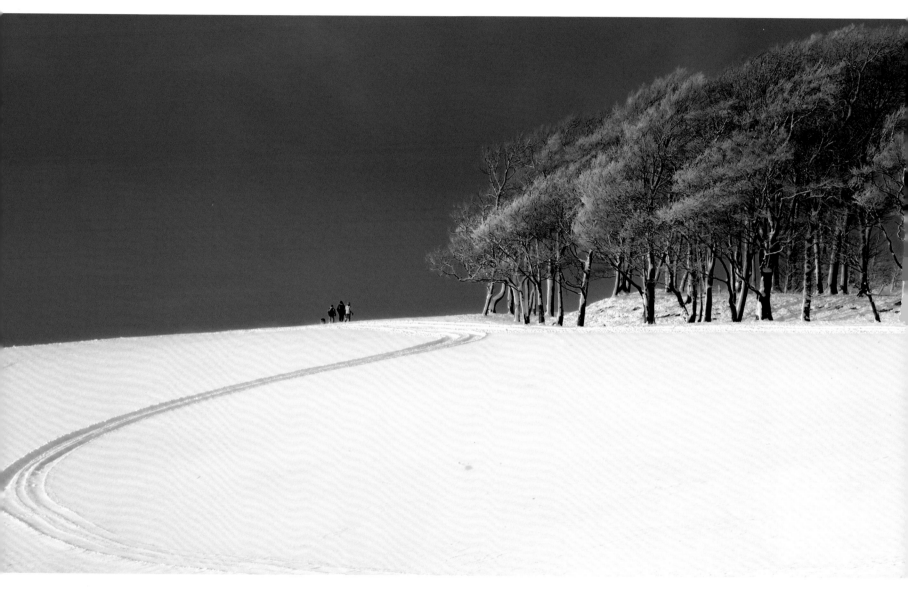

ALEX VAREY

Golfer avoiding gnarled old tree on New Year's Day, Bristol, England

Wandering with friends through the grounds of Ashton Court in Bristol on New Year's Day, I saw a golfer by this lovely gnarled tree. I was struck by how beautifully the low winter sunshine was lighting the scene and the juxtaposition of the large tree and the diminutive golfer.

TIM MORLAND

Chanctonbury Ring, South Downs, West Sussex, England

My first visit to Chanctonbury Ring came after heavy snowfall in January. Access to my chosen car park proved to be impossible so after just managing to get through to an alternative I trudged up to the ridge with backpack and tripod. I found another photographer just packing up his equipment and it is him you see, together with dog and children, disappearing over the horizon. Fresh tracks from a 4WD vehicle completed a spectacular view. A wonderful winter's afternoon.

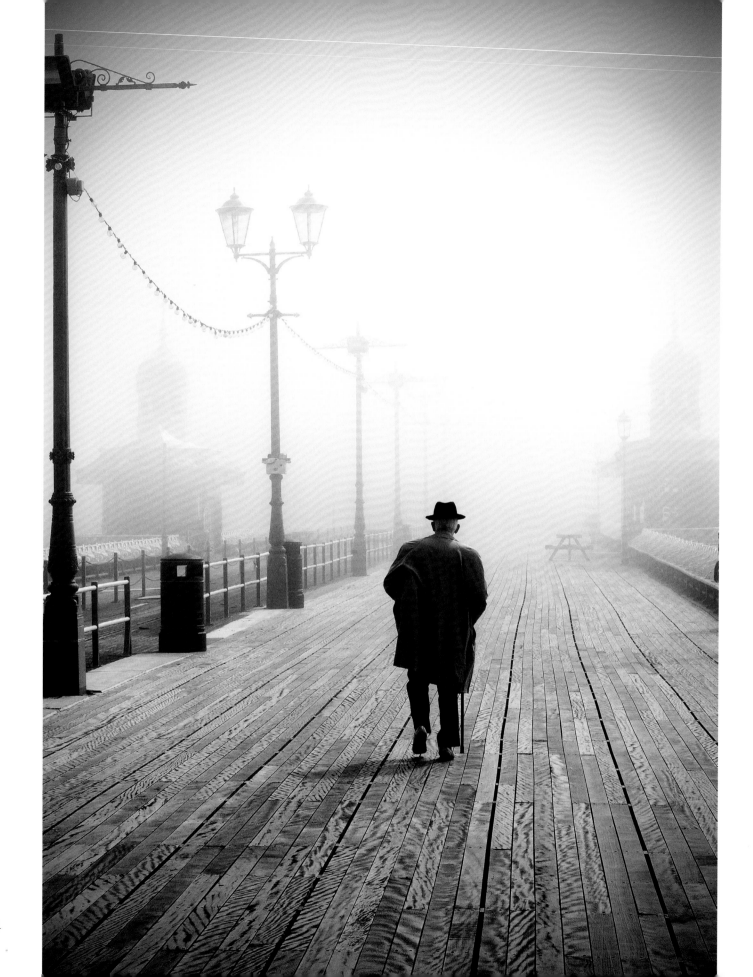

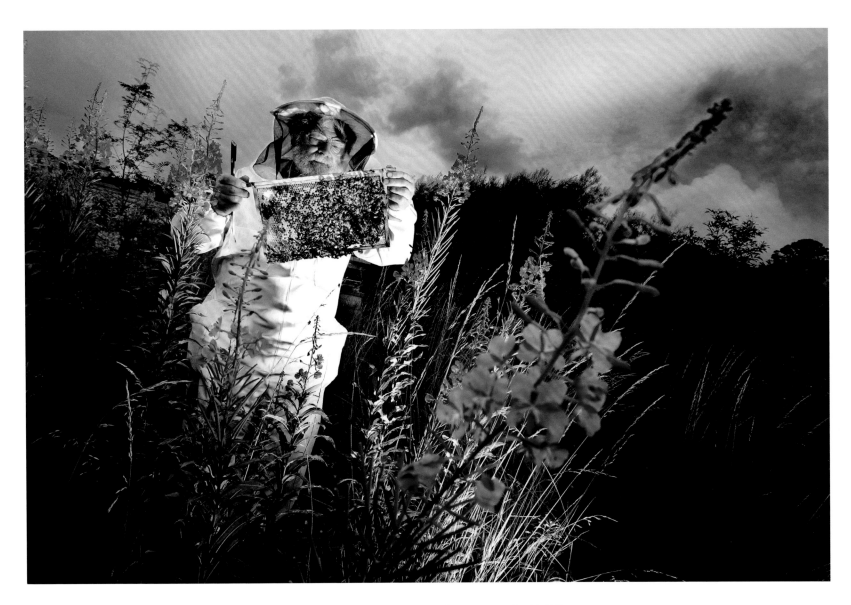

⋯ GARY TELFORD

Back to the good old days, Blackpool North Pier, Lancashire, England

With a heavy sea fog on a warm Blackpool morning, I had a chance to pop out for an hour and knew that the North Pier at Blackpool would look good in the mist. By chance, this elderly man walked into shot at the right time and I managed to get a few shots before he disappeared back into the mist.

⋆ STEPHEN GARNETT

Beekeeping, North Yorkshire, England

With honey bee populations under threat of decline, the Wharfedale Beekeepers' Association promotes beekeeping through education and training for the benefit of the environment and mankind. Here secretary Alan Thompson views a bee-covered honeycomb at one of the group's apiaries at Linton in the Yorkshire Dales.

LIVING THE VIEW
youth class

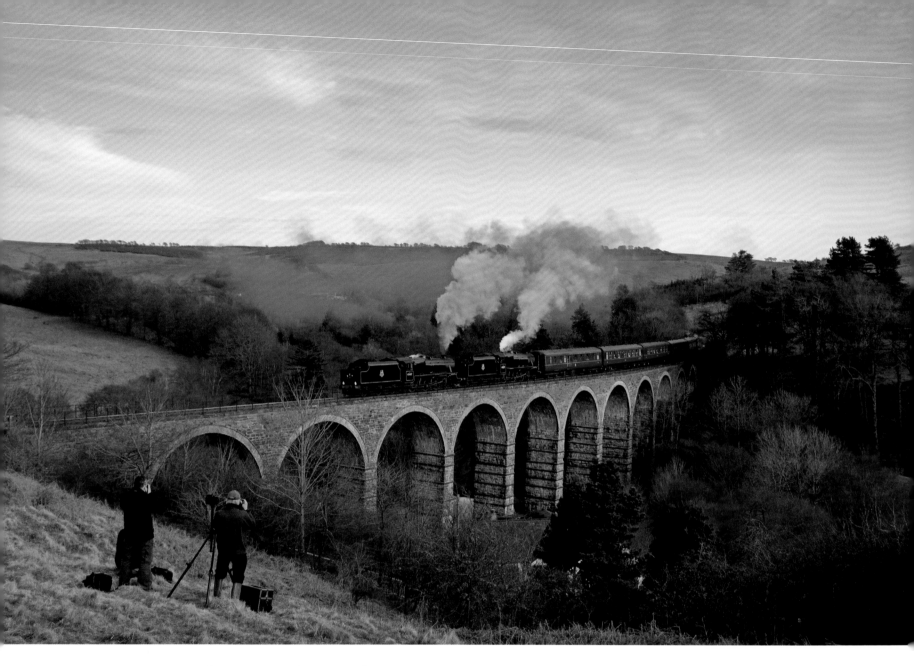

LIVING THE VIEW YOUTH CLASS WINNER

⚶ TALIESIN COOMBES

Taking the shot, Pinmore Viaduct, Ayrshire, Scotland

It is very rare for steam charters to run on the line from Ayr to Stranraer. This April, the Great Britain III Railtour made a return journey between Glasgow and Stranraer. This shot was taken on the way back with the locomotives, working tender-first, crossing Pinmore Viaduct in evening light. There were many photographers on the hillside trying not to get in each other's way, but I wanted to record the scene as it was, so included two to add to the composition.

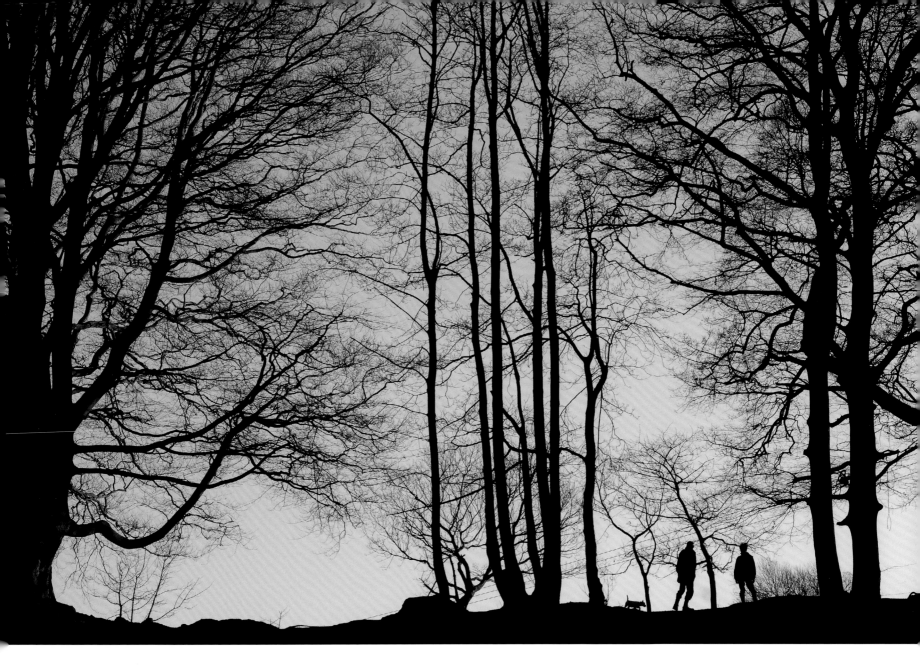

✝ CHRISTOPHER RUSSELL

Early evening stroll, Buckland Rings, Lymington, Hampshire, England

After a hard day's graft, building dirt jumps, the sun was setting over the local build-place of Buckland Rings. I noticed that, when the frequent dog walker or innocent hiker crossed the skyline of trees, brilliant silhouettes emerged. Walker after walker passed by but none of them seemed to stand out. However, when a couple and their dog strolled by it created a more impressive shot and seemed to show them living the view!

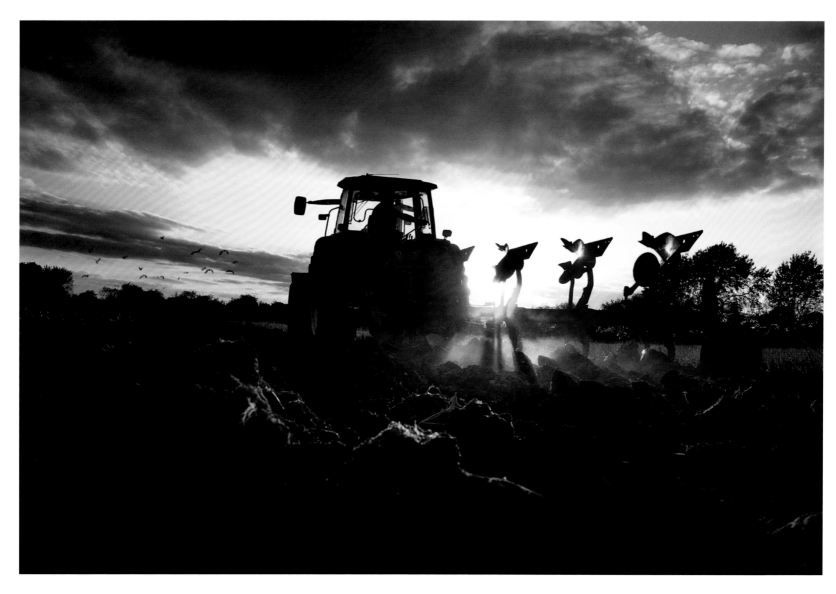

🌱 **JAMIE UNWIN**

A local farmer at sunset, near Islip, Oxfordshire, England

It was a late autumn day and the local farmer was preparing the ground for next year's crops but the sun was barely above the surrounding trees. I rushed across the field to him and, as I was getting closer, noticed that, at a certain point along the row, the sun would illuminate the dust created by the plough. I knew I had to capture this. So I recomposed, trying to include the sunset, the seagulls, the tractor and the plough, but most importantly I wanted to capture the dust as the sun hit the minute particles sending them into a blanket of flying gold. As the farmer started along the row again I knew it was now or never, as the sun was already partly covered by the hedge. As he came past, I waited and waited, then just for that split second... I got it.

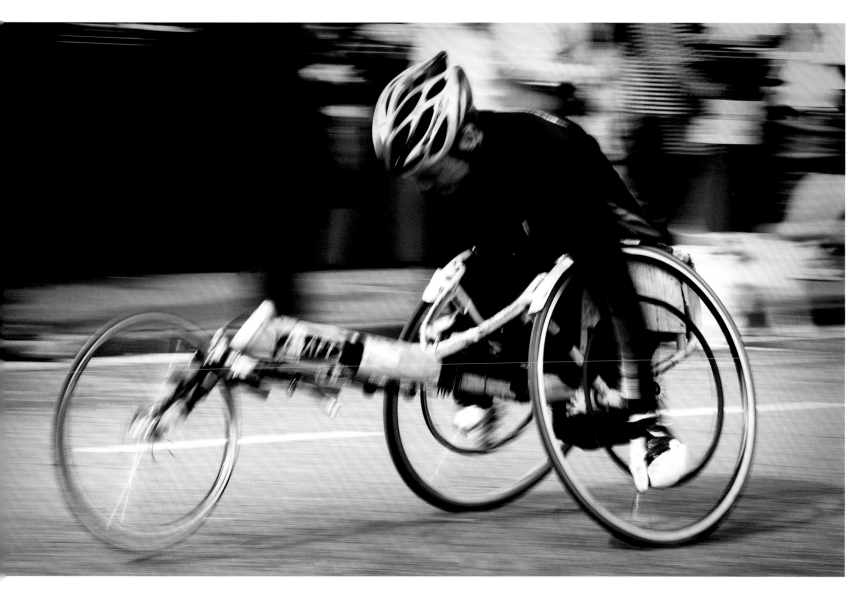

WILLIAM LEE

The Lincoln 10K, Lincolnshire, England

A wheelchair user determined at the start of the annual 10K road race in Lincoln.

URBAN VIEW
adult class

URBAN VIEW ADULT CLASS WINNER

DARREN CIOLLI-LEACH ···⟩

Concrete rain forest, Ratcliffe-on-Soar, Nottinghamshire, England

This was taken underneath a power station cooling tower. I was amazed how such a manmade structure looked so beautiful, reminiscent of a mist-filled forest with snow on the ground.

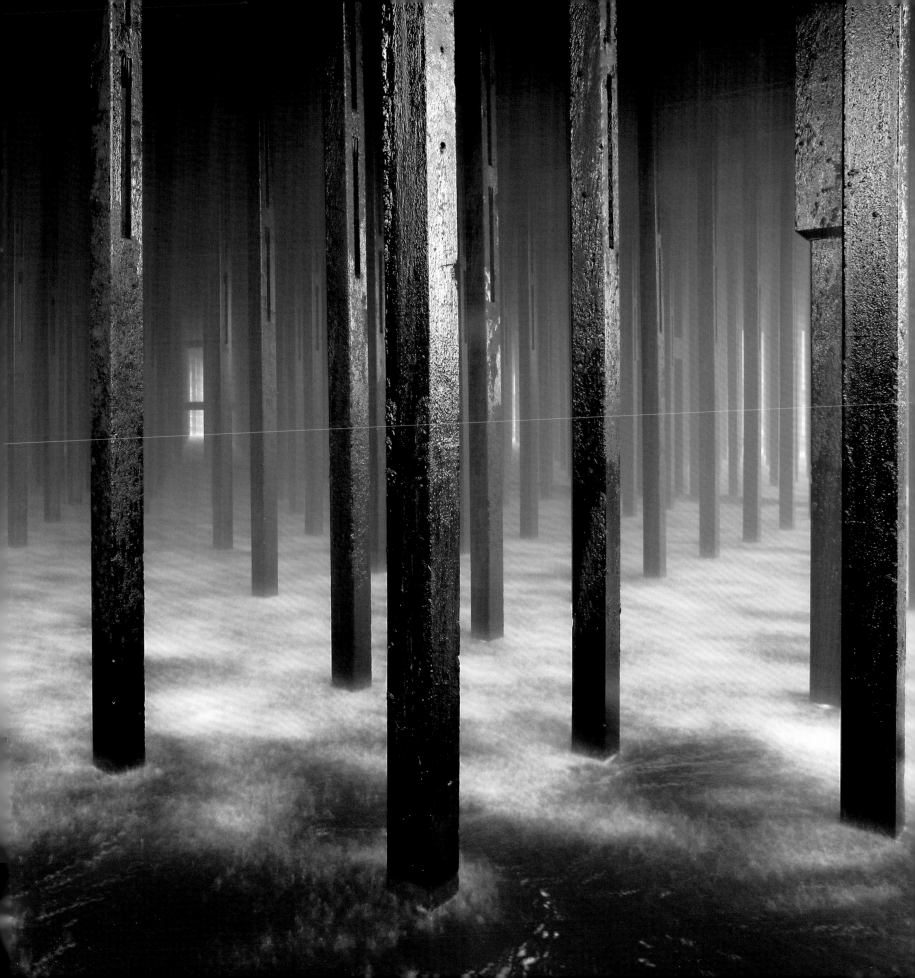

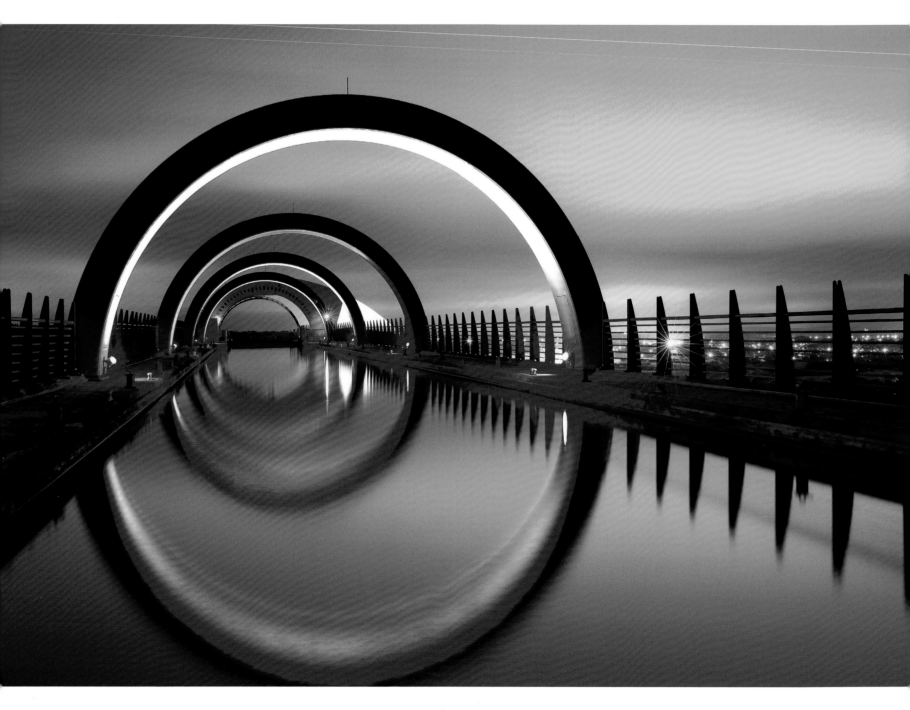

URBAN VIEW ADULT CLASS RUNNER-UP

✝ DAVID STANTON

Falkirk Wheel at night, Scotland

The Falkirk Wheel is a fantastic piece of engineering that joins the Forth and Clyde Canal to the Union Canal and it is a photographer's dream. It comes into its own at night and this image was taken from the top end where it comes out onto the Union Canal. I just loved the arches and the way they reflected in the water. The night was overcast, which was a help as the lights from the Falkirk area lit up the clouds with the warm glow you see here.

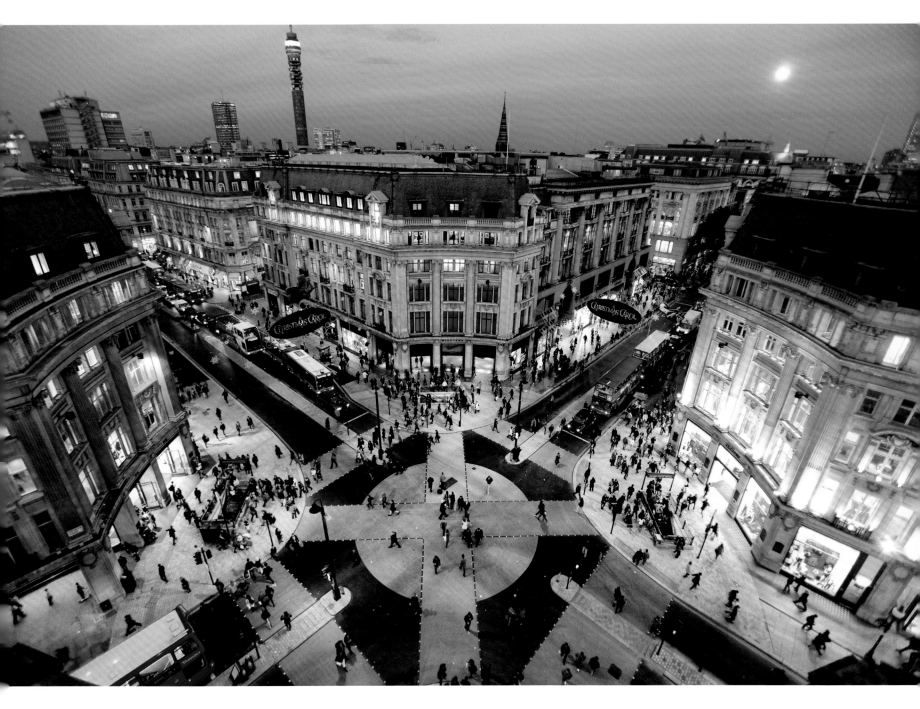

MATTHEW CHEETHAM HIGHLY COMMENDED

The new crossing at Oxford Circus, London, England

Part of a shoot to capture the opening of the new Oxford Circus crossing for Westminster City Council. Modelled on the infamous Shibuya crossing in Tokyo, its aim is to ease congestion around the Underground entrances and outside the shops.

Judge's choice Nick White

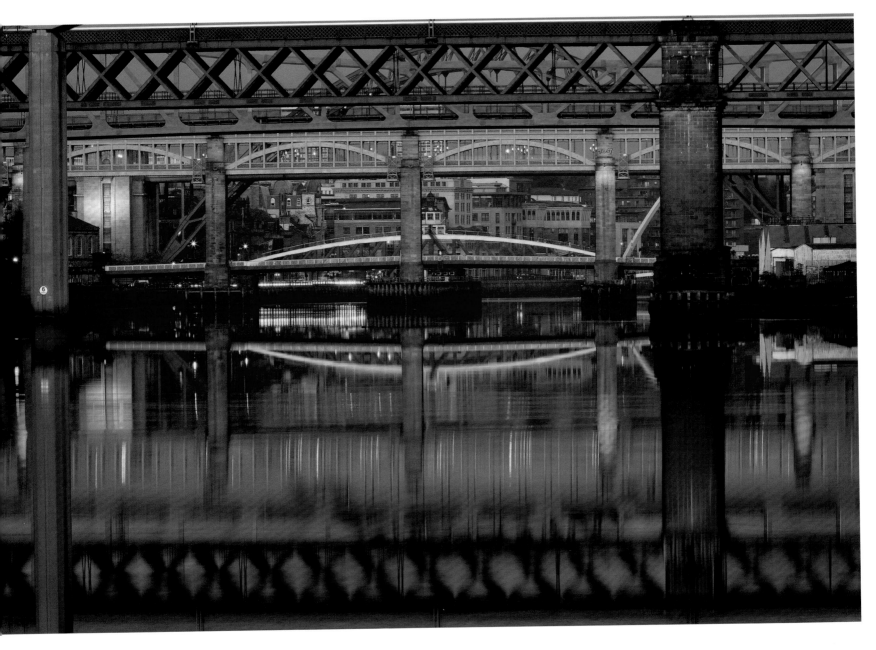

✝ **ANDREW WHITAKER** HIGHLY COMMENDED

The Newcastle and Gateshead Quayside at dusk, Tyne and Wear, England

Searching for, and trying to do something different with this popular subject, had led me half a mile away from the Newcastle and Gateshead Quayside. I was on the Gateshead side of the River Tyne near the Staithes. My hope was to try and take a telephoto shot as the bridges began to light up when night descended. Zooming in so that the bridges took up the whole frame, all I needed now was to wait for the right light and for the water to become calmer, so I could achieve the reflection needed to complete the picture. As luck would have it, the tide started to influence the flow of water as the light faded, presenting me with the opportunity I had been waiting for.

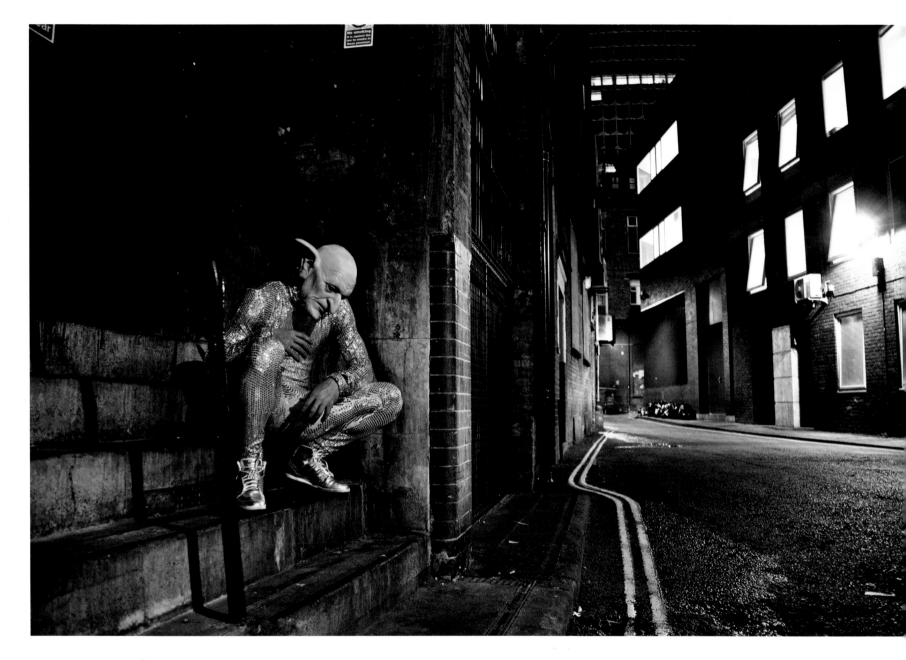

🛉 JONATHAN LUCAS HIGHLY COMMENDED

Midnight Goblin - it's amazing what you find in London's backstreets...,
London, England

Wandering the hidden networks of London's West End at midnight, one can discover myriad
kinds of euphoria, madness and destitution. This glitzy, clubbed-out goblin is, perhaps, an
example of all three. Shot at high ISO for a gritty, grainy film-like vibe.

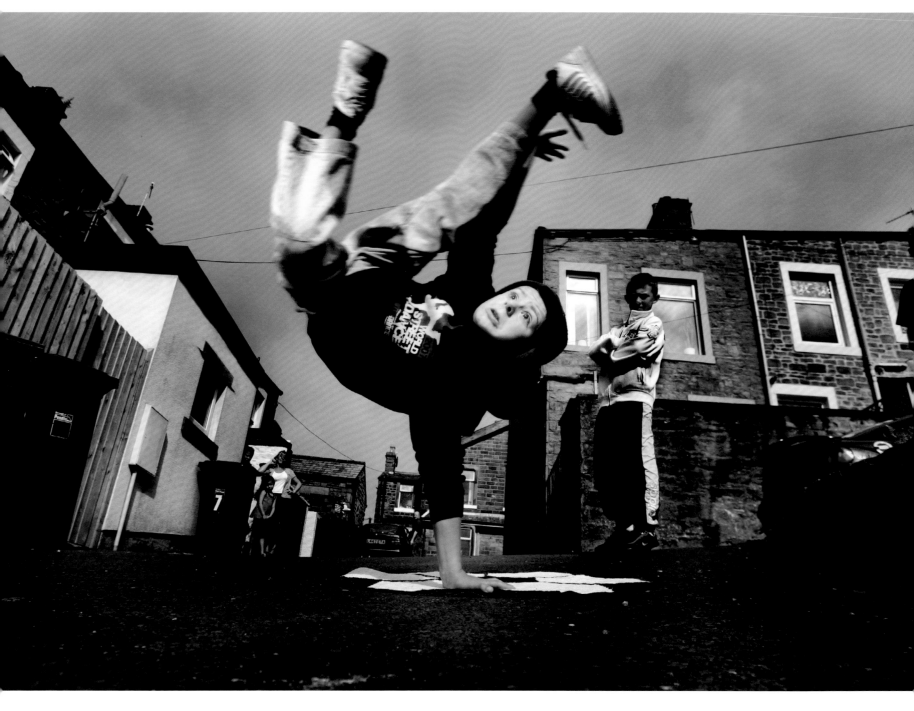

✝ STEPHEN GARNETT

Daniel Bannister, Street Dancing Champion, Barnoldswick, Lancashire, England

Friends and neighbours look on as young street dancer, Daniel Bannister, practises his moves in the terraced streets of Barnoldswick.

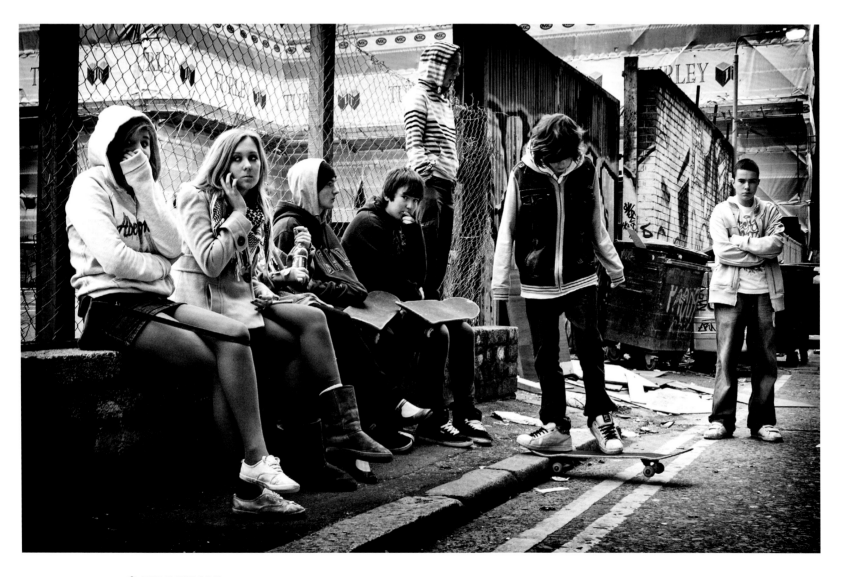

⚜ RYAN WILSON

Teenage dreams – so hard to beat, Belfast, Northern Ireland

Some teenagers killing time on a Sunday afternoon in October just off College Street in the centre of Belfast. I was on a walkabout looking for inspiration for a project on streetlife. They are mainly watching two things – a graffiti artist at work and a bit of a fight that was brewing at the end of the alley between two rather drunk and dodgy guys. There's a hidden eighth person here too – can you spot her? The title is inspired by the opening lyrics of Teenage Kicks by The Undertones – I thought the line and the image went well together.

Judge's choice Julia Bradbury

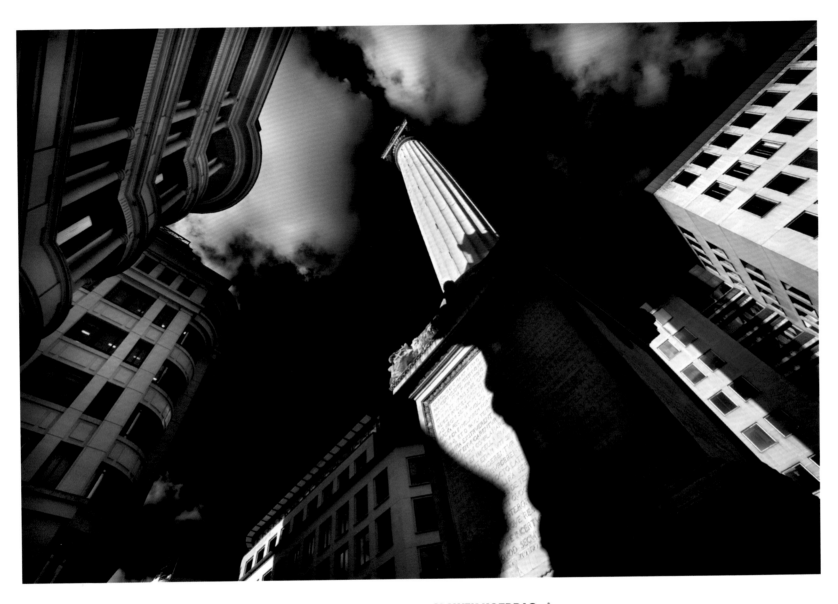

⚡ KAH KIT YOONG

SLAWEK KOZDRAS ⋯⋗

The Monument, London, England

The Waterfront, Liverpool, England

One of the activities on my tourist's agenda was climbing Sir Christopher Wren's Monument to the Great Fire of London for the panoramic views. With the task accomplished, back on street level, I noticed the interplay of light and shadow on the column. I knew that this dramatic light coupled with cumulus clouds against a deep blue sky should be visualized in black and white. The composition placed the Monument in a position of dominance against the surrounding buildings. The decisive moment occurred when the clouds parted around the top of the column.

I took this photo in Liverpool in the spring. The newly renovated embankment turned out to be a very inspiring place and I wanted to represent the flow and dynamism of the relatively simple setting. The flow culminates in a brilliant piece of angular modern architecture, which contrasts nicely with the 'soft' benches. For me, that's what photography is all about; finding stark, interesting contrasts in places away from the flashiest locations.

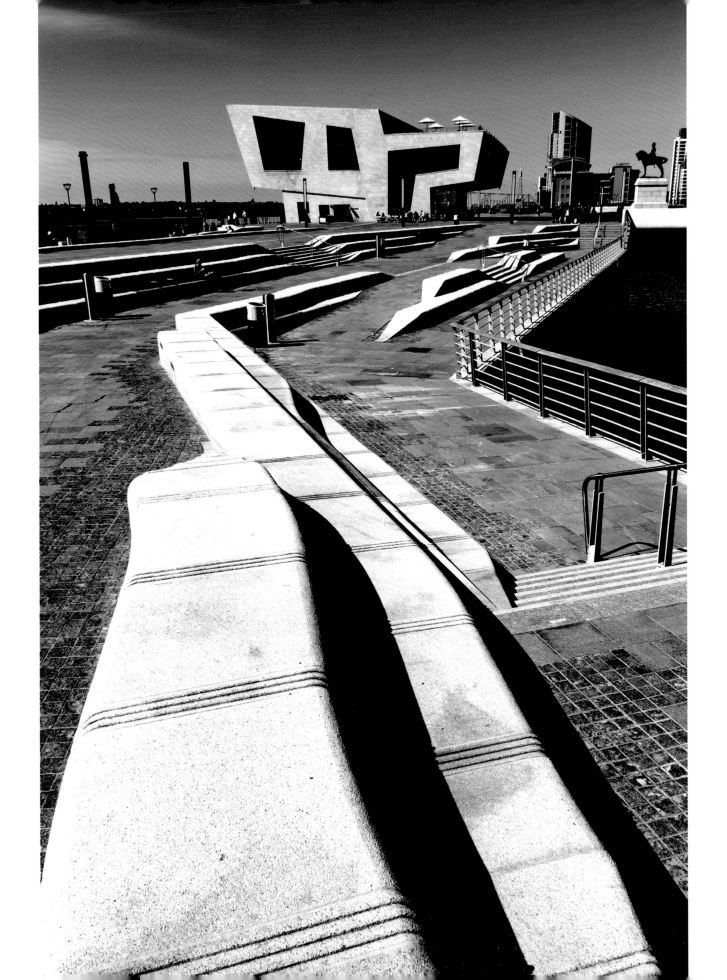

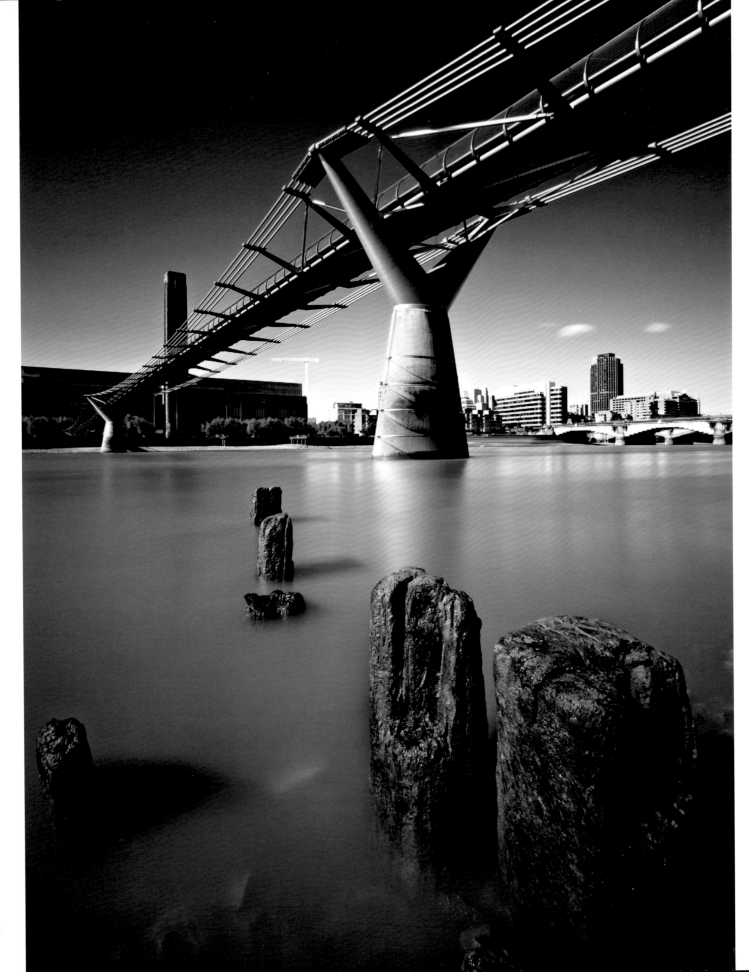

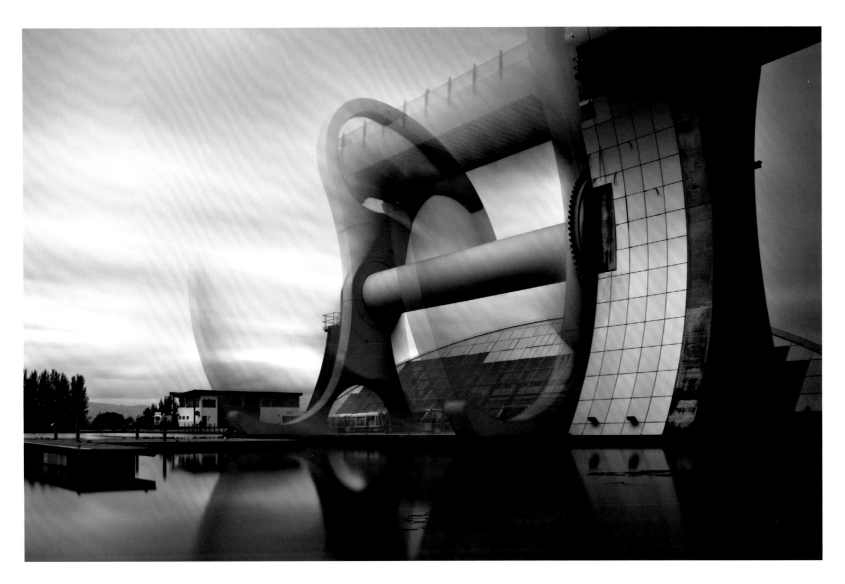

ADRIAN HALL

Millennium Bridge, London, England

In this image I wanted to capture the living and evolving nature of London while stripping it back to its essential elements. To do this, I wanted the juxtaposition of the soaked old posts from the banks of the Thames with the futuristic Millennium Bridge leading to the old source of power, the Tate Modern, which has now evolved into a great museum. One of my favourite of things with this shot is that it looks so simple but many elements had to come together to capture this image in the way I wanted it to be. Luckily there is a great pub serving Cornish beer next to the location so the preparation, though lengthy, was not too arduous.

DONALD CAMERON

Falkirk Wheel, Scotland

This is a long exposure shot capturing the rotation of the Falkirk Wheel in Scotland – the world's first revolving canal boat lift. It takes approximately four minutes to fully rotate and lifts boats up to the next level of the canal. An amazing piece of architectural design and engineering, apparently it only takes the equivalent power of boiling a kettle to drive each rotation.

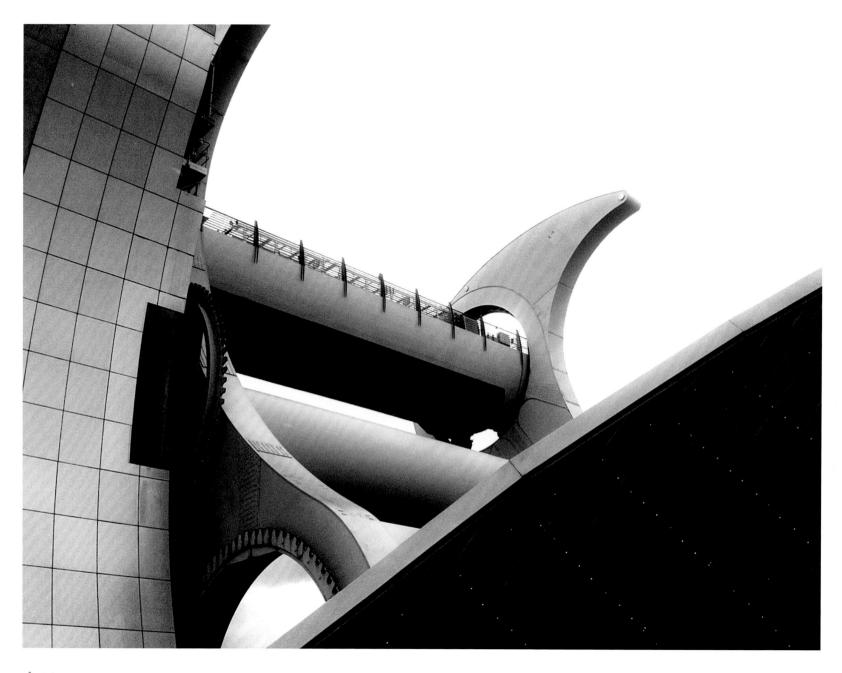

GORDON FRASER

Falkirk Wheel, Scotland

I have driven past the signs for the Falkirk Wheel so many times but, on this day, I decided to follow them to see what the fuss was all about. An impressive feat of engineering. The overcast day leant itself to some nice graphic black and white photography.

ROBIN SINTON ⋯⋗

Reflections on Infinity, Stockton-on-Tees, England

The Infinity Bridge gets its name from the fact that the bridge and its reflection can make the shape of the lazy eight, infinity symbol. I had photographed the bridge before but the light wasn't at its best. This time I hoped that I would have a good evening sky as a background. Unfortunately, the weather again did not co-operate. As it grew dark I saw the multi-coloured floodlighting start to appear. It was then just a question of finding the viewpoint and juggling with the exposure to try and retain just a hint of the fast darkening sky.

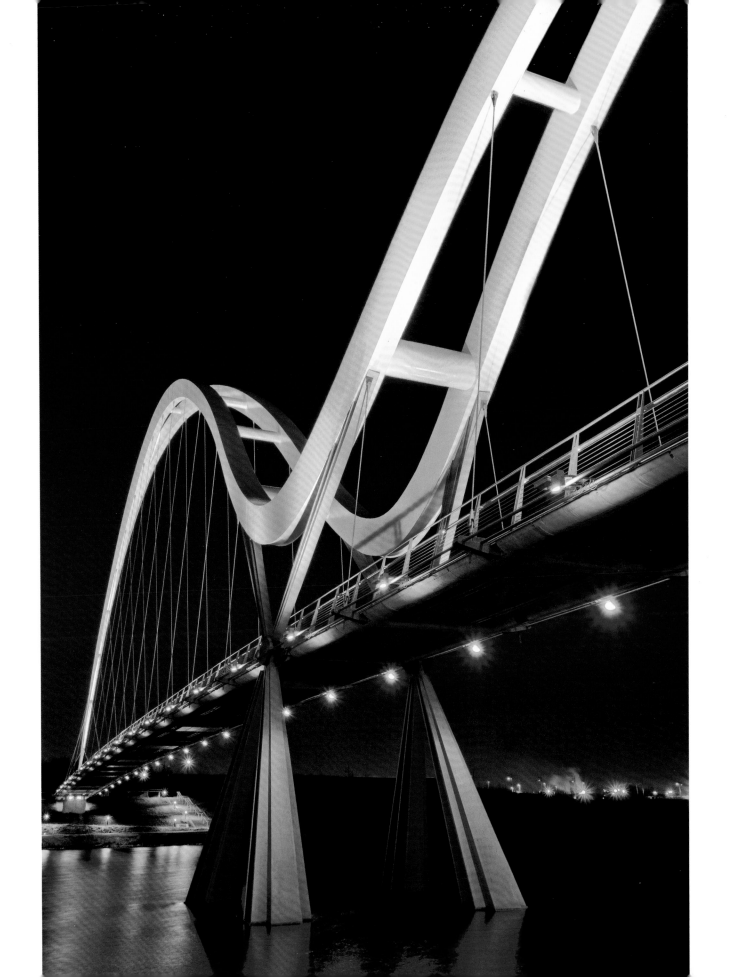

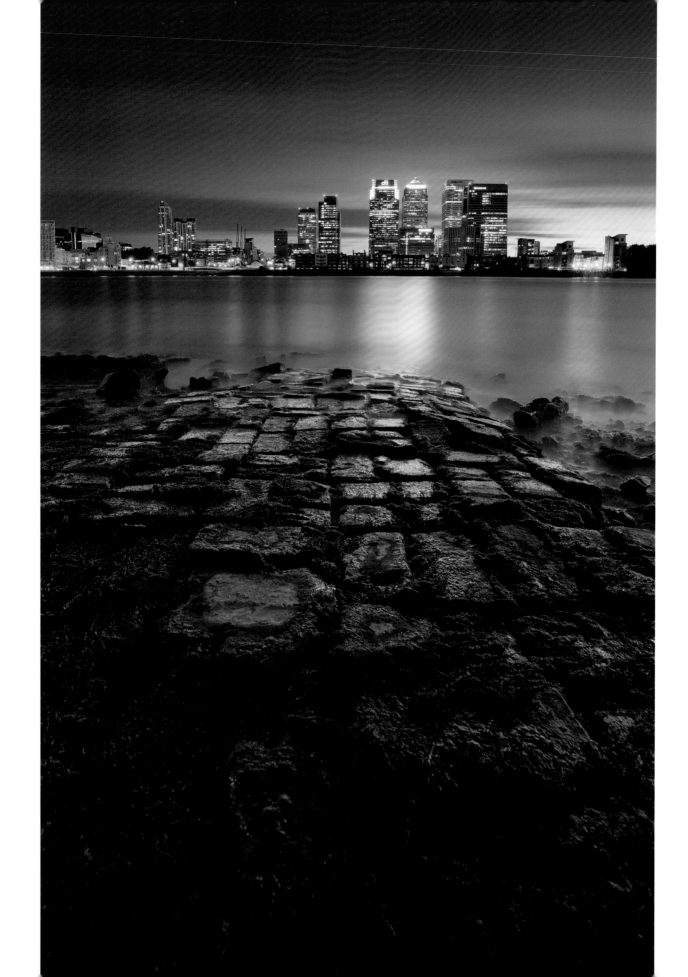

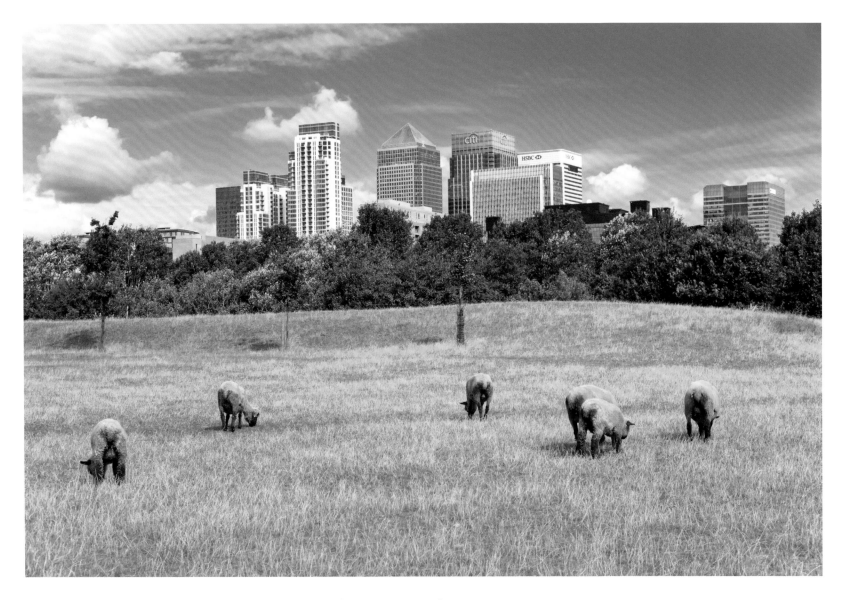

VACLAV KRPELIK

Canary Wharf, London, England

This spot in North Greenwich, facing Canary Wharf, is hidden from Londoners by a mass of rubbish which must be crossed over before high tide! The difficult access brings tranquillity to this place, which is the reason why I often find myself there, sharing the view with only my camera, listening to the sounds of distant city life. To get the desired composition, a certain level of tide has to come together with the right time after sunset, which happens only twice a month. To get all the elements working together was not easy but after many attempts I finally got what I was hoping for.

PAWEL LIBERA

London Docklands from a different angle, England

I found this view amusing and interesting at the same time as this field, with grazing sheep, is next to one of London's financial centres.

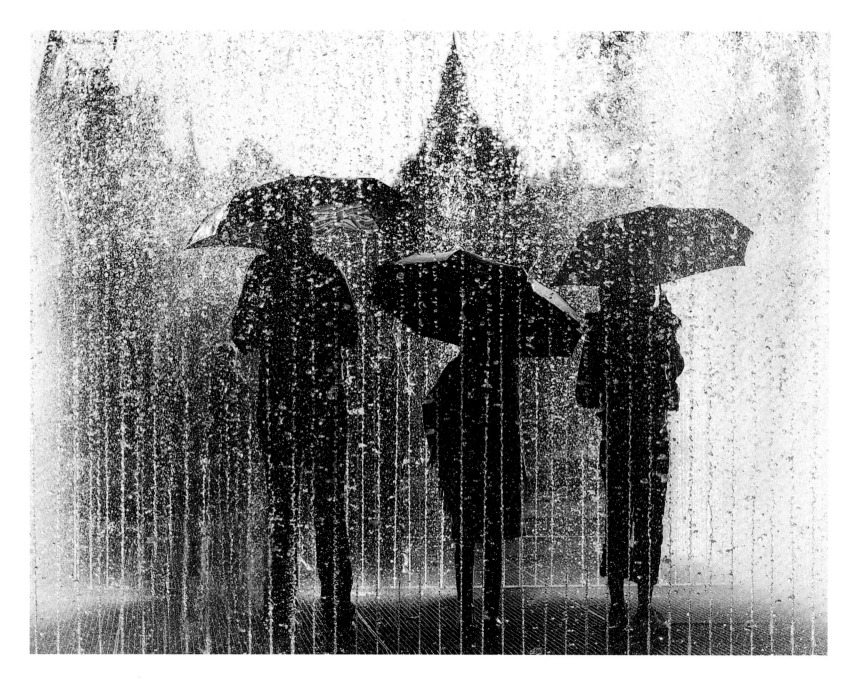

MARTIN POSNETT

Fountain on the South Bank, London, England

A Fountain maze, which allows you to step into it and then closes behind you. This image was all was about waiting for the right shape... and a lot of luck!

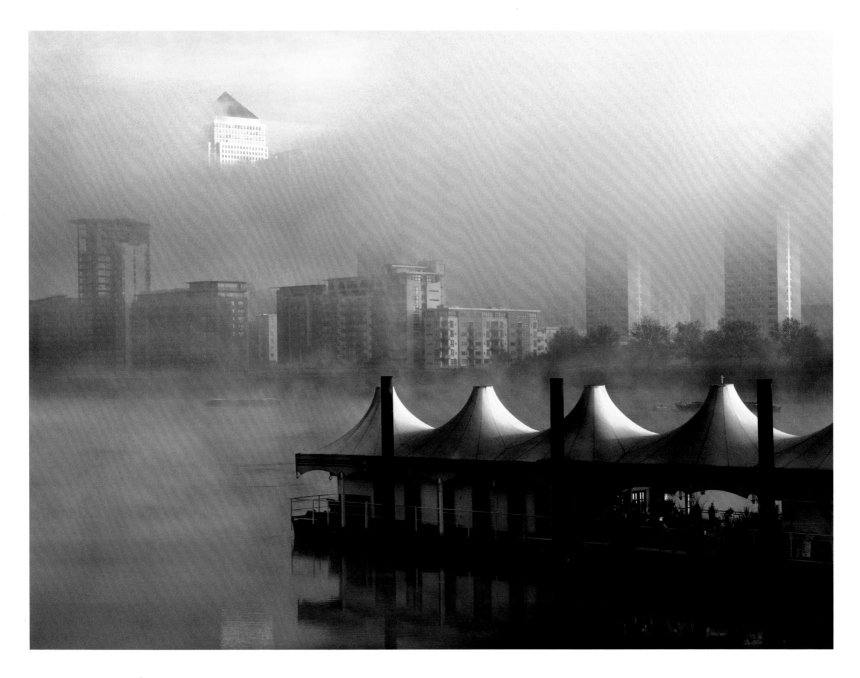

CHRIS LEDGER

Fog over the Isle of Dogs, London, England

Usually you have to wait patiently for the light. Occasionally you just get lucky. Arriving early at the Thames' Greenland Quay river bus jetty one November morning, I discovered that fog had rolled in from the Thames estuary over night. Significantly though, the rising sun was just beginning to burn holes through the white out giving a truly ethereal feel to a scene that, even on an average day, can be a fine viewpoint. Fortunately, I only had a short distance to run back for my camera and, in the meantime, conditions actually got even better as the top of One Canada Square (aka the Canary Wharf Tower) emerged... Everest-like. I was late for work that day.

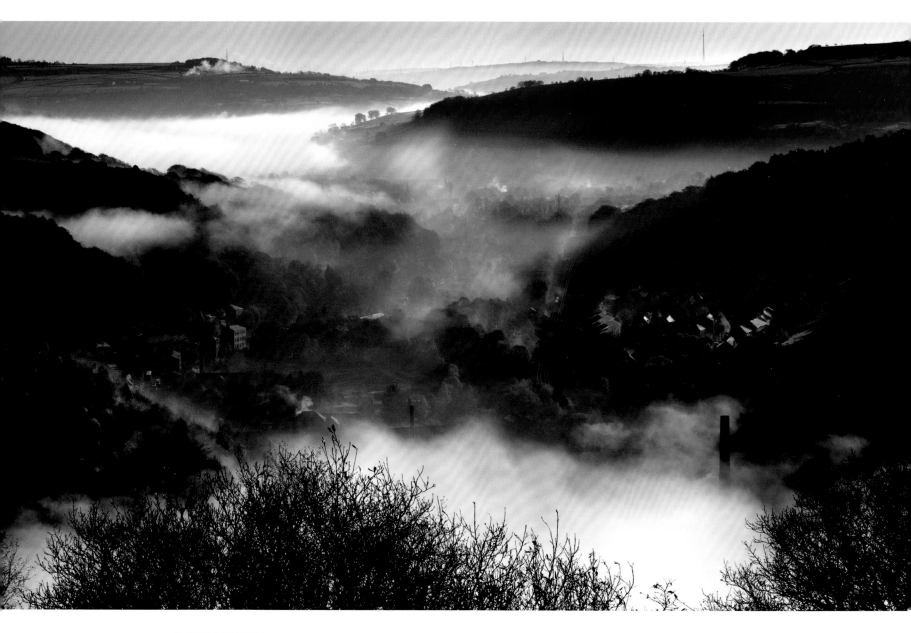

✝ NIGEL HILLIER

View from Rawtenstall Bank, Rossendale, Lancashire, England

I shot this on the way back from taking my children to school one cold morning in November.

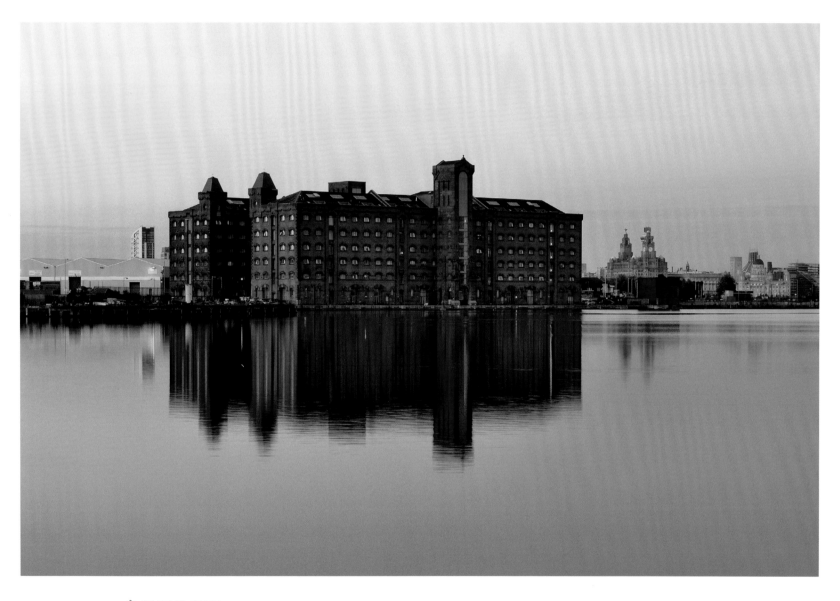

GARY McGHEE

East Float Dock at sunset, Birkenhead, Wirral, England

I had pre-visualised this shot some time ago and I was just waiting for the right conditions. After a couple of successive windless evenings, I took the short drive to this Birkenhead dock and wasn't disappointed. The pinky, pastel sunset colours were a nice added bonus.

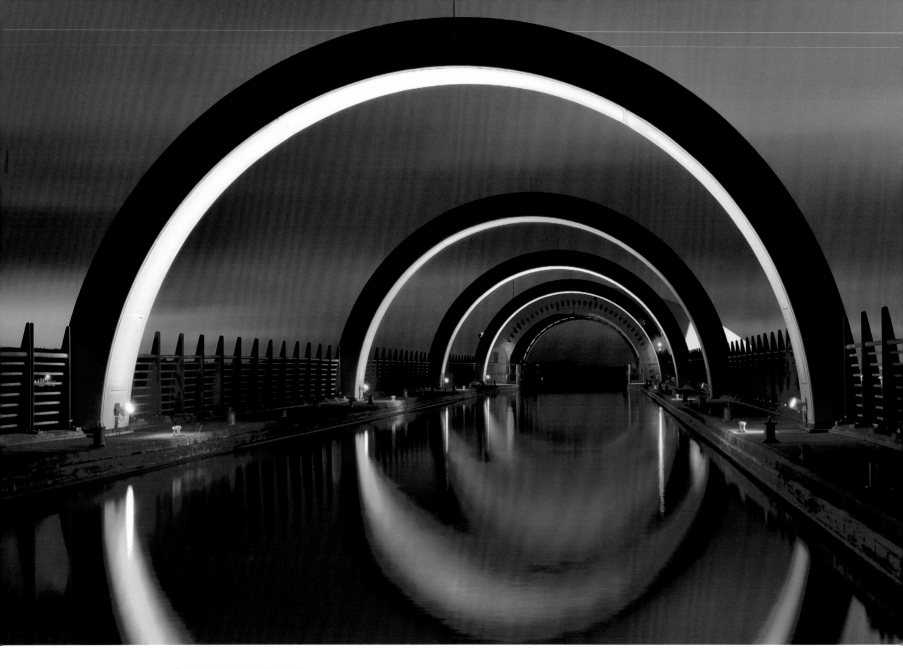

✠ **ANTHONY BRAWLEY**

Forth and Union Canal and Falkirk Wheel, Scotland

An abstraction of the standard view showing the concentricity of its architecture and mechanical make-up. A long exposure captured the orangey glow of light pollution in the clouded sky.

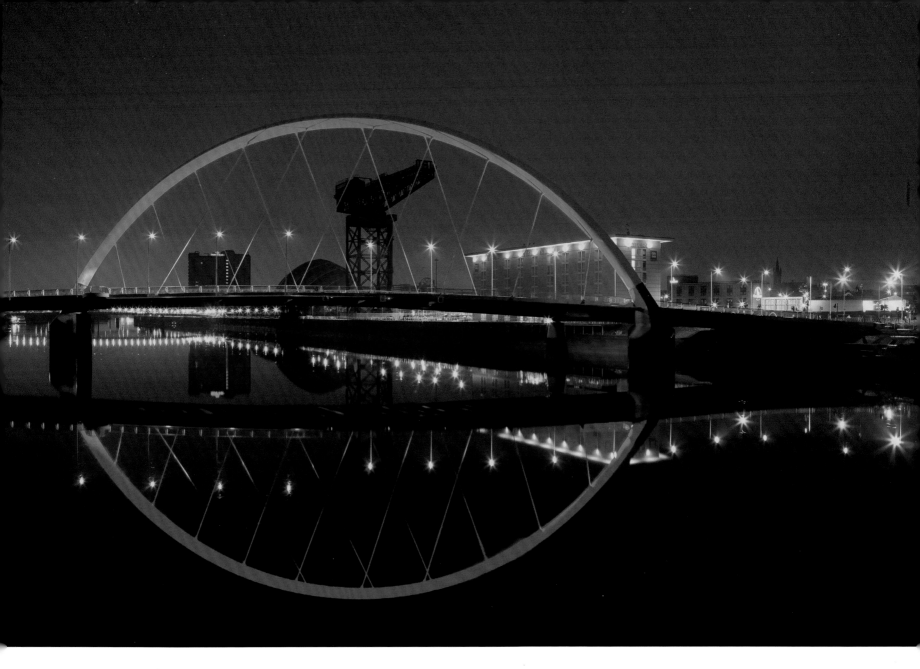

BILLY CURRIE

Glasgow Clydeside on Christmas Eve, Scotland

I was really keen to do some night photography along the Clyde in Glasgow and decided to venture into the city at 3.30am on Christmas Eve in hope that I would miss all the festive revellers making their way home. I was right; I have never seen Glasgow so still and peaceful. The city was very different to any other visit and was by far the most beautiful I have seen it. The trip was well worth losing some sleep over and I have been back many times since.

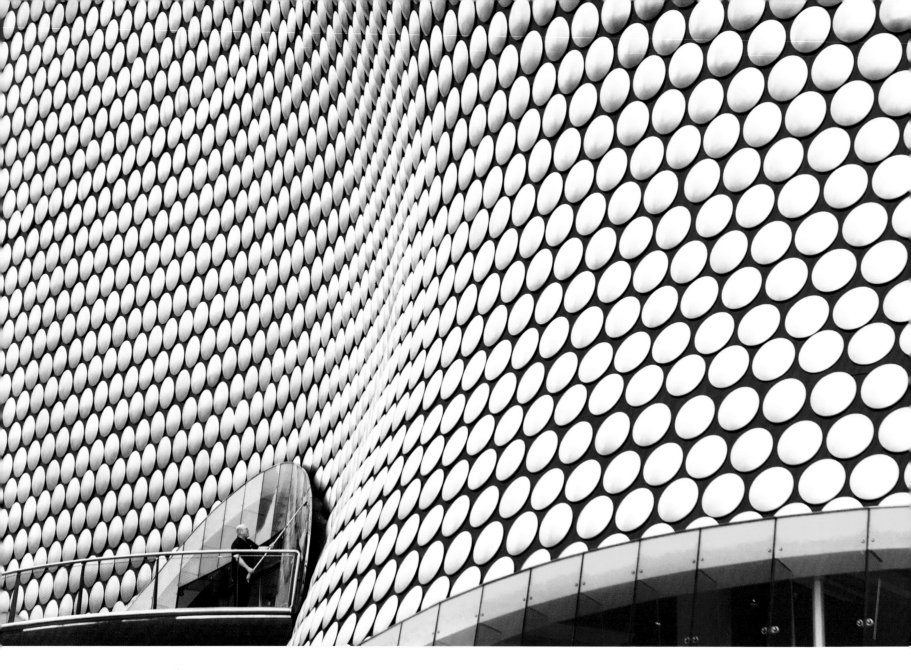

ROGER TAPP

The never-ending task, Birmingham, England

I was passing through Birmingham and had a couple of hours to kill. I know the city quite well so decided to have another look at the Selfridges building on the edge of the Bullring. Frequently photographed, it is hard to get an image that hasn't been seen many times before. Then it happened. That little piece of luck so often needed by photographers to give them a memorable and different image. A man emerged from the store and started to clean the windows and the picture was complete. I just had time to raise my camera to my eye and shoot a couple of frames before he moved his position and the picture vanished. But I was happy; a little bit of luck had given me a unique image in a familiar setting.

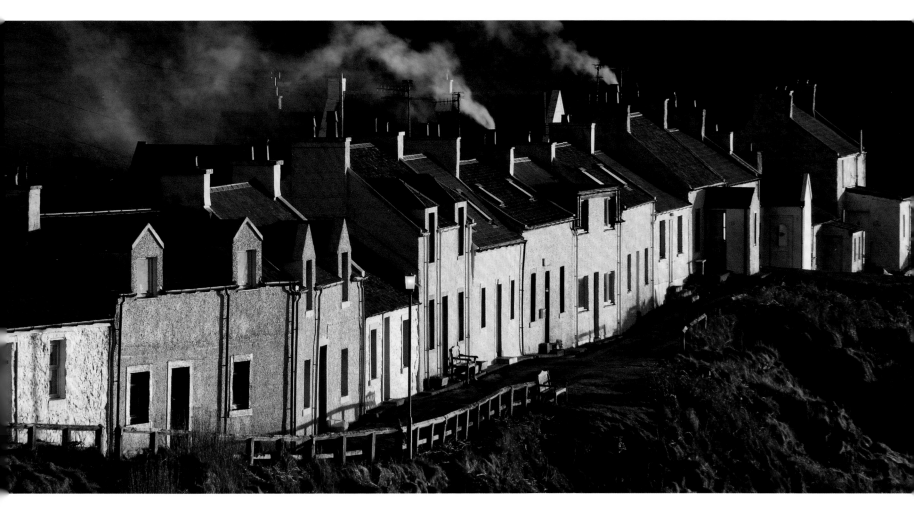

✝ ANDREW JONES

King Street, Portnahaven, Islay, Scotland

The village of Portnahaven lies at the south-western tip of the Hebridean island of Islay.
The whitewashed houses that line the harbour here provide an attractive subject for
photography at any time of day. On this particular day, I waited until the last hour of sunlight
when the rays of the setting sun bathed the buildings in a wonderful, warm golden light. I
was lucky that this coincided with a time when there were no parked cars along the road;
the last vehicle had only driven off minutes earlier!

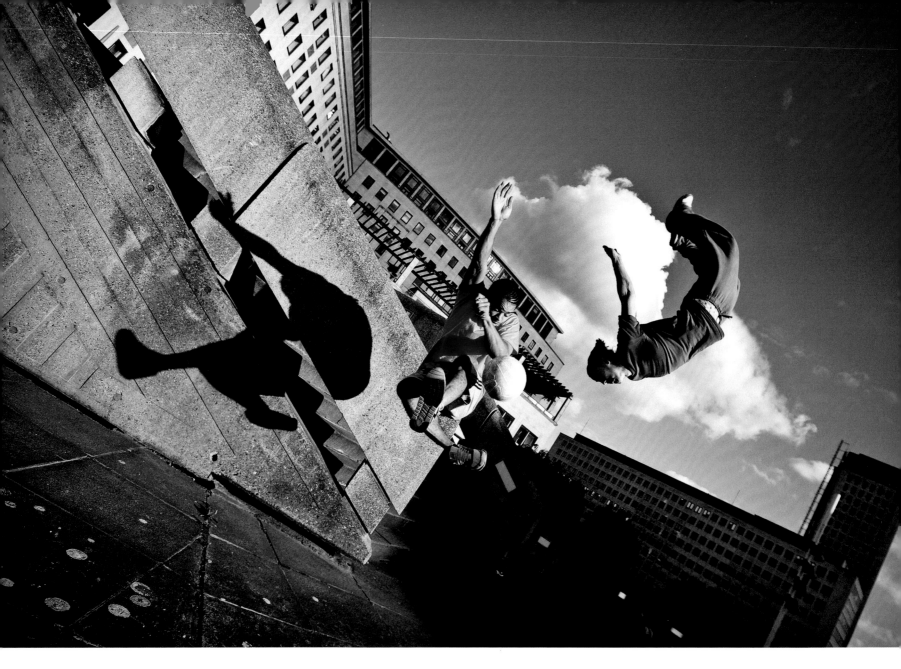

✤ JONATHAN LUCAS

Architectural playground, South Bank, London, England

Daniel Ilabaca and Jeremy Lynch fuse their respective skills of parkour and freestyle football within the angles and vantage points on offer at London's South Bank. Their forms, like kinetic sculptures, briefly alter the vista for 1/750th of a second.

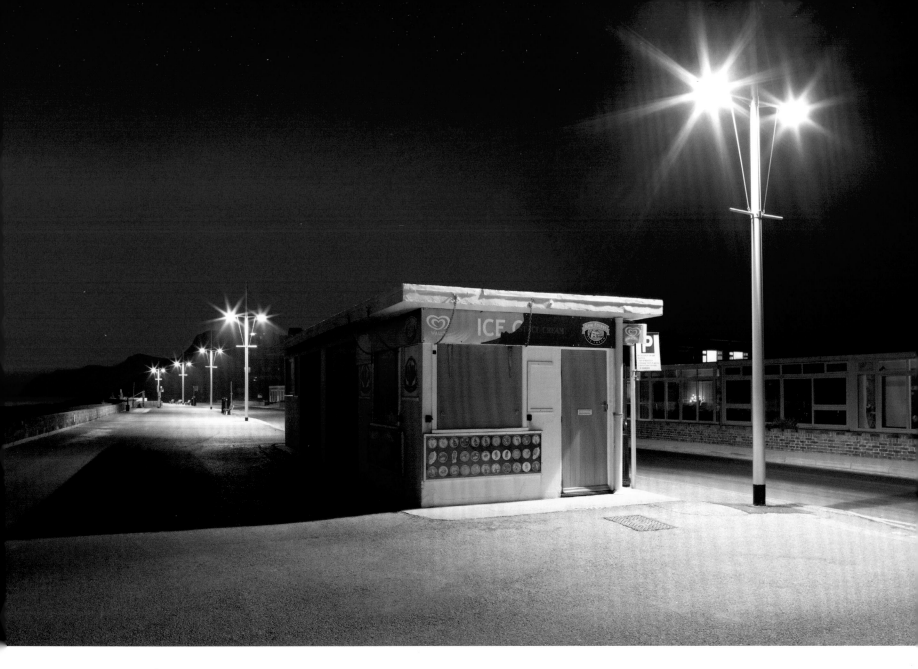

⚡ MIKE KEMPSEY

Off-season tranquillity, West Bay, Dorset, England

Minus five and falling, the freezing weather has removed all traces of life from the streets. Cloaked by the night and assisted by its attendant streetlight, the aged kiosk turns simplicity into beauty with a proud display of shutter and door. As winter passes, the beauty fades. Ignored by the masses it passes the summer unnoticed but for its wares. But as the nights begin to draw in, the glory of desertion shall soon return.

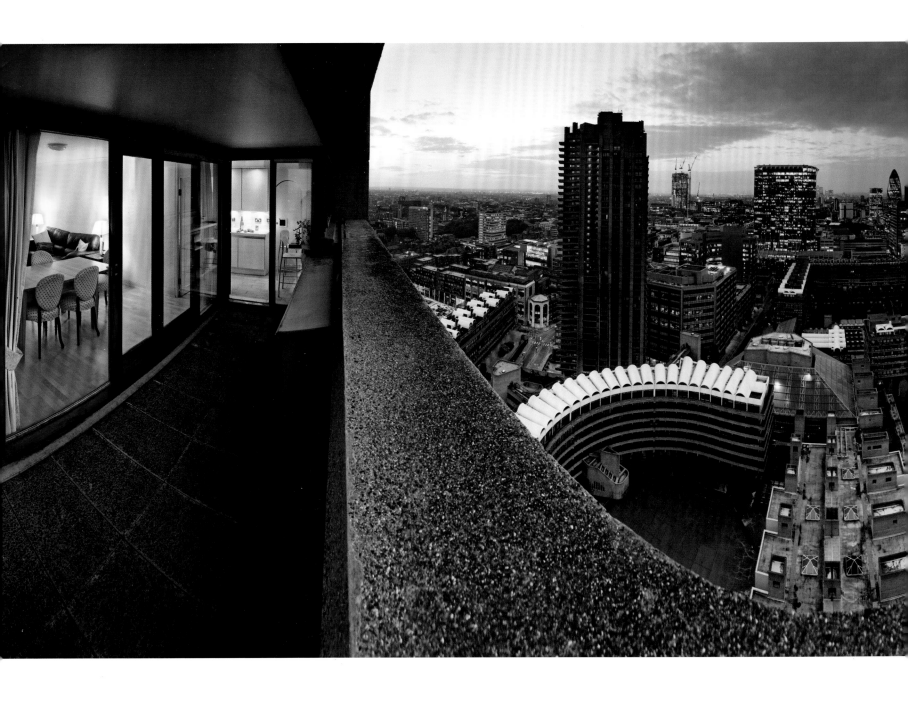

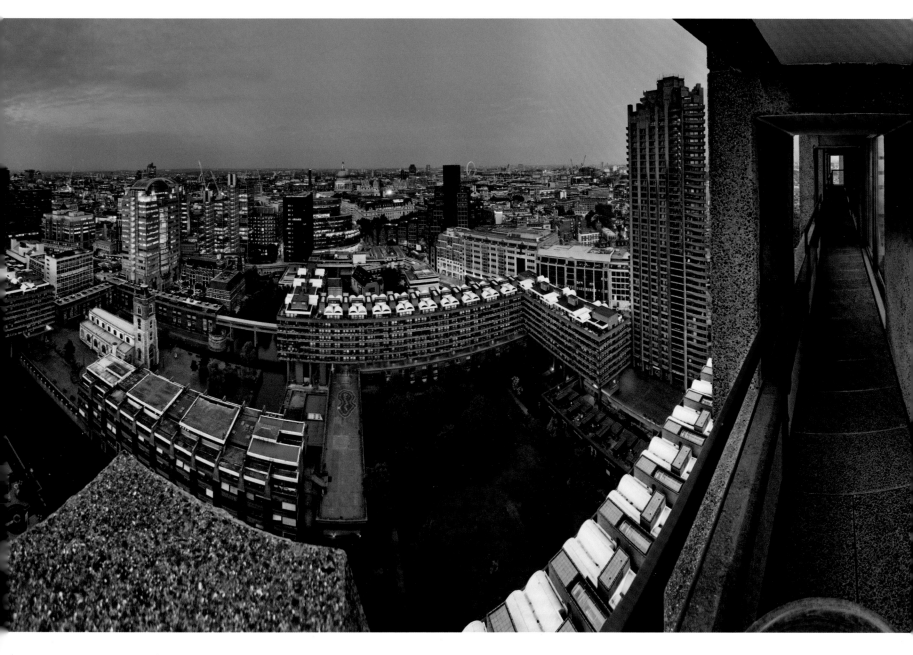

CHRIS LEDGER

Pre-dawn London from the Barbican, London, England

This image is part of a series, taken from a 30th floor balcony at London's Barbican Estate, that attempts to record the expansive view at different times of day and in different weather conditions. Clearly panoramic images were called for. Trouble was, I'd never actually made any when starting the project... Some months of intensive experimenting later, I returned to the balcony equipped with both a panoramic tripod head and, still more importantly, the newly gained experience to attempt the task.

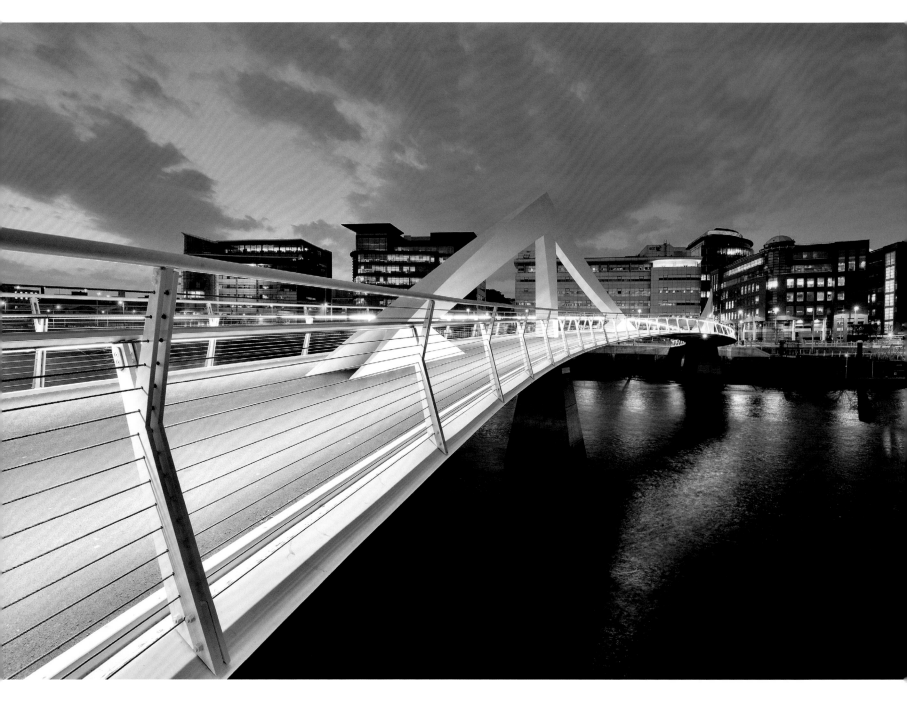

ANTHONY BRAWLEY

Tradeston Bridge, Glasgow, Scotland

I was drawn to the lines and curves of the bridge, colloquially known as the 'Squiggly Bridge', and wanted them to feature heavily in the image and lead the eye back towards the buildings which have popped up along the edges of the River Clyde and Glasgow's financial district. The super bright whites of the bridge complemented the coolness of the sky.

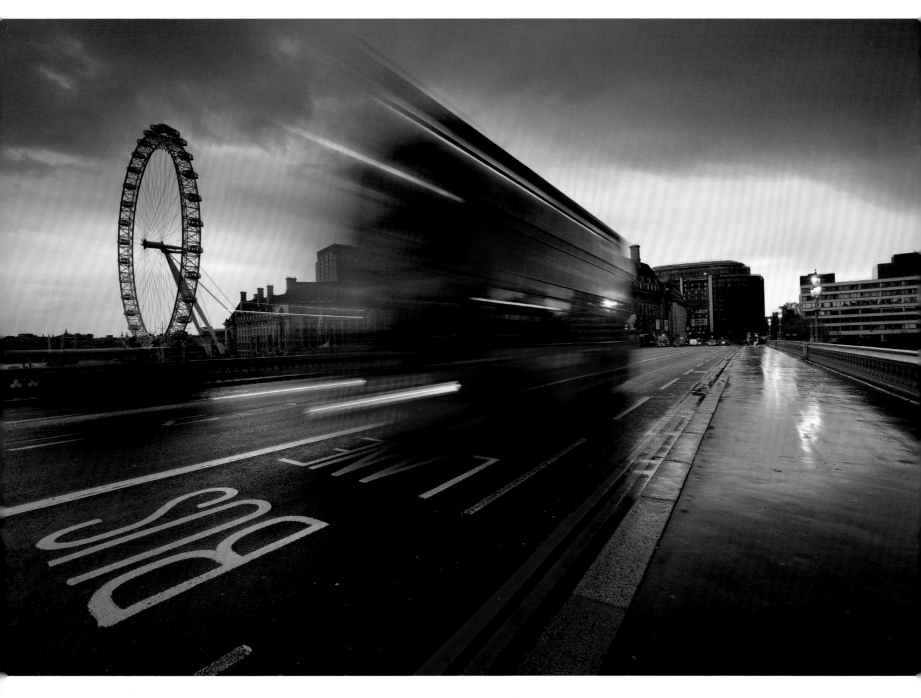

🟑 KAH KIT YOONG

Westminster Bridge, London, England

I set myself the challenge of photographing some of London's icons in a refreshing manner. With the warm tones of dawn starting to light up the sky, I used a neutral density grad filter to balance the sky with the foreground. It allowed me to concentrate on achieving just the right timing and shutter speed to capture the bus, as it was about to pass the London Eye to the other side of the Thames, in a single exposure.

URBAN VIEW
youth class

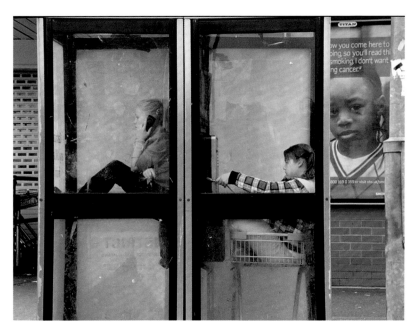

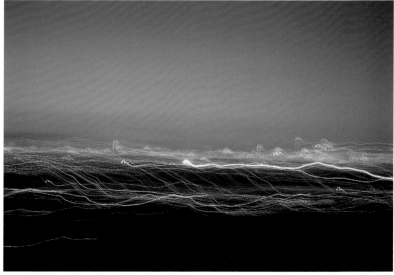

URBAN VIEW YOUTH CLASS WINNER

✝ SAM CARTWRIGHT

Double dial in telephone boxes, Farnworth, Lancashire, England

I was out with my camera one day; it was a deserted Sunday afternoon in a small northern town. There was a large supermarket in the centre with phone boxes beside it. By chance, I saw this image of the two girls. I captured it as quickly as I could. To me it seemed somehow both bleak and fun – Who are they phoning? Each other, no one, the Prime Minster?

✝ TOM COLE

The Electricity of London – from Grange Hill Allotments, London, England

This image was the result of a simple photographic experiment in which I studied the period before night fully falls; when the city's lights become more and more prominent. Using a long exposure, at this point of half-darkness, allowed me to capture an abstract, linear composition from many individual focal points of light. The effect created is one of flow; the fine lines of light wind along horizontally, like electrical cabling. Clear parallels can therefore be made between the intense electrical atmosphere of the image and the energy required to light up London every night.

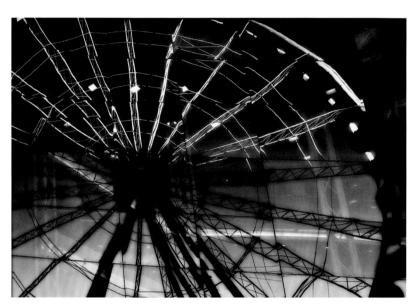

✝ WILLIAM LEE

Big Wheel, Birmingham, England

Birmingham's big wheel reflected in the Symphony Hall, photographed during a day trip with my uncle.

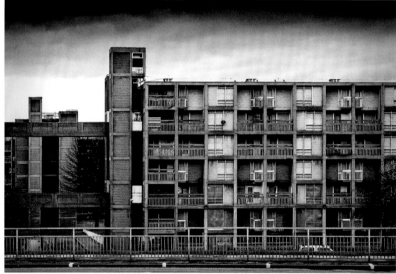

✝ WILLIAM LEE

Housing of the past – Park Hill Housing Estate, Sheffield, South Yorkshire, England

The eerie Park Hill housing estate in Sheffield, with most apartments boarded up. First built in 1957, it is currently being renovated.

YOUR VIEW
adult class

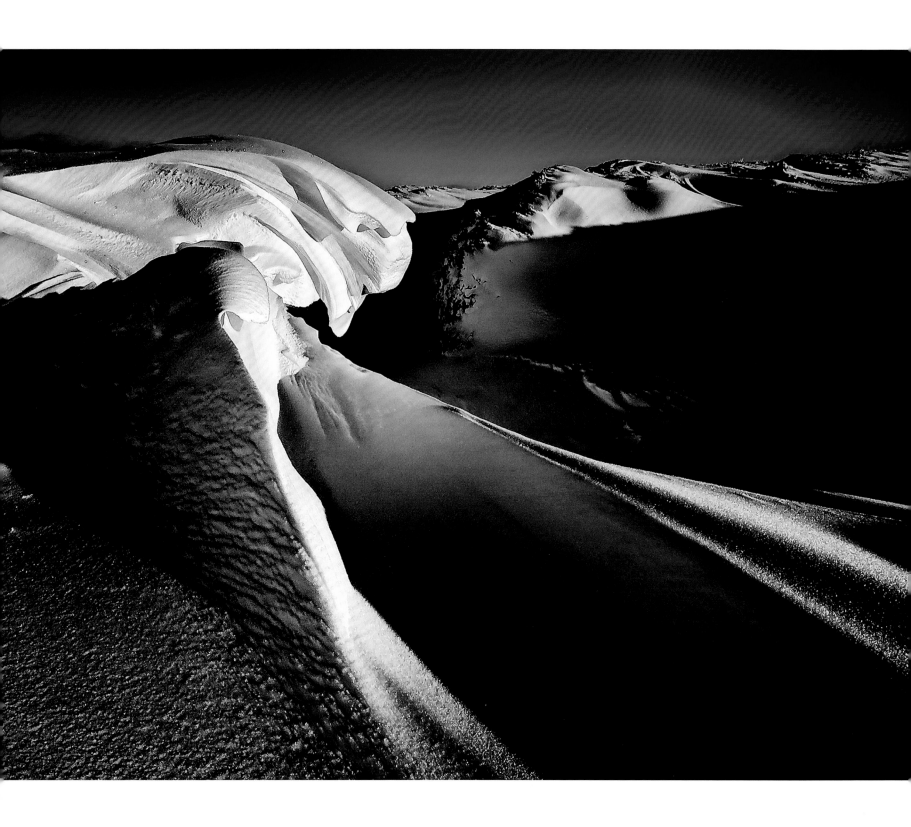

YOUR VIEW ADULT CLASS WINNER

⟨⋯ **PAUL ROBINSON**

Kinder Scout, Peak District National Park, Derbyshire, England

One day in January, I went on a solo hike up Kinder starting at Edale. I ventured deep onto the summit plateau, into untrodden terrain, lured in by some amazing, naturally-formed snow sculptures, including this cornice. Already out of my comfort zone, I didn't dare get any closer in case the cornice collapsed above me or for fear of falling into the deep grough beneath it. Getting the composition right was tricky, not only because I was waist deep in snow and sinking but, due to the low angle of the sun, I also had to avoid getting my own shadow in the shot. Once I was satisfied with the shots I'd taken, I was then in a bit of a predicament wading my way back through the snow to relative safety.

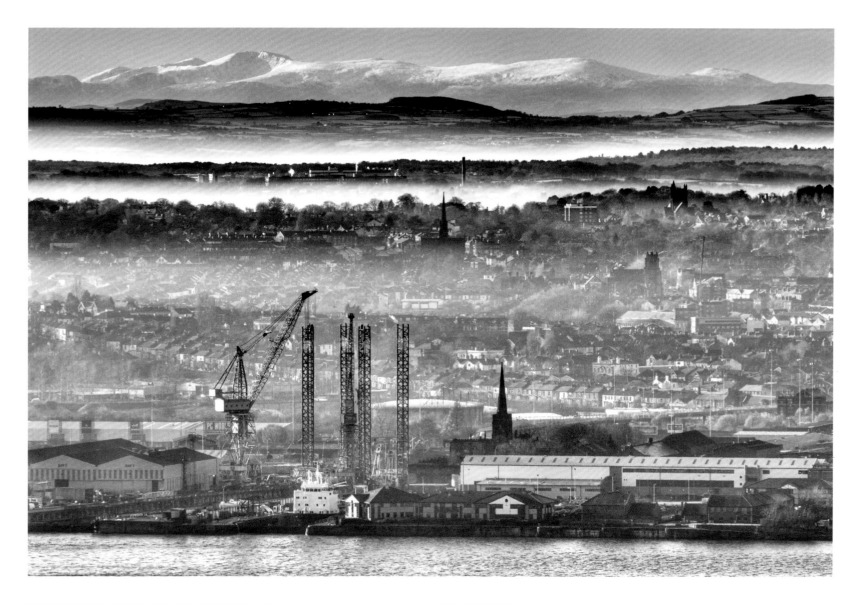

YOUR VIEW ADULT CLASS RUNNER-UP

⚜ TOM FAIRCLOUGH

Looking south from Liverpool Cathedral, Merseyside, England

A winter's day, looking from Liverpool Cathedral across the River Mersey to Cammell Lairds, Birkenhead Priory, the Wirral Peninsula and the mountains of North Wales.

SIMON PARK ⋯⋗ HIGHLY COMMENDED

Trees and wind, Isle of Man

I've visited this row of trees many times and have known there were great pictures to be had... if only I could find the right combination of light, sky and wind. The movement represented was certainly intentional; I was aiming for a blending of clouds and branches, which corresponded to the emotional response I got as the wind rushed through the trees. I've always tried to make these trees work as a panoramic, but eventually settled on the square format – it contains the composition quite nicely.

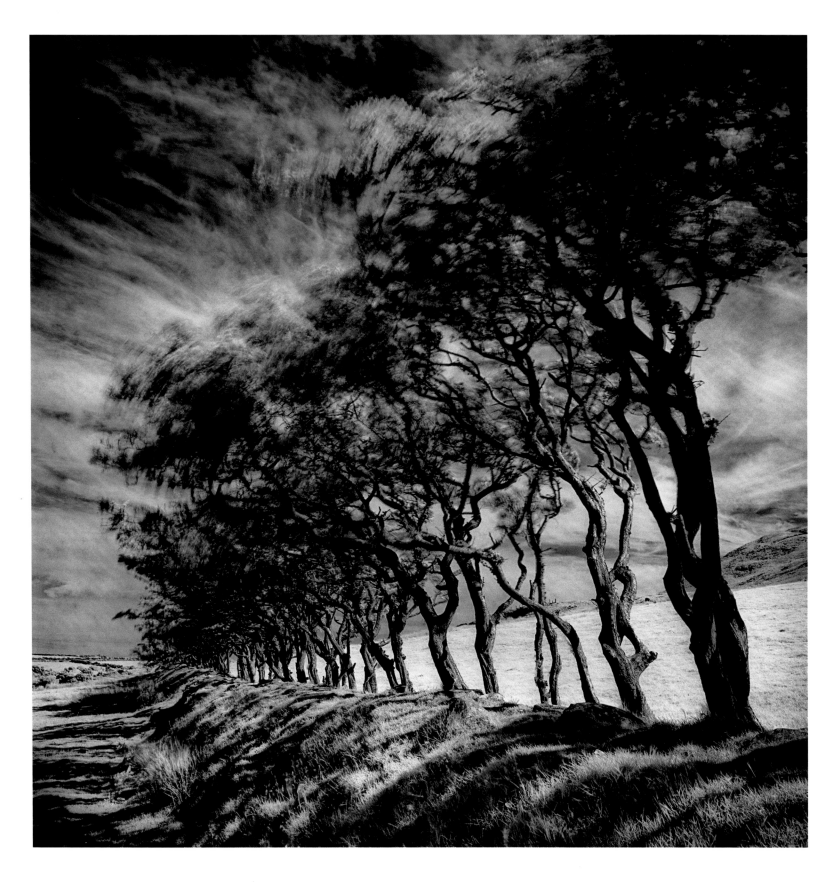

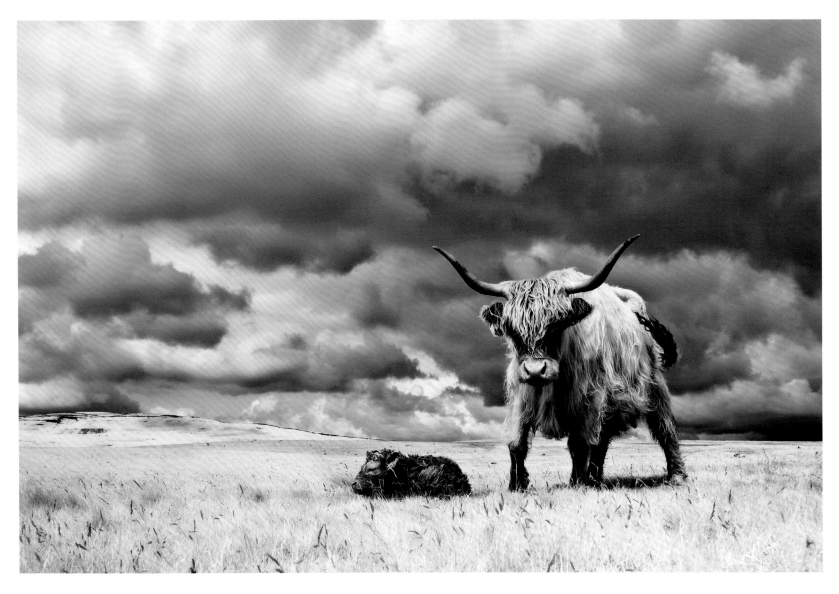

PETER MARTIN HIGHLY COMMENDED

Sandymouth, Cornwall, England

The initial appearance of this rocky beach was one of grey but it was quickly apparent that many other colours existed, just waiting to be discovered. This photograph shows where the beach meets the cliff face at Sandymouth with the rugged red in the cliff contrasting with the smooth curves of the pebbles. The two halves of the picture are naturally linked together by the red rock fragments that have fallen from the cliff onto the beach.

STEVE SHARP HIGHLY COMMENDED

Near Malham in summer, North Yorkshire, England

A highland cow stands protectively by her newly born calf near Malham in the Yorkshire Dales.

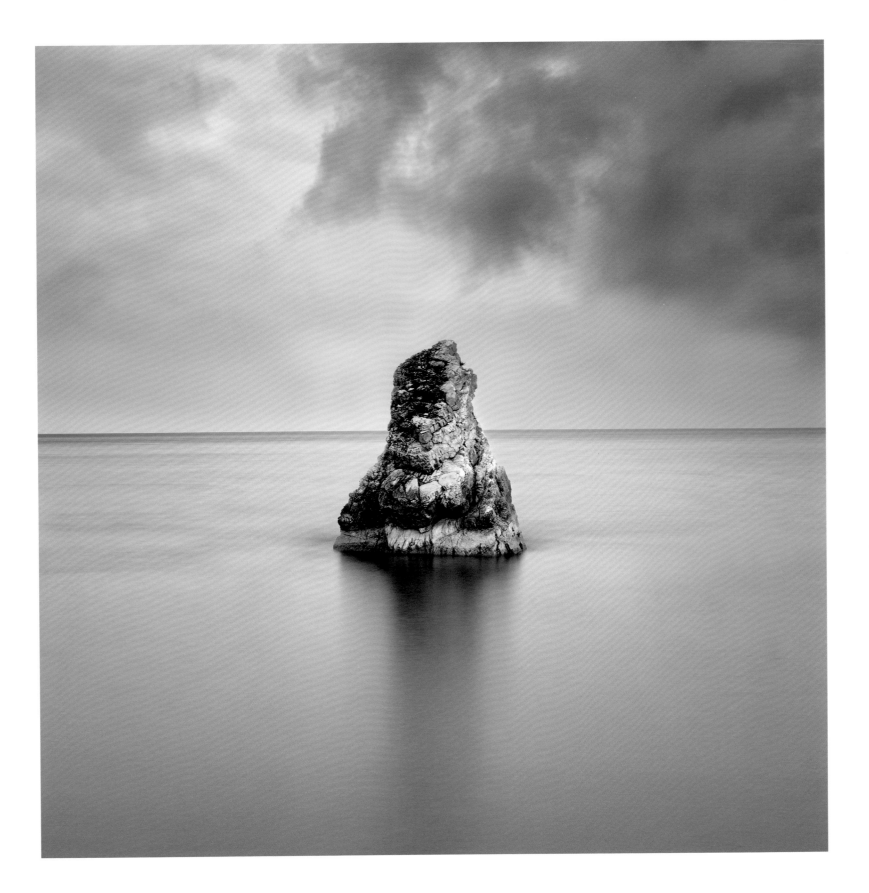

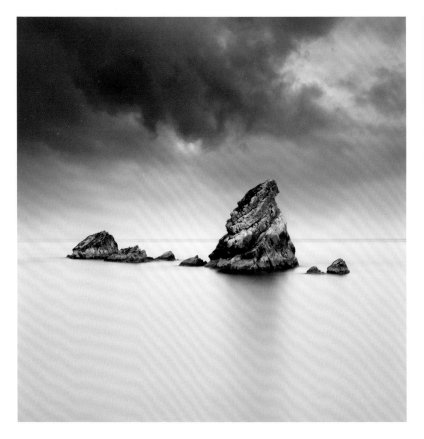

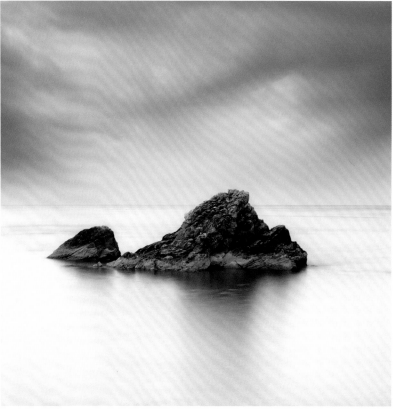

MARCIN BERA

If I could say I love you, Dorset, England

Mupe Bay, with its sequence of Cretaceous rocks, is a bay, with a shingle beach, to the east of Lulworth Cove and is part of the Jurassic Coast. The rock formations and breathtaking scenery make this one of the nicest places on the south coastline.

MARCIN BERA

Credulous, Dorset, England

The Jurassic Coast is one of the most beautiful places in Great Britain and this image is a simple example of a wonderful and graphic rock formation. I spend many summer evenings here with my camera seeking out conditions like this.

Judge's choice Martin Evening

MARCIN BERA HIGHLY COMMENDED

I'm sorry I failed you, Dorset, England

Stunning Mupe Bay is located near the picturesque village of West Lulworth. The spectacular scenery changes all the time, depending on the level of the sea tide. I took this image one late evening in summer time.

Judge's choice Jon Jones

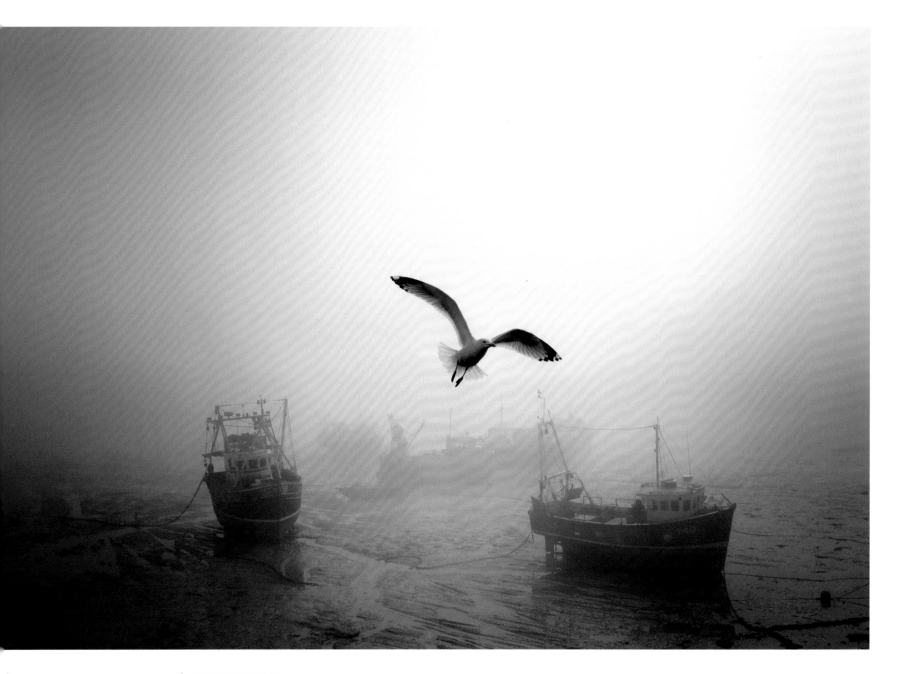

✝ CEDRIC DELVES

Folkestone harbour, Kent, England

A view of Folkestone Harbour at low tide on a foggy, spring day. It is all faintly reminiscent of Coleridge's 'Ancient Mariner', with gulls emerging ghost-like out of the murk – actually, more often than not scrounging for chips.

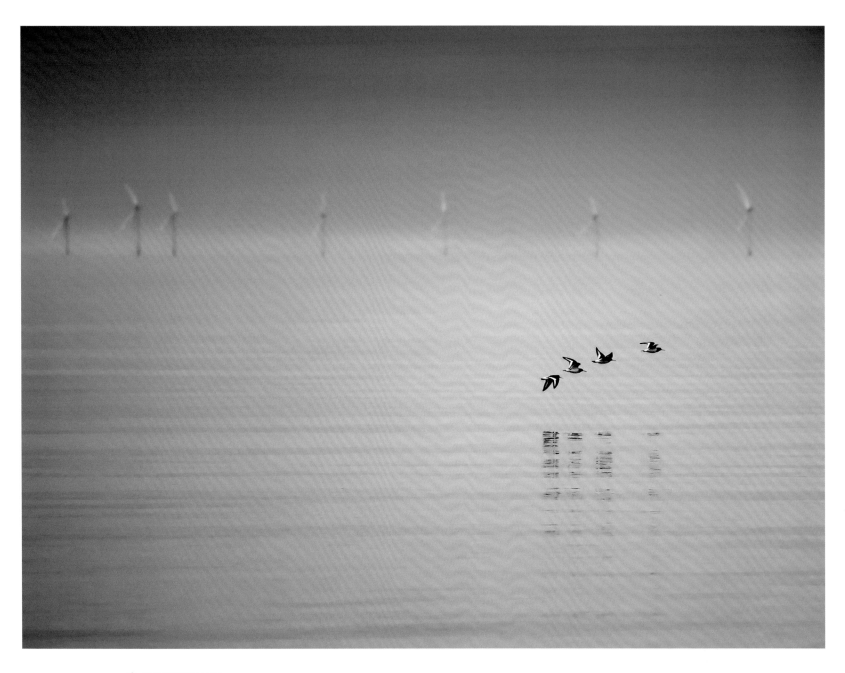

STU MAYHEW

Shellness, Isle of Sheppey, Kent, England

This was taken on a cold February day and I was lucky to catch the reflections, as the sea was so calm. I think the grace of the birds in flight is matched by the distant wind farm.

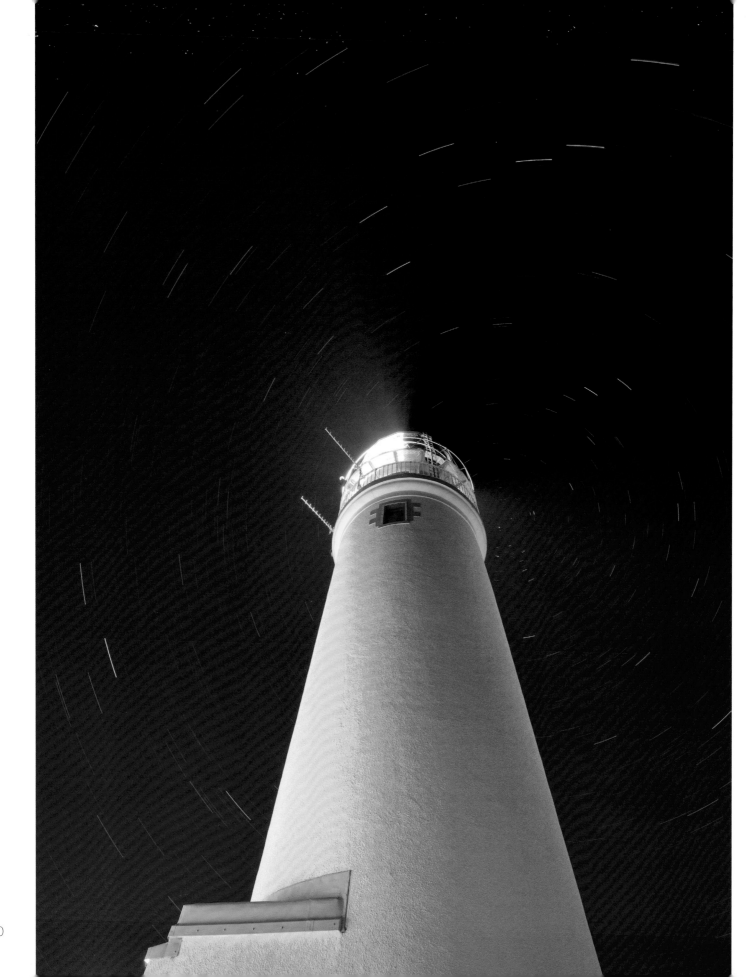

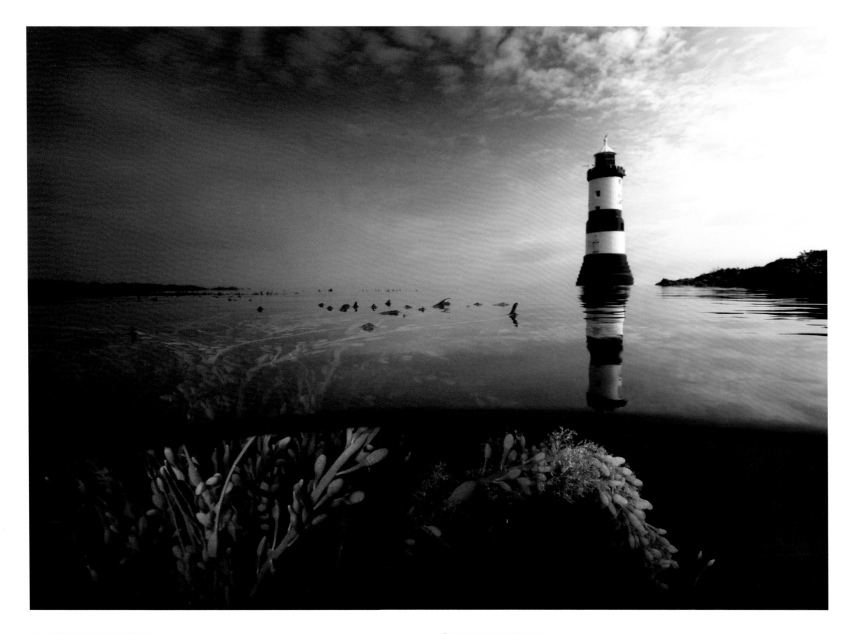

FORTUNATO GATTO

GRAHAM EATON

Universal clock – Star trail over Rua Reidh Lighthouse, Scotland

Penmon dawn, Anglesey, North Wales

During a starry night, thanks to its remote geographical position, Rua Reidh Lighthouse is the only shining light, along with that of the stars. As per my usual habit when taking night shots, I brought a power torch with me to help me to focus and I balanced the brightness of the lighthouse building using a light painting technique. I decided to keep the Northern Star to the side of the Lighthouse to highlight both vortexes – the light trail and the star trail – a universal movement able to pace time, feelings and photographic vision.

Penmon Lighthouse on Anglesey is commonly photographed but I wanted to capture an image that showed the hidden world. I wanted to use a single frame, not HDR or photo merge techniques. I visited Penmon several times before the conditions of sky, tide and still, clear water, came together. The biggest problem is water clarity, so the shot had to be taken in winter when, after a calm period, the water is clearest. I saw many other photographers, while I was working on this shot, who must have wondered what I was doing in the water.

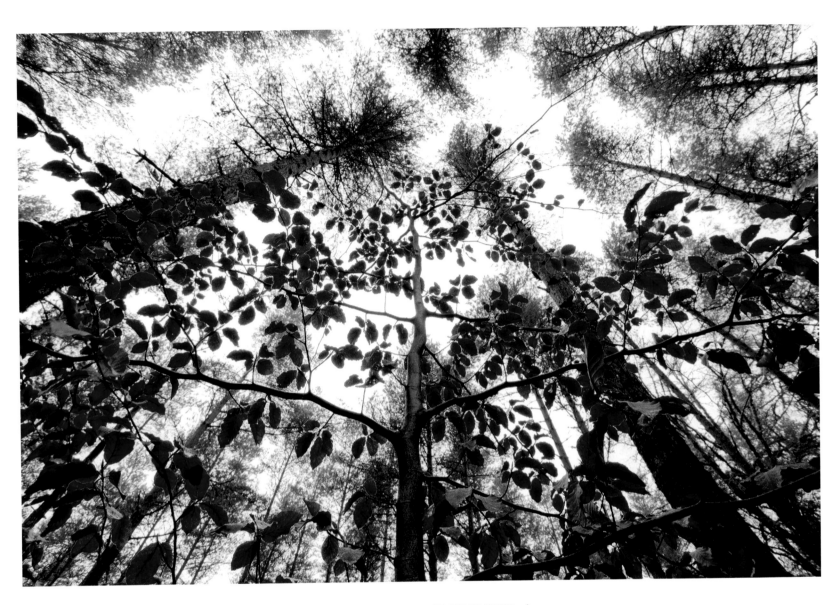

⬆ **WILCO DRAGT**

Beech and pine, between Inverness and Loch Ness, Scotland

I was on a two-week photo trip to Scotland in mid-winter and my 'base camp' was at a friend's house in Inverness. Close to her home, I found a lovely pine forest with young beech trees, where I spent many happy hours trying out different approaches to capture the essence of the forest.

CRAIG EASTON ⋯⟩

Two trees, Bramley, Surrey, England

This was one of those chance occurrences that happen when you get up early. Whilst driving down the lanes on a freezing, foggy morning in Surrey, I noticed the flooded fields and parked up. I could see the two trees in the distance and in order to get the viewpoint I was looking for I had to climb down and cross the field/lake. I was on my way to an appointment but, having left early, I had enough time – I even had spare socks and shoes in the car. It must have been quite a sight for passers-by to see a photographer, with his trousers rolled up, wading across a field on a freezing January morning and, although cold, I'm glad I did it.

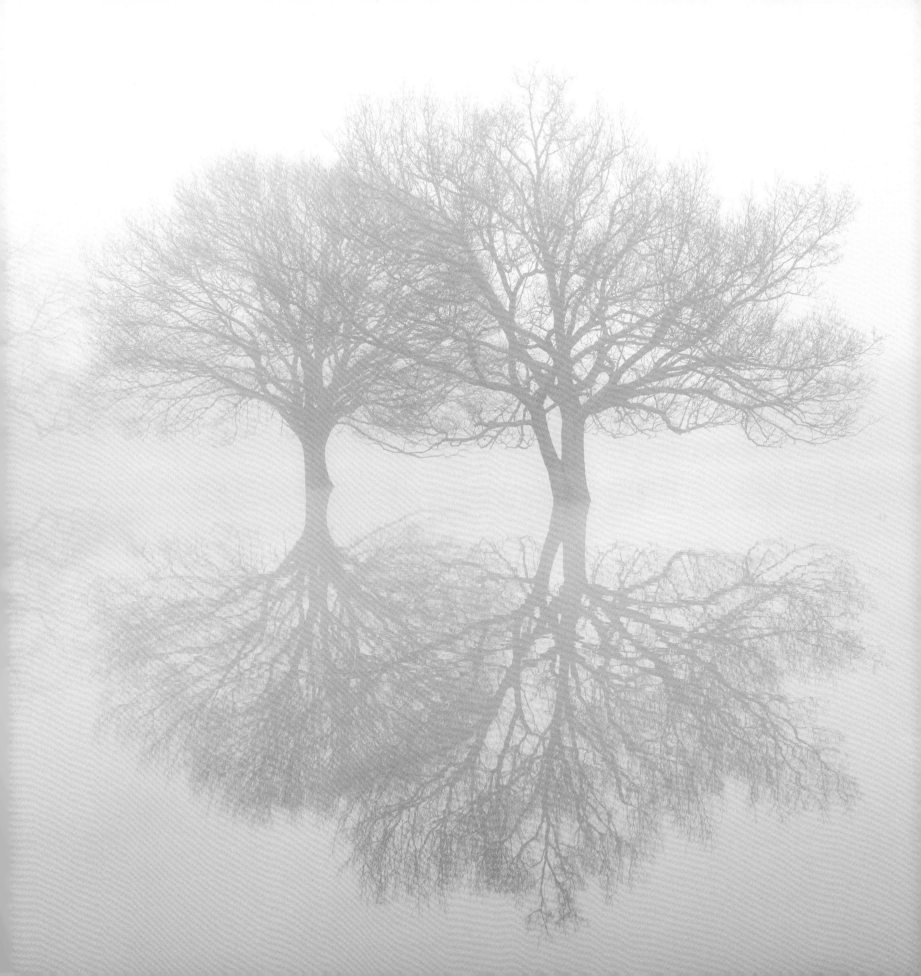

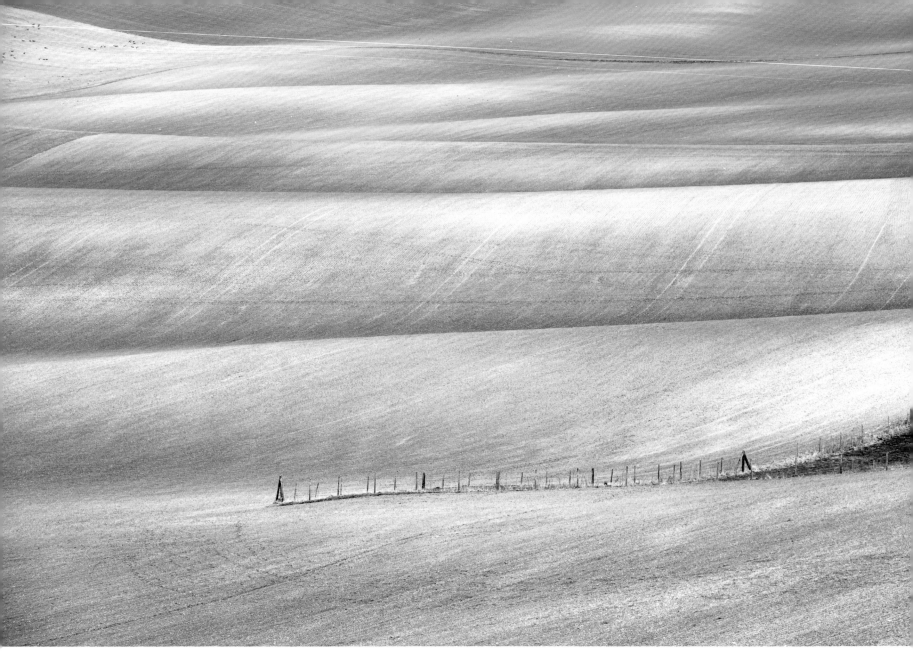

PETER STEVENS

Rolling hills near Therfield, Hertfordshire, England

These beautiful rolling hills have been captured in a soft, but rapidly changing light, showing the many shades of green and blue in the contours of the landscape.

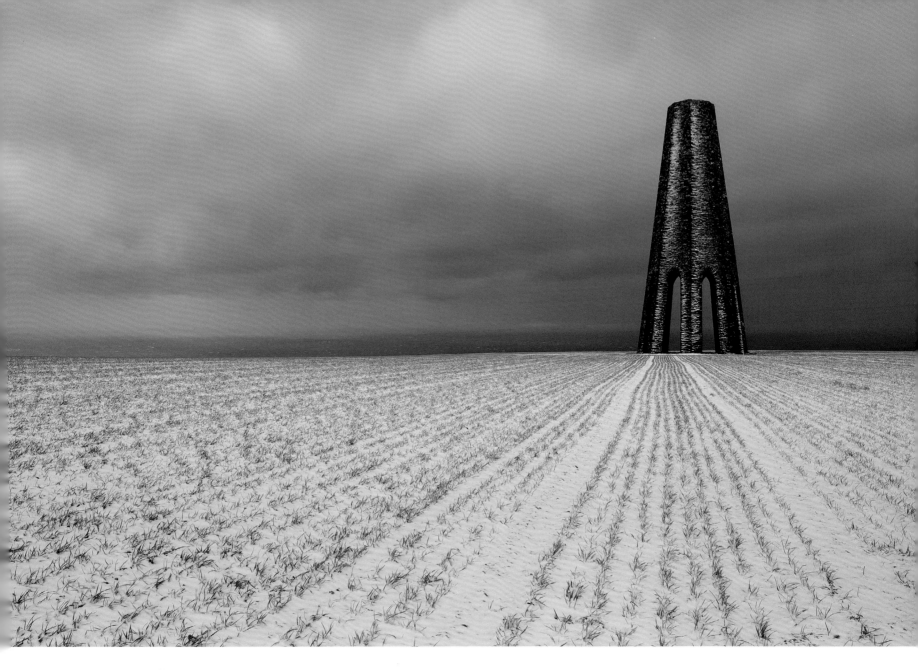

MARK LAKEMAN

Arctic blizzard at the Daymark Tower, Kingswear, Devon, England

As the winter chipped away at our sanity a little more, I decided to challenge Mother Nature to do her worst. I drove as far as I could before the roads became too dangerous and then walked around two miles to the Daymark Tower. Just to see if I could. The fields were a good foot deep, in places, on the north-facing slopes. The Daymark itself stood in no more than a few inches of snow. However the storm force north-east wind and horizontal piercing snow made me realise that Mother Nature was seriously not happy. A few hours of exposure later I headed back to the car and to the warm.

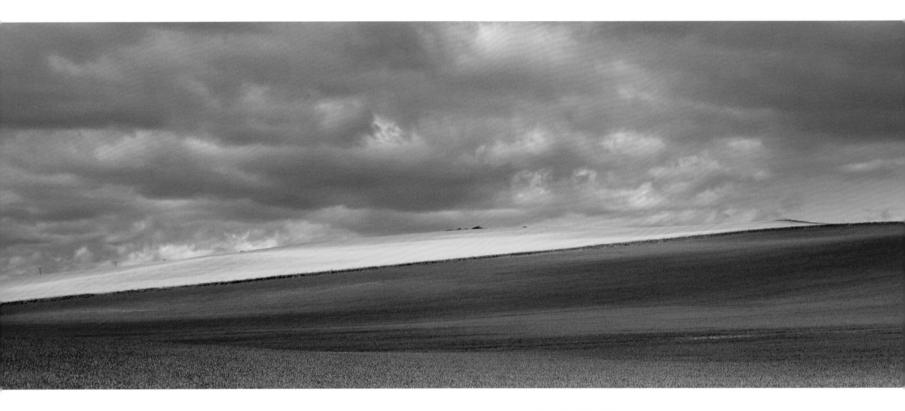

IAN CAMERON

Slash of rape, Duffus, Moray, Scotland

There are quite a few rolling fields of wheat, punctuated by oil seed rape, in the Moray area but the nearer you get to the coast the tidier and less complex the backdrop becomes, until it is just sky and fields. At this stage, the scenes become striking bands of colour. This slash of vivid yellow rape was sandwiched between a heavy grey sky and fresh shoots of new grown wheat but it is the dappled light playing across the fields that makes this easily one of my favourite agricultural images.

ROBERT WOLSTENHOLME

The love of trees, Cranham, Gloucestershire, England

This ancient beech tree is in the Cotswolds Commons and Beechwoods National Nature Reserve. It seems to me as if the tree is reaching out to us. Some of us love trees and, although they can't love us in return, the emotional well being they bring to us is a bit like love perhaps? My wife, Suzy, spotted the heart shape in an earlier image of this tree, so I went back to get an image with stronger emphasis on the heart. Which proves that getting a good photo needs more than just some technical ability! We don't know how old this tree is, but 400 years would be a fair guess. I hope our special National Nature Reserves can be kept safe for another 400 years and more.

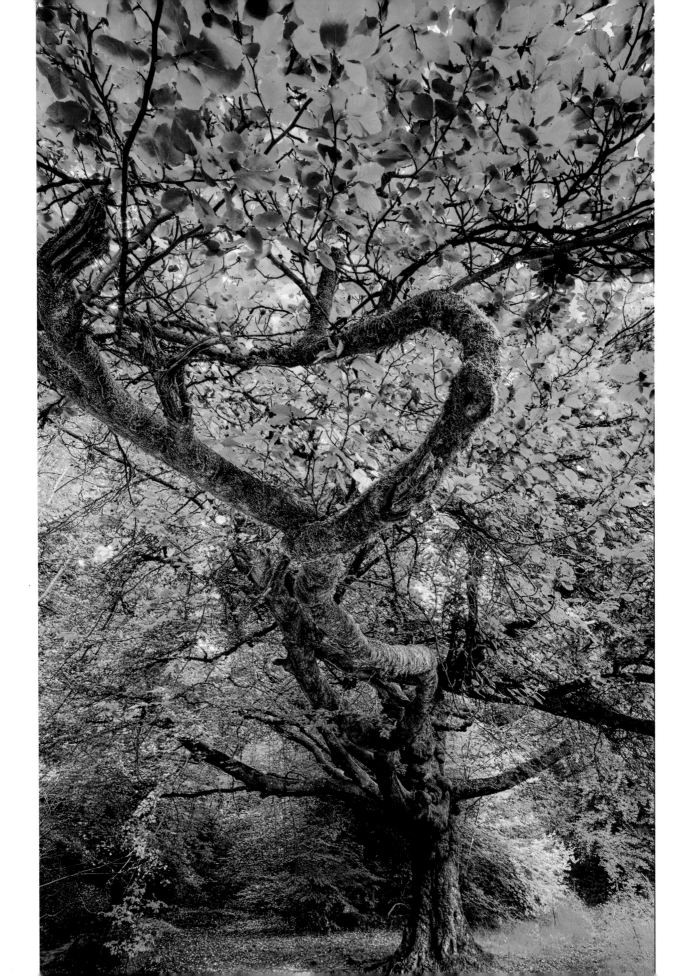

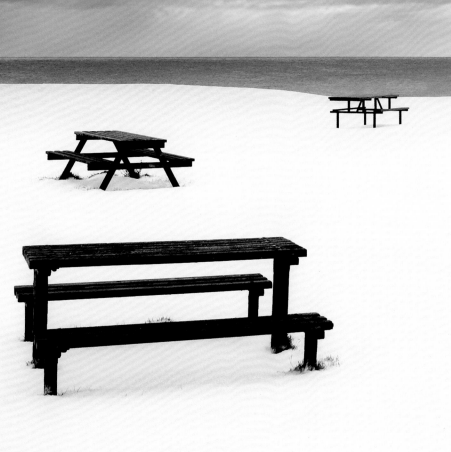

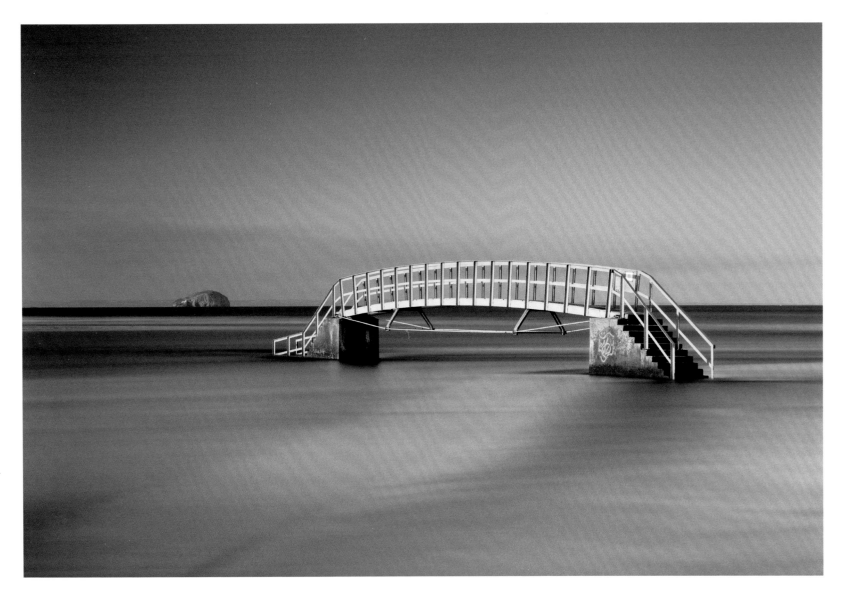

MARK BRADSHAW

Newbiggin-by-the-Sea, Northumberland, England

It was still dark when I arrived at this seaside town on the north east coast and, being so early, the snow was unblemished – not one solitary mark on the scene. The dark wood of the seats made a striking contrast with the whiteness below, but it was their curve, that led to the sea and greyness beyond, that most inspired the picture. It's the sort of image I try to look for and photograph; where the focus is on the ordinary, something most of the time passed by and overlooked. I have been back to the same spot but without the snow it just isn't the same. It gave the seats a chance to be seen. This was their day in the sun.

Judge's choice Charlie Waite

RICHARD JOHNSON

Bass Rock, Dunbar, Scotland

Bass Rock is a volcanic formation over 100m high and home to 150,000 gannets. This image was taken from Belhaven Bay at Dunbar during Spring Tide. A long exposure was used to soften the sea and give the bridge a feeling of isolation.

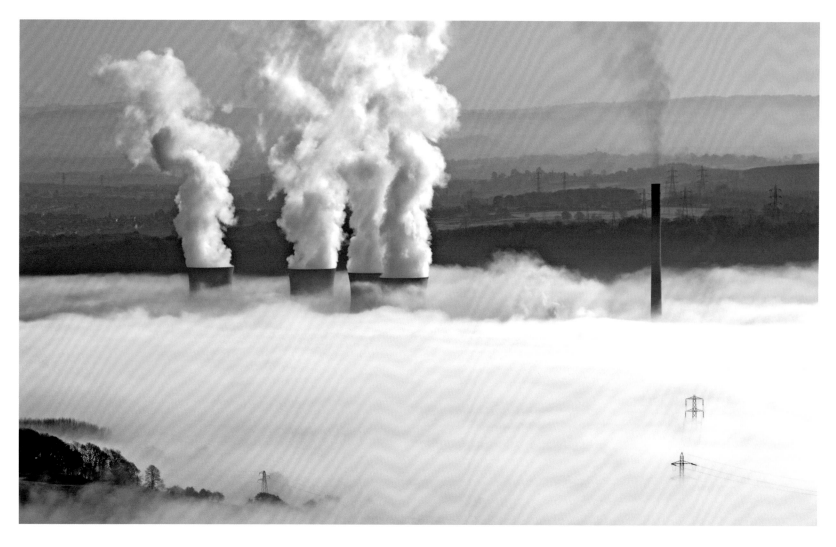

CHRIS LEWIS

Power in the mist, Ironbridge Power Station, Shropshire, England

Ironbridge Power Station stands on the banks of the River Severn in Shropshire, half a mile from the World-famous Iron Bridge. Low-lying mist often accumulates in the river valley during late autumn. On this particular October day, conditions were just perfect to photograph the scene from the nearby Wrekin, which at over 1,300 feet provides an ideal platform above the mist. The mist was constantly moving and at times completely covered the cooling towers. In this particular shot, it almost seems as though the mist is being drawn up from the valley floor and out through the tops of the cooling towers.

Environment Films Ltd
'Britain in our Hands' Award

STEWART MITCHELL ···⟩

Angry seas, Aberdeen, Scotland

At the outer breakwater of Aberdeen Harbour, the waves from the south-easterly, October gale pound the lighthouse in dramatic fashion.

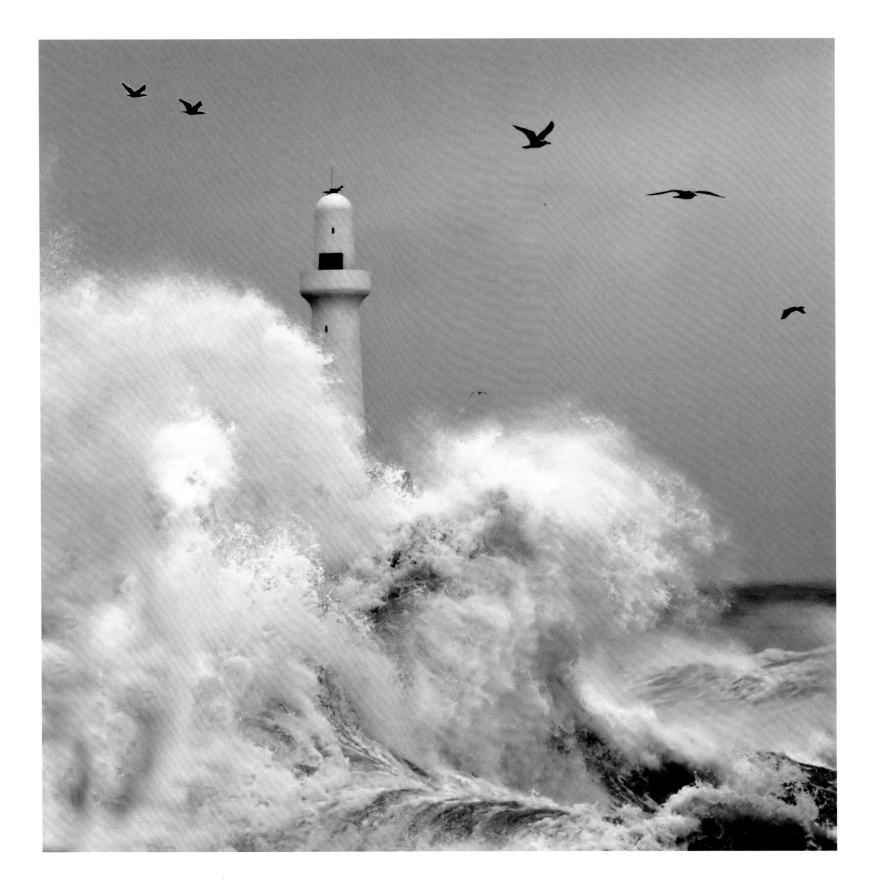

IAN SNOWDON

Heather and rowan, Farndale, North Yorkshire Moors, England

I had visited this spot several times, with the view to capturing this particular image. The lonesome rowan tree and the mimicking shapes of the heather were a dream in the making. After many, weather-related, failed attempts, the (almost) perfect day arrived. Still a bit on the blustery side, but every other element fell into place, beautifully.

JOHN ECCLES

Enjoying the bluebells, Savernake Forest, Wiltshire, England

We were told about this wood in the Savernake Forest where, even though it was May, the bluebells were still in flower, so we took our nine month old Irish Setter for a walk there. He had been running around amongst the flowers and stopped in front of me, giving me the opportunity to get the shot whilst my partner lent against a tree. By using a wide aperture, I was able to focus attention on the dog and keep the background blurred.

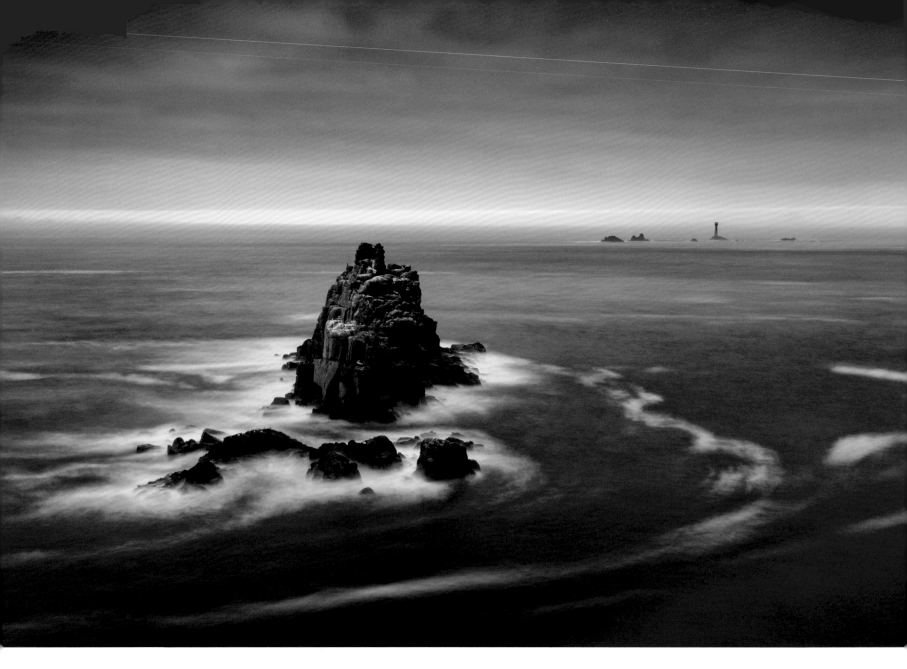

✝ **ADAM BURTON**

The Armed Knight, Land's End, Cornwall, England

Finding a different composition from Land's End is a challenging task. Being an incredibly popular location, the coast here has surely been photographed from just about every angle. When I came upon this view, its simplicity instantly struck me. Resisting my usual temptation to include some cliff in the foreground, I instead chose to feature only the island (The Armed Knight) and Longships Lighthouse in the distance. I used a long exposure to record the water trails encircling the island as swirls of white. Returning home, I felt very pleased to have captured a composition of Land's End that I hadn't seen before.

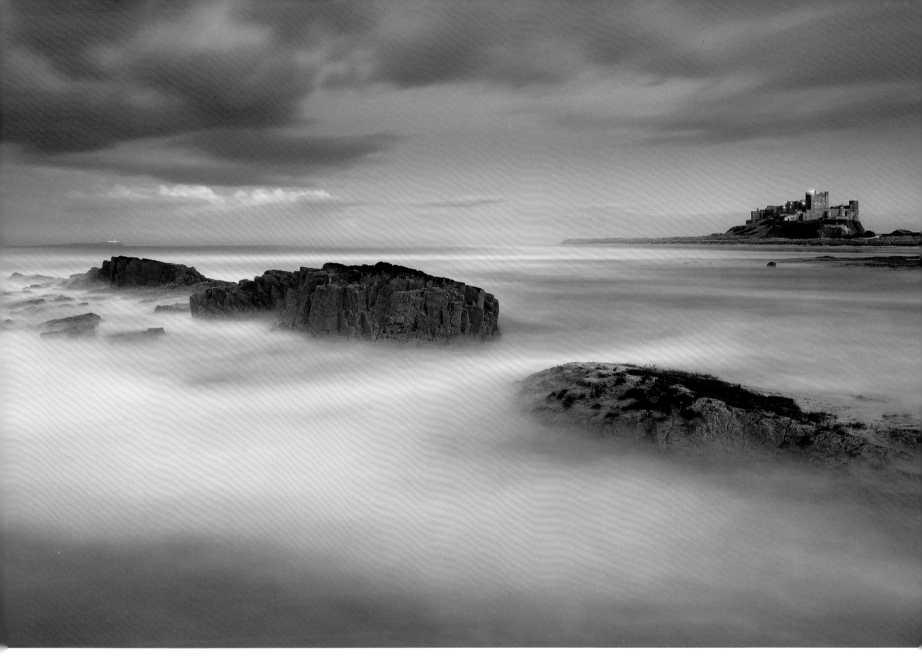

LEE RUDLAND

Bamburgh Castle at dusk, Northumberland, England

My first photographic trip to Northumberland was certainly a hectic one. Too much to shoot in so little time. I decided to stick with the original plan. Bamburgh Castle was top of my list and luckily I was blessed with good light on my first evening in this beautiful county. This shot was my final exposure in a two-hour session. Taken nearly a full hour after sunset, a very long exposure was required to capture the fading light and this helped to convey a sense of mood and drama perfectly fitting for this wonderful location.

☂ WILCO DRAGT

Winter on Rannoch Moor, Scotland

It was the last day of December on Rannoch Moor and was very cold, with grey and dull skies. The lochs were covered with a thick layer of ice. Because of the bleak skies, I decided to look for forms and patterns in the ice. It didn't take long to find this patch of black ice and lovely air bubbles. At first I started using a macro lens, but then switched over to wide angle, with the front of the lens almost touching the ice. I imagined the converging lines of the needle-like tiny bubbles would strengthen the composition. While making the images, I thought about the champagne bubbles that would appear later that evening, celebrating the start of the New Year.

DOUG CHINNERY ⤑

Cloud at Roker, Sunderland, England

So often I carry a rucksack of camera gear and tripod with me, yet on this day while walking my dog, Stan, at Roker in the North East of England, I had just my compact camera in my pocket – I seldom leave the house without it. I was drawn to this single cloud in a pure blue sky over the sea and visualised this image with the cloud centred in the image and a mono conversion simulating a red filter that renders blues as rich blacks. I made several images, despite Stan's boredom, and this was my favourite. Calm, symmetrical, haunting.

Judge's choice John Langley

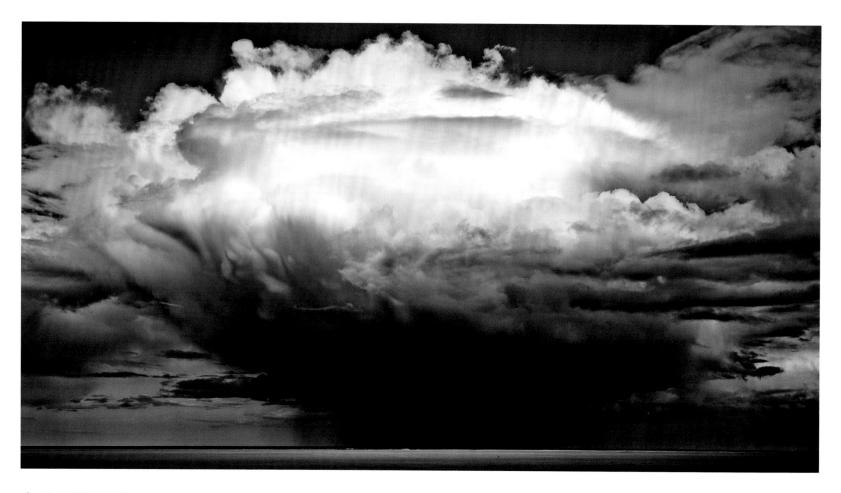

GARY WAIDSON

Incoming Storm, Lindisfarne, Northumberland, England

I was out with my camera on the sands near Jack Mathison's Bank and the weather was lively to say the least. I've always found it amusing how people think of clouds as light, insubstantial things. If you could actually weigh this developing Cumulonimbus, climbing nearly 2,000 feet into the air, it would tip the scales at well over 70,000 tons, 1,500 tons of which is water. The extreme flatness of the tidal sands allowed the cloud to be the true star of this picture. All that was left for me to do was run for cover.

MARK VOCE

La Vallette Bathing Pools, Guernsey, Channel Islands

I had wanted to visit the bathing pools at St. Peter Port for some time. Fortunately, the opportunity presented itself last summer while en route to France. It was surprisingly cool and blustery for a summer's morning, although that didn't deter the die-hard swimmers who kept swimming through the shot. I set up my camera and waited for the tide to lower just enough to start revealing the boundaries of the pool. I then used these and the railings to guide my eye around the pool and through the shot.

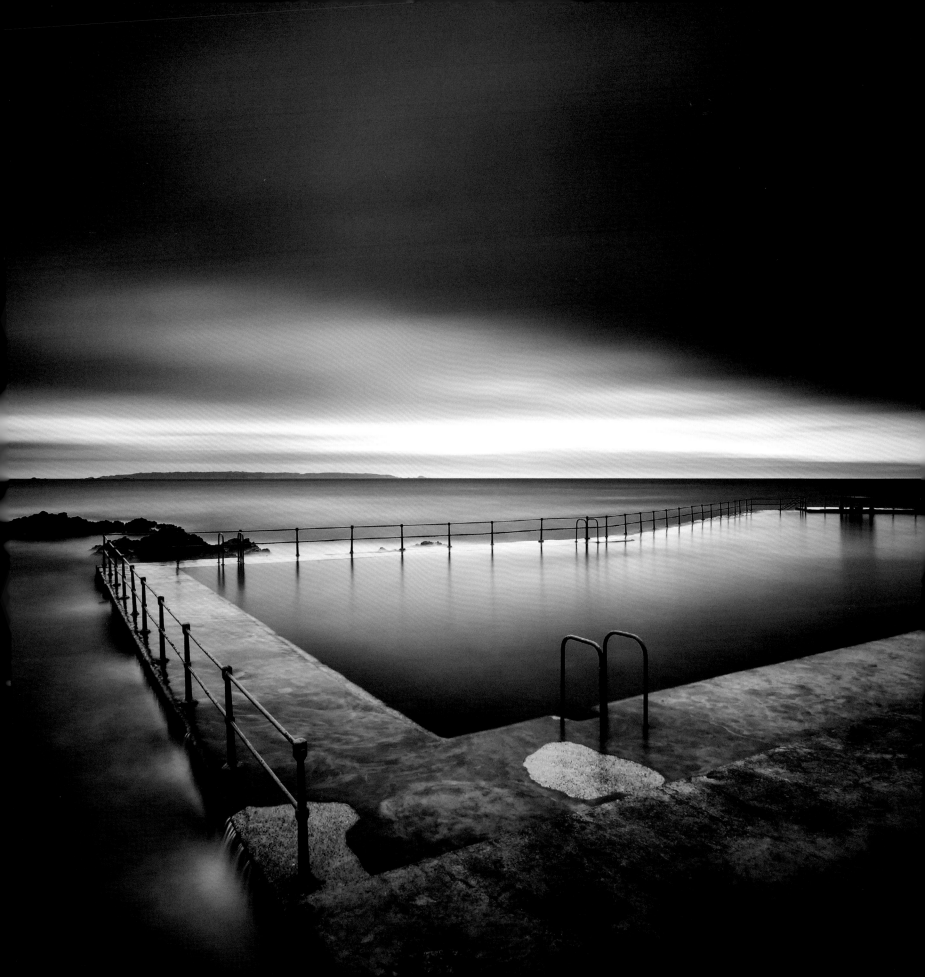

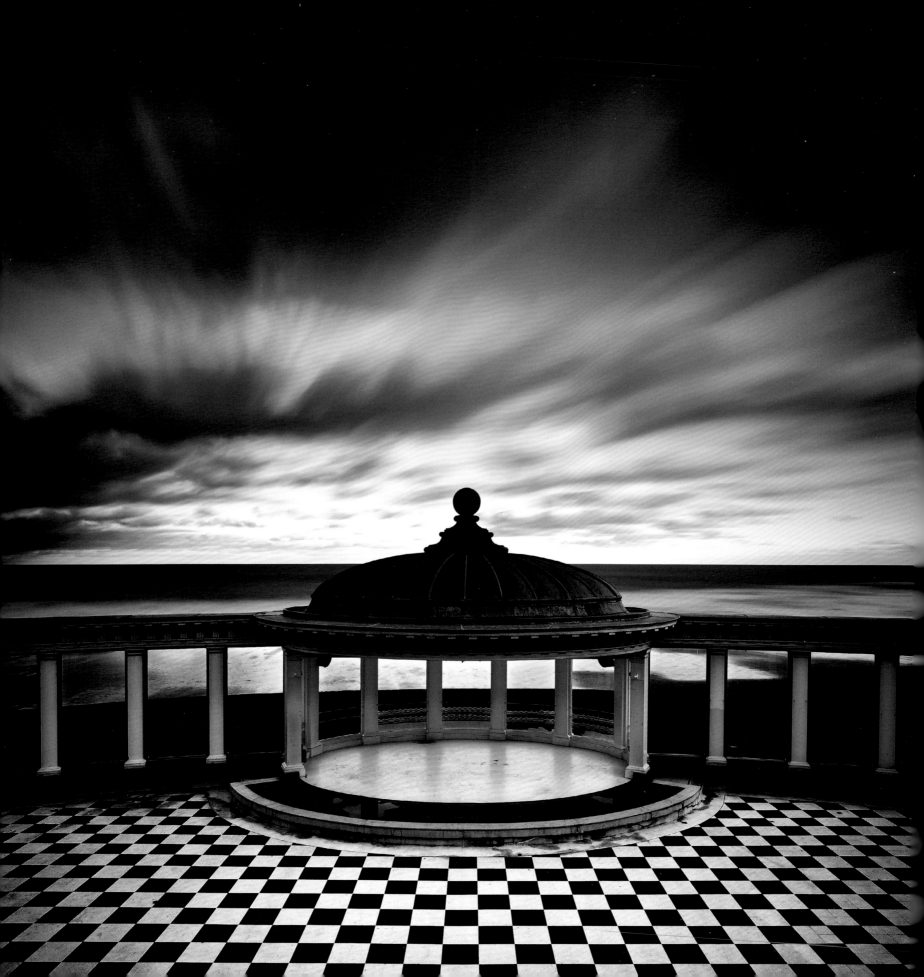

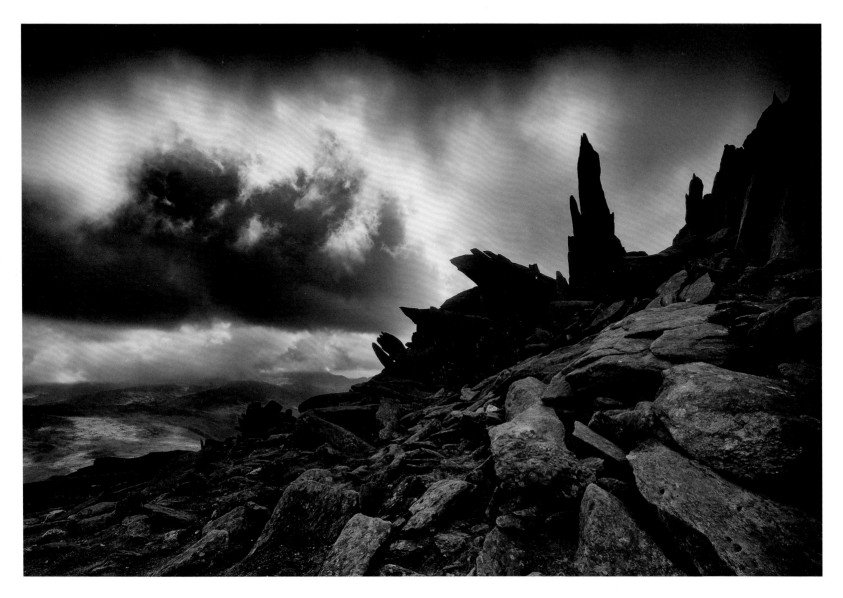

MARK VOCE

Scarborough Spa in winter, North Yorkshire, England

As I arrived at Scarborough Spa, just before sunset, the cloud was starting to thicken and a storm was on its way. I immediately headed to the upper level that allowed me to look down into the Spa complex. The incoming tide was bringing with it more clouds; it felt like the sea and sky were rushing towards the camera. As I set up my shot, I wanted to create a bold, symmetrical composition in the centre of the frame. The fading light led to a long exposure of several minutes, allowing the clouds to blur as they passed overhead.

PAUL ROBINSON

Castell y Gwynt, Glyder Fach, Snowdonia, Wales

The weather on Glyder Fach changed from bright and sunny to dark and overcast in a short space of time and, by the time I reached Castell y Gwynt, conditions felt appropriate for the hostile terrain. I had to react quickly to the changing light and swirling cloud in order to get this shot.

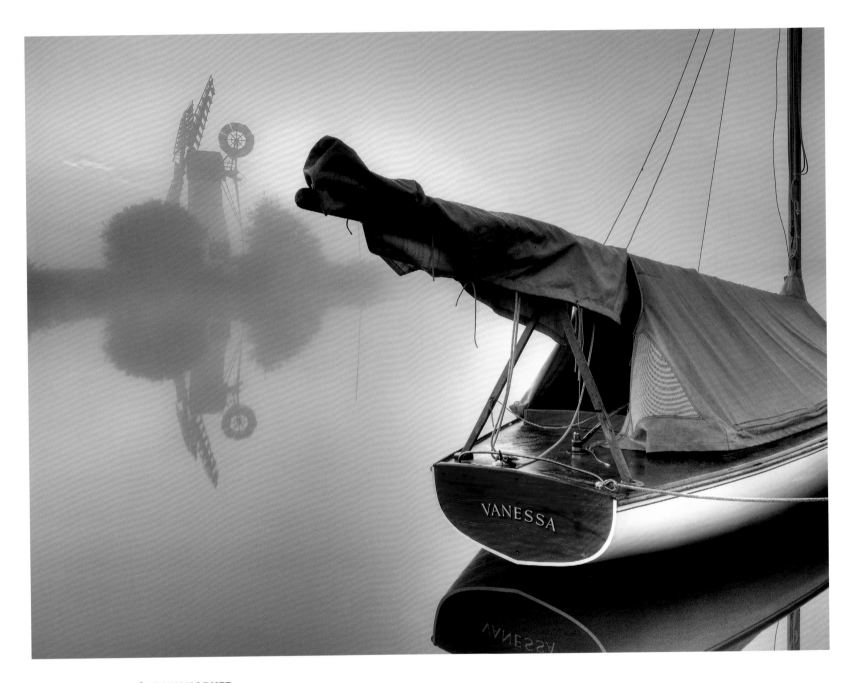

🌿 GARY HORNER

Thurne, Norfolk, England

Early morning mist settling over the River Thurne, in early autumn, with Thurne Wind Pump in the distance and the yacht 'Vanessa' in the foreground.

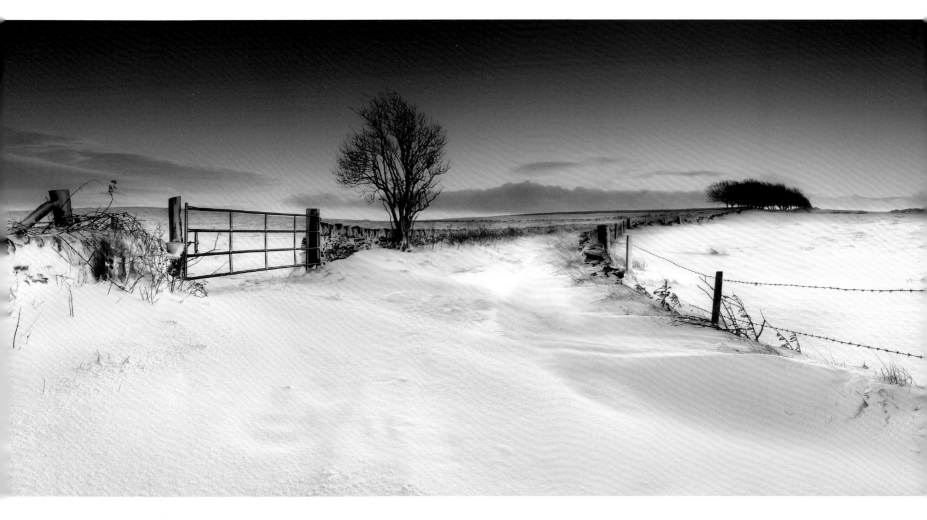

ROBERT BIRKBY

Winter solstice, Halifax, West Yorkshire, England

This photograph was taken at sunrise on 21 December. Heavy overnight snow inspired me to venture out but after driving only a couple of miles the road became impassable. Whilst seeking a scene before the sun got higher, I noticed the textures and patterns in these snowdrifts beside the main road. The gate and pathway seemed to enhance the composition, leading towards the sun. The result was the best photo of the day and my own personal favourite.

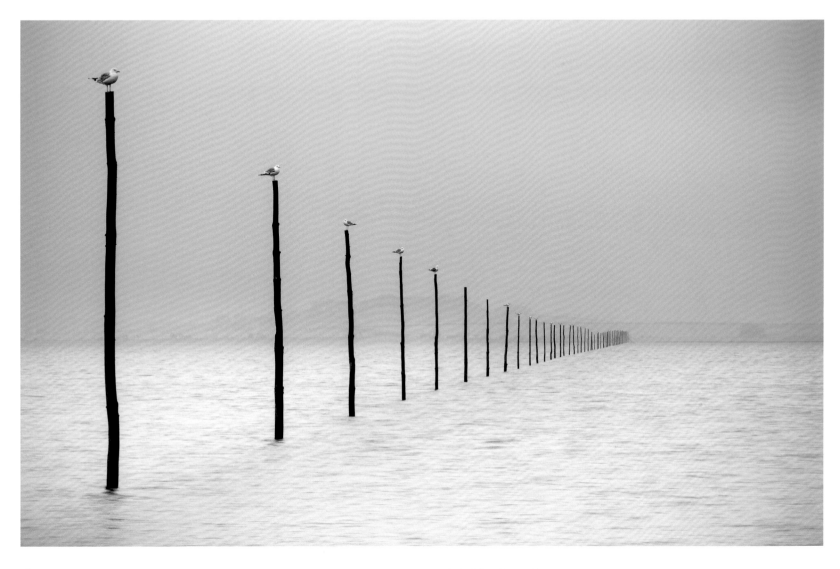

COLIN JARVIS

Pilgrim's Way, Northumberland, England

To me, this image encapsulates the meditative aspect of the pilgrimage to Holy Island using the ancient Pilgrim's Way. It was taken on a very peaceful, still morning in August at around 7am. The roosting seagulls contribute to the peacefulness of the scene and I liked the fact that some of the posts were vacant as I felt this suggested the imperfection of the human spirit.

JAMES OSMOND ···⟩

Pylons in the Marshwood Vale, Dorset, England

There is a peculiar satisfaction to be found in capturing the beauty hidden in something traditionally thought of as an eyesore.

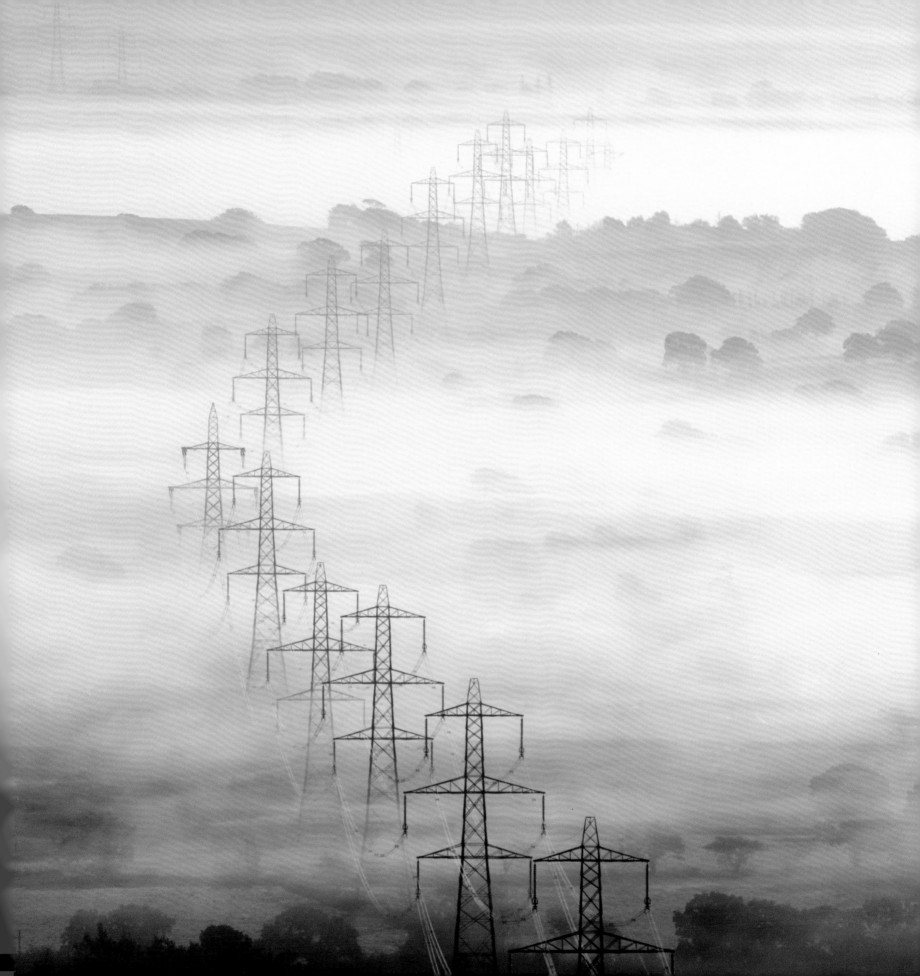

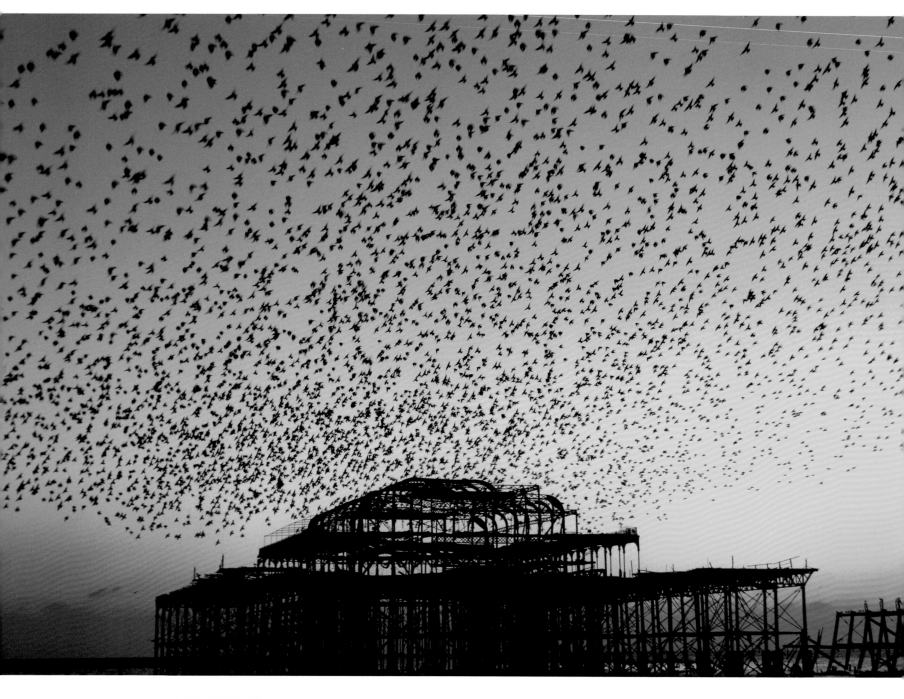

ROSLIN ZUHA

Brighton starlings, East Sussex, England

On an autumn evening along Brighton beach, I was fortunate enough to have my camera with me when the starlings put on the most impressive aerial acrobatic display I have ever seen. The entire sky was filled with birds performing an incredible sunset dance over the decaying West Pier. It was a magical moment that I will always remember.

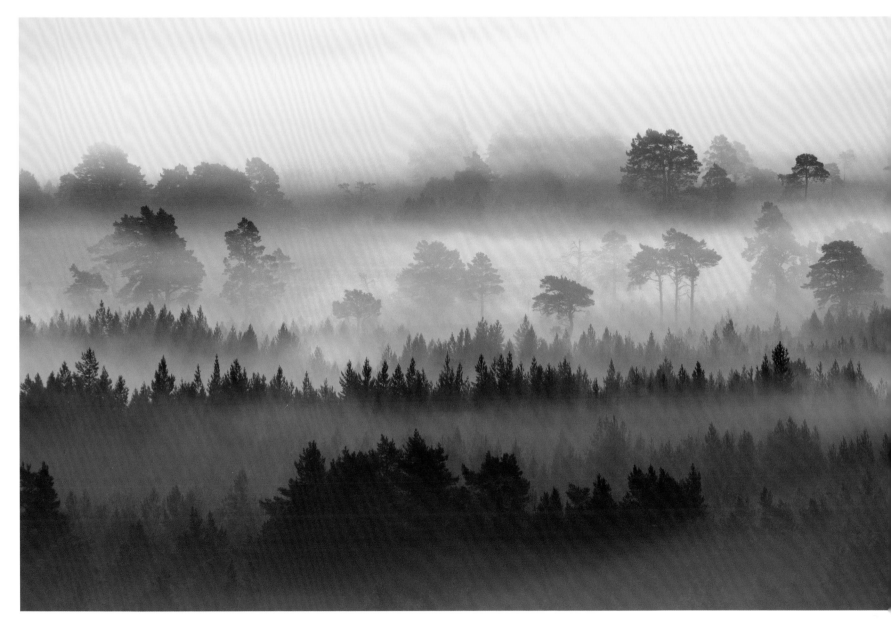

🌲 PETER CAIRNS

Caledonian Forest at dawn, Cairngorms National Park, Scotland

The fragmented islands of 'The Great Wood' stand as a reminder of a forest that once covered most of Scotland. These pines, some of which are 400 years old, would have stood when wild wolves walked beneath them. Here, at Rothiemurchus and elsewhere, the forest is being invited to return.

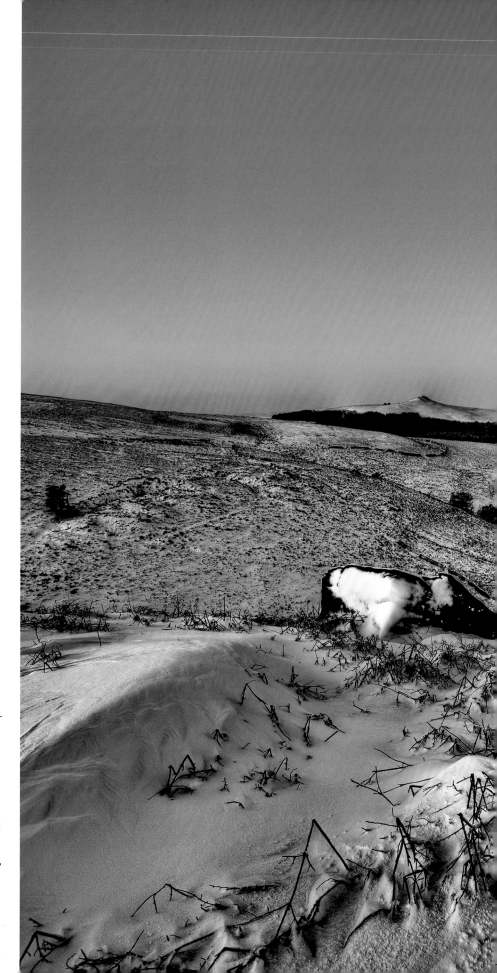

ADRIAN ASHWORTH ⋯⟩

Hordron rainbow, Derbyshire, England

The image was taken in early January at Hordron Edge in the Peak District. It was a late sunrise at 8.18am, although I'd taken an hour and a half to make it to the top, as the snow was three feet deep in places. The shot looks down towards Ladybower Reservoir and has the moon going down in the distance as the sun gave this amazing reflective colour in the sky and surrounding hills. Three shots later, my camera fell over in the snowdrift and that was my morning's work, and pleasure, finished. A warm mug of Bovril and two hours careful cleaning and I was ready to go again.

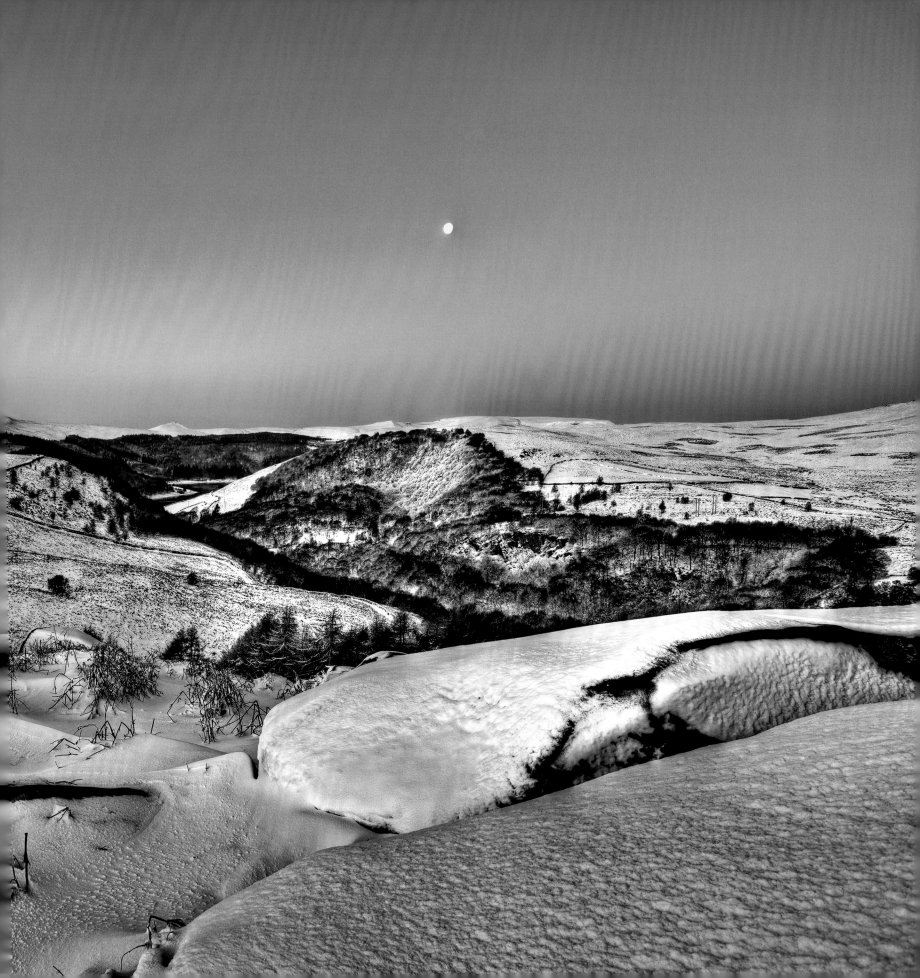

YOUR VIEW
youth class

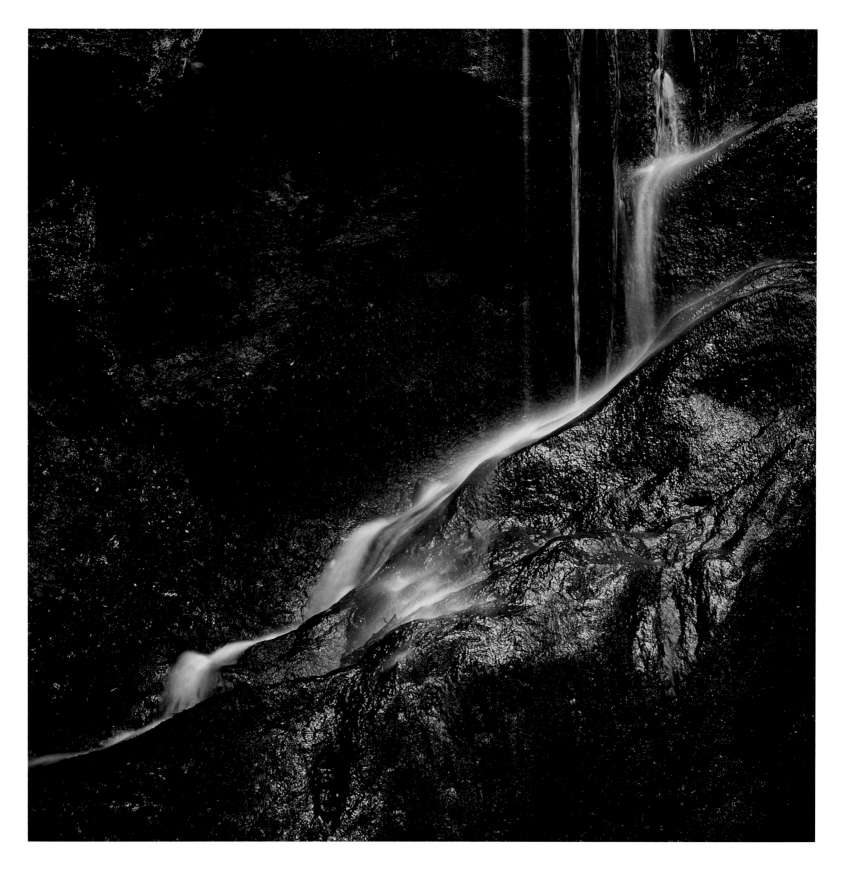

YOUR VIEW YOUTH CLASS WINNER

···> **WILLIAM LEE**

Roughting Linn, Northumberland, England

This photograph was taken at Roughting Linn waterfall, whilst on a photographic weekend with Smethwick Photographic Society. I thoroughly enjoyed the weekend, which included a trip out to the Farne Islands.

JAMIE UNWIN ···> HIGHLY COMMENDED

A small stream near where I live, Oxfordshire, England

I had awoken early wanting to take photos of the sunrise but unsure of what exactly to include. I set off on my bike at 4am, whilst it was still dark and decided to head to Otmoor, only a brisk ten-minute cycle away. Once there, I cycled along a small track, which was bordered by a wall of frosted trees, surrounded by fields and fields covered in thick ice. The sun was just breaking through so, thinking I had to act quickly, I decided to see whether the stream was a possibility. To my surprise the stream was not frozen solid, but still flowing through the bleak countryside. Just before the sun disappeared behind a cloud I took this photo.

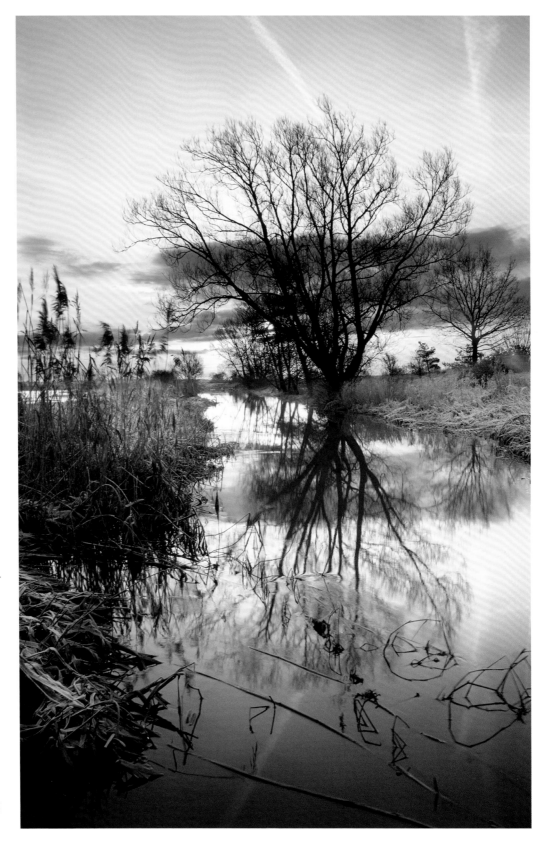

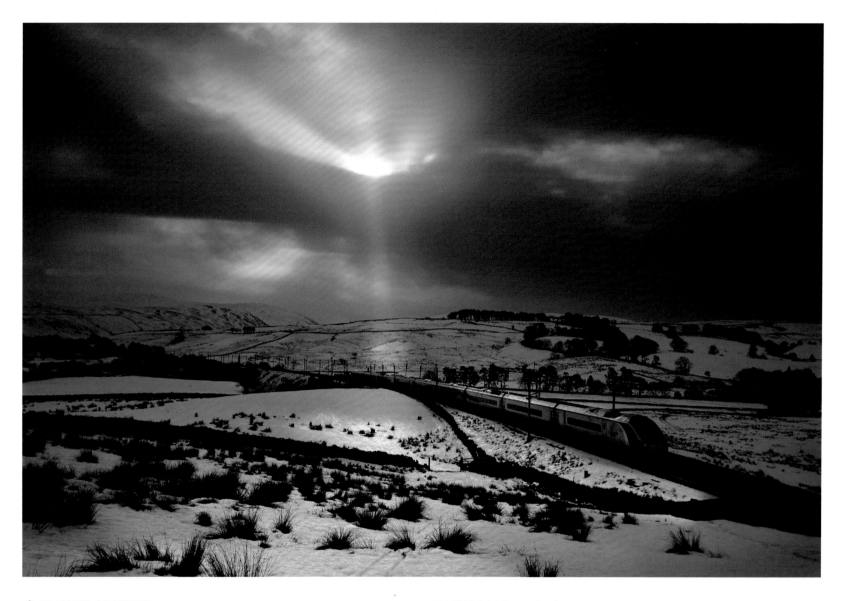

TALIESIN COOMBES

Sunlight on Shap, Cumbria

The climb up to Shap Summit in Cumbria is one of the famous railway gradients and a great challenge to trains travelling north to Carlisle and Scotland. With snow on the ground and a biting wind, I was waiting for a northbound steam special, in late December, when this dramatic lighting appeared; sadly not at the time of the steam special but, fortunately, as compensation, when a southbound Pendolino tilting electric train passed en route to London.

TALIESIN COOMBES

Travelling, Machynlleth, Wales

I wanted to capture, in a timeless way, the beginning of a journey. The opportunity presented itself at Machynlleth Railway station on the last day of the summer steam services on the Cambrian Line. Despite being August, the weather was grey and wet so, rather than focus on the train, I took a close up of the leather travel bag with the engine in the background. As there is little to fix the time or place, it allows the viewer to have their own ideas as to who was travelling, where to and the reason for their journey.

Judge's choice Damien Demolder

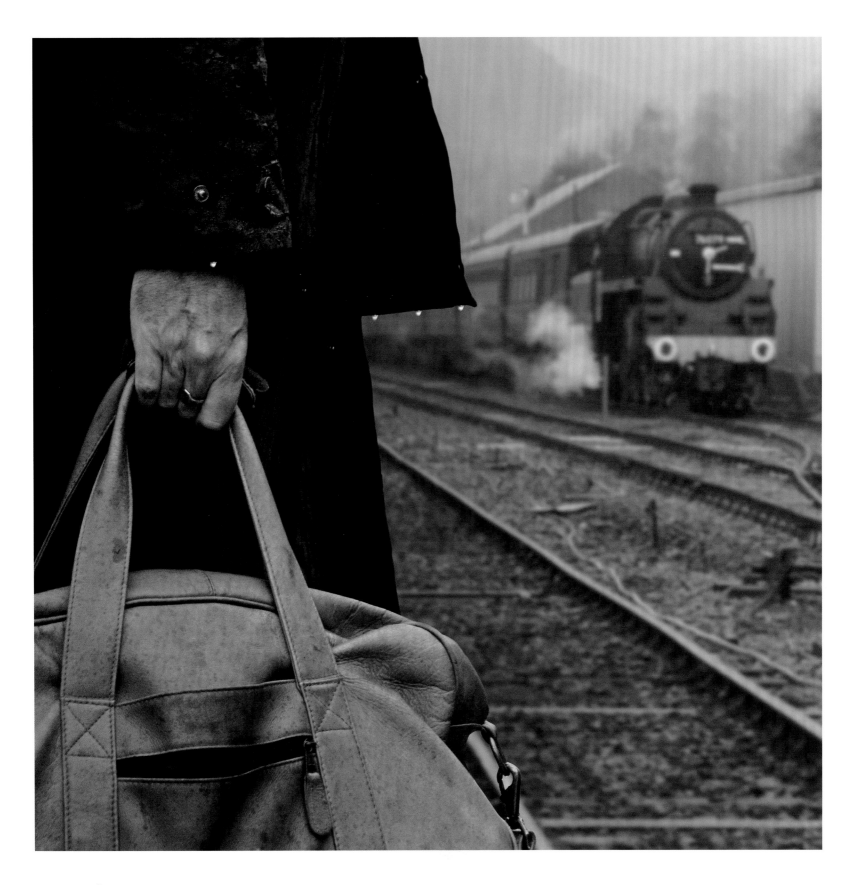

BRIAN CLARK (p.3)
Nikon D2x with 12-24mm at 12mm. 1/20 sec @ f22, ISO100. 2 stop + 3 stop ND graduated filters, tripod.

JAMES OSMOND (p.5)
Canon EOS 5D with 17-35mm lens @ 24mm, 1/8sec @ f/22, ISO100.

MIKE KEMPSEY (p.13)
Canon EOS 30D with 17-40mm lens @ 17mm; Lee Filter System. 1/125th, f/8, ISO100.

ANTONY SPENCER (p.16)
Canon EOS 5D MkII, 17-40L @ 0.8 sec, f.8, ISO50

TALIESIN COOMBES (p.19)
Nikon D300 18-200mm lens @ 26mm. 1/250 sec @ f/7.1, ISO200. Fill-in flash.

CHRIS HOWE (p.21)
Canon EOS 1Ds MkII with 24-70mm @ 70mm; 6 secs @ f/14, ISO 200. Second 1 sec exposure for sky. Processed in Adobe Lightroom & two exposures merged in Adobe Photoshop CS3.

SŁAWEK STASZCZUK (pp.22–23)
Canon EOS 5D MkII with Sigma 100-300mm @ 300mm, 1/320 sec, f/8, ISO400, tripod.

DUDLEY WILLIAMS (p.27)
Nikon D3, 17mm, 8s @ f/16, ISO100. RAW file processed in Adobe Lightroom. Very minor global adjustments to contrast, clarity and sharpening only.

MARSHALL PINSENT (pp.28–29)
Nikon D70. Sigma 10-20mm @ f/8. Blend of 3 bracketed exposures.

MARCUS McADAM (p.30)
Canon EOS 5D MkII, 17-40mm f/4 lens at 20mm. f/20 at 0.6 secs. Gitzo Tripod. Lee 0.9 ND Grad to hold back sky. Warm clothes! With exception to a slight levels adjustment, this image is not manipulated.

SERGEY LEKOMTSEV (p.31)
Canon EOS 400D. Peleng fisheye lens @ 8mm. HDR technology.

DUDLEY WILLIAMS (p.32)
Nikon D3, 20mm, 8s at f/14. RAW file with minimal adjustment to contrast, brightness and blacks in Adobe Lightroom only.

DAVE PECK (p.33)
Canon EOS 7D, Sigma 10-20mm @ 10mm. f/11 @ 1/20 sec, ISO100. Aperture priority. RAW file converted in Capture One and sharpened in Adobe Photoshop.

JEANETTE LAZENBY (p.34)
Canon EOS 30D with EFS 10-22mm Lens. Circular polariser, graduated filter, tripod, cable release and mirror lock-up used.

JIM PARREN (p.35)
Olympus E620 + Zuiko 9-18mm at 10mm. ISO 100, f/22, 3.2 secs. Hitech reverse 3-stop ND grad over sky, Lee 2 stop ND grad inverted over foreground. Rendered with Capture One. S curve applied and sharpened.

DAVID PULFORD (p.36)
Nikon D3 with 24-70 AFS 2.8 lens. Lee 0.6 Graduated ND Filter. Mirror lock up. Cable release. Some adjustment to levels and colour saturation and dodging of lighthouse in Adobe Photoshop Elements.

KRZYSZTOF NOWAKOWSKI (p.37)
Canon EOS 5D MkII + EF 17-40mm f4/L @ 17mm, 1 sec @ f/20, ISO50. Converted to B&W in Adobe Photoshop.

ANTONY SPENCER (pp.38–39)
Canon EOS 5D MkII with 17-40L. 6 secs @ f/11, ISO100.

MATT WHORLOW (p.40)
Canon EOS 5D MkII, with Canon 24-105 f/4L lens (at 24mm). Lee 0.9 ND grad 1/4 sec at f/16, ISO100. Minor curves adjustment.

JOHN ROBINSON (p.41)
Nikon D3x with Nikkor 24mm PCE (Tilt Shift) lens. Lee 2+3 stop ND graduated filters.

KEVIN SKINNER (p.42)
Canon EOS 5D MkII with EF 100-400mm f/4.5-5.6L IS USM, 1/160 sec @ f/14, ISO100. Processed in Photoshop CS2.

ADAM EDWARDS (p.43)
Canon EOS 40D with Tamron 28-75 lens, 1/8 sec @ f/5.6, ISO160. Square crop in camera RAW. Levels, curves, shadows/highlights adjustments and B&W conversion applied in Adobe Photoshop.

FORTUNATO GATTO (p.44)
Canon EOS 5D MkII with 17-40mm @ 19mm, f/18, 30 secs @ ISO50, Polariser, Tripod, Remote Control. Single exposure. Singh Ray Filter NDG 0.6 Reverse to balance the exposure and a ND 0.9 to catch most of light shades. Levels & saturation adjusted in Adobe Photoshop.

PETER RIBBECK (p.45)
Nikon D300 with Tokina 11-16mm lens @ 11mm, f/20, ISO200. This is a vertorama (two shots manually stitched one above the other to give a vertical panorama).

FORTUNATO GATTO (p.46)
Canon EOS 5D MkII, Canon 17-40mm, 28mm, f/16, 0.5 sec, ISO 100, Lee Filter NDG 0.6 Hard, Tripod, Remote Control. Single exposure, no HDR or blending. Saturation & levels adjusted in Adobe Photoshop.

COLIN GRACE (p.47)
Nikon D200 with Nikkor 18-70mm @ 38mm. 0.8 seconds @ f/16. RAW format converted in Adobe Lightroom and adjusted in Photoshop. Slight cropping; levels & curves to add contrast; shadows and highlights tool to bring out some detail under bridge.

JON PEAR (p.48)
Nikon D2xs with a Nikkor AFS 70-300mm VR lens. 1/640th at f8, ISO200. Minimal adjustments in Adobe Photoshop CS3.

DAMIAN SHIELDS (p.49)
Fuji S3 Pro on a tripod. 1.5 secs @ f/22. ISO100. Four exposures combined.

ALEX NAIL (p.50)
Canon EOS 5D, 17-40 f/4L, 1/8-1/30th, f/11, ISO100.

STEPHEN EMERSON (p.51)
Canon EOS 5D with EF 17-40mm. 1/25 sec, f/13, ISO50, 0.9 ND Grad filter.

CHRIS CLOSE (pp.52–53)
6x17 Art Panorama, 90mm f5.6 Nikkor Lens, Fuji Provia 100.

EMMANUEL COUPE (p.54)
Canon EOS 1Ds, 17-40L @ 17mm. f/16, long exposure.

KARL WILLIAMS (p.55)
Canon EOS 450D, Sigma 10-20mm f4-5.6 zoom @ 10mm, 3 exp HDR (-2EV, 0EV, +2EV); middle exposure: 1/250 sec @ f/8; post-processing in Photomatix and Photoshop CS4.

DAMIAN SHIELDS (p.56)
Fuji S3 Pro on tripod, 1/125 sec @ f/8, ISO100. Three separate shots.

PAUL KNIGHT (p.57)
Canon EOS 5D with EF 28-105mm @ 38mm, 1/160 sec @ f/11.

PAUL FORGHAM (p.58)
Canon EOS 40D with EF-S 10-22mm USM @ 10mm, f/9.0, 0.6 Lee ND Soft Grad, 1/160 sec, ISO200. Manfrotto Tripod. Adjustments to saturation and levels in Adobe Photoshop plus selective dodge, burn and sharpening.

WAYNE BRITTLE (p.59)
Canon EOS 5D MkII, 17-40mm 'L' Series Lens, ISO100 plus a Manfrotto Tripod. Main Exposure: 1/20 sec @ f/11. With 2 more exposures made at plus and minus 2 stops either side of recommended exposure.

PAUL SANSOME (p.60)
Canon EOS 5D MkII with 24-70mm lens @ 24m. Lee ND 0.6 Graduated filter. ISO 200, f/10, 15 secs. Manfrotto tripod.

NICOLA HARKNESS (p.61)
Canon EOS 5D @ 24mm, f/4.0, 6 secs.

ADAM EDWARDS (p.62)
Canon EOS 5D MkII with Sigma 12-24 lens @ f/22. Manual blend of 2 exposures to maximise detail in both sky and foreground. Levels, curves and selective colour adjustments applied in Photoshop.

MARTIN CHAMBERLAIN (p.63)
Canon EOS 40D with EF-S 10-22mm lens @ 13mm. 1 sec, f/13, ISO 100. Tripod. Processed from RAW file in Adobe Lightroom, local tonal adjustments and sharpening in Adobe Photoshop.

JIM GROVER (p.64)
Canon EOS 1Ds MkIII with 70-200 f/2.8L @85mm, f/2.8, 1/40 sec, ISO 100. Tripod. Selective contrast added to the tree lines and shadows enhanced. Processed in Aperture.

DAVID CLAPP (p.65)
Canon EOS 1Ds MkIII with 300mm lens, f/2.8 + 2xII Converter. 1/60 sec @ f11.

DIMITRI VASILIOU (p.66)
Mamiya 67 Pro II, 110mm Mamiya lens, Fuji Velvia 50 film, 1/2 sec @ f/22.

GRAHAM DUNN (p.67)
Canon EOS 5D MkII with 24-105mm lens, 1/4 sec at f/14, ISO125. Polarising & ND graduated filters. Processed using Adobe Lightroom & Photoshop CS3 (contrast & saturation adjusted and dust spots removed).

NEIL MacGREGOR (p.68)
Nikon D700, Nikkor 17-35 f/2.8D AFS lens @ 20mm, 2 secs @ f/16. 0.6ND Grad. Tripod. RAW file processed in NX2. Curves/levels adjustments in Adobe Photoshop.

ALESSIO BOZZO (p.69)
Nikon D80 with 18-35mm lens @ 23mm, ISO100, 4s, f/8.

GLENN HARPER (p.70)
Mamiya RZ67 with 50mm lens, Velvia 100F, Nikon Coolscan adjusted in Adobe Photoshop CS3.

IAN THORNE (p.71)
Nikon D300; 1/13 sec at f/16, ISO500.

DAMIAN SHIELDS (pp.72–73)
Tripod mounted Fuji S3 Pro 1/250 sec @ F3.5-22, ISO100 and composed of 15 separate shots.

ANTHONY BLAKE (p.74)
Canon EOS 5D with 70-200L IS 2.8 lens @ 120mm. Tripod, remote shutter release using mirror lock-up. ISO50, f/16, 0.8 sec, Lee 0.6ND Grad, Heliopan Circ Polariser. RAW image processed in Adobe Lightroom.

MARTIN EDGE (p.75)
Nikon D300 with 17-35mm lens @ 26mm. ISO200, Auto WB, F/8 at 1/90 sec with a .9 Hard Graduated Lee filter. Minimal use of Recovery tool in Adobe Lightroom 2.

THOMAS GRAHAM (p.76)
Nikon D200 with Tokina 12-24 F4 at f/11, ISO100, bracketed and HDR, curves and sharpening applied.

THOMAS GORMAN (p.77)
Pentax 67II Medium Format Film Camera, Fujifilm Velvia 50, 55 - 100 mm lens, 0.3ND Graduated filter. 1/13 sec @ f11, ISo 50.

JAMIE RUSSELL (p.78)
Nikon D300 with Sigma 17-70mm f/2.8-4.5 Macro DC lens @ 40mm. 26 sec, f/3.8, ISO200. RAW converted to TIFF in Adobe Lightroom with white balance corrected, slight adjustment to contrast, and selective noise removed.

GARY WAIDSON (p.79)
Canon EOS 5D, EF75-300mm f/4-5.6 @ 300mm. ISO100, f/22, 1.3 secs. Tripod mounted. Spotting and local contrast control.

DUDLEY WILLIAMS (p.80)
Nikon D3 with 29mm, 5:4 crop, 2secs @ f/16, ISO100. RAW file processed in Adobe Lightroom with just minor global adjustments to brightness and contrast. White balance set to daylight.

DAVID KENDAL (p.81)
Canon 5D MkII with EF 17-40 f/4L, Lee ND Grad filter. RAW Image converted via Canon DPP then finished in Photoshop (checked WB, straightened horizon, adjusted curves, adjusted saturation, sharpened).

ROB CHERRY (p.82)
Nikon D90 with Sigma 10-20mm @ 20mm, B&W ND filter 110, 111 secs @ f/10, ISO200. Converted to black & white in Photoshop CS4.

TRISTAN CAMPBELL (p.83)
Ebony RSW45 with Schneider 47mm XL lens. Fuji Pro160c film.

ADRIAN HALL (p.84)
Canon EOS 400D with 10-22mm lens @ 10mm, 0.4 sec @ f/11, ISO100.

STEVE SHARP (p.85)
Canon EOS 1Ds MkII with 16-35mm lens, 4-stop ND grad (soft) Adjustments to levels, curves & USM.

BRIAN CLARK (p.86)
Nikon D2X with 12-24mm at 18mm. 1/8 sec @ f/11, polarising filter (partly polarised), 2 stop ND graduated filter, tripod.

GRAHAM COLLING (p.87)
Nikon D700 with 18-35mm f/3.5-4.5 Nikon Lens, 0.6 ND Graduated Filter. 5 exposure HDR combined in Photomatix, f/16 from 1/15 sec to 1 sec at 1 stop intervals.

SŁAWEK STASZCZUK (p.88)
Canon EOS 350D with Sigma 100-300mm @ 100mm, 1/125 sec, f/8, ISO100, tripod, remote.

WILLIAM LEE (p.93)
Canon EOS 300D with Sigma 10-20mm lens. 1/800 sec @ f/5.6, ISO200. Adobe Photoshop CS4 for conversion to B&W plus dodge and burn tools.

TALIESIN COOMBES (p.94)
Nikon D300 with 18-200mm lens @ 32mm. Shutter priority, f/9, ISO200.

ALIXANNE HUCKER (p.95)
Samsung Digimax D73.

SAM CAIRNS (p.96)
Canon EOS 1Ds MkII with EF 24-105mm lens. 0.4 sec @ f/16, ISO50. Gitzo tripod.

TALIESIN COOMBES (p.97)
Nikon D300 with 18-200mm lens @ 65mm. 1/500 sec @ f/6.3, ISO640. Contrast added.

JON BROOK (pp.100–101)
Canon EOS 5D MkII with 24-105mm @ 24mm. f/8, 1/60 sec, ISO200. Minor adjustments to levels & cropping in Adobe Photoshop.

JONATHAN LUCAS (p.102)
Canon EOS 20D with EFS 10-22mm @ 10mm. f/19, 1/10 sec, ISO400.

WILFRIED BANCHEREAU (p.103)
Canon EOS 40D with 10-22mm lens. f/3.5, ISO100, HDR of three shots at 1/200, 1/50, 1/13 sec blended with Photomatix. Gorillapod.

STEPHEN GARNETT (p.104)
Canon EOS 1D MkII with 16-35mm lens @ 31mm. 1/250 sec @ f/8. General adjustments in Adobe Photoshop - selective colour and hue/saturation.

STEPHEN GARNETT (p.105)
Canon EOS 1D MkII with 70-210mm lens. 1/500 sec @ f/2.8. Adjustments to levels in Adobe Photoshop but no other manipulation.

DAVID WILLIAMSON (p.106)
Canon EOS 5D MkII with EF70-200mm f/2.8L IS USM @ 195mm. 1/1000 sec at f/2.8, ISO100. Edited in Adobe Lightroom. Clarity reduced to soften the background.

CEDRIC DELVES (p.107)
Leica M9, 21mm Elmarit lens, 1/2000 sec @ f/8, ISO160.

ANDREW FOX (p.108)
Canon EOS 5D with 70-200mm lens @ 70mm. 1/1000 sec @ f/3.2, ISO160.

RHYS DAVIES (p.109)
Canon EOS 5D MkII with EF16-35mm f/2.8L II USM lens with Cokin soft Grad ND8 + ND4 filters. 1/250 sec @ f/8, ISO100. Local contrast & exposure adjustments and sharpening.

ANDREW DUNN (p.110)
Canon EOS 350D with EFS 18-55mm lens.

DAN LAW (p.111)
Nikon D80 @ 600mm. 1/4000 sec, f/4.0, ISO125.

JONATHAN LUCAS (p.112)
Canon EOS 5D MkII with EF 15mm f2.8 fisheye, 6 secs @ f/4, ISO100.

BOB McCALLION (p.113)
Olympus E410 with Zuiko 50-200 SWD lens, 1/25 sec, f/14, ISO200, tripod. Brightness, contrast and sharpness levels adjusted in Olympus Master 2 software.

STEPHEN GARNETT (p.114)
Canon EOS 1D MkII with 170-210mm lens. 1/500 sec @ f/2.8. Off-camera flash lighting subject from the right. General adjustments in Adobe Photoshop to selective colour and hue/saturation.

KEITH EVERY (p.115)
Nikon D300. Aperture priority, 1/80 sec @ f/16. Levels adjustment and sharpening.

KRZYSZTOF LIGEZA (p.116)
Nikon D300 with Sigma 10-20 @10mm, 1/30 sec @ f/13. ND grad 0.6. Adjustments to colour, contrast (levels) plus distortion corrections; cropping and sharpening.

ROBERT BIRKBY (p.117)
Canon EOS 5D with 25-105mm lens at 50mm. 1/60 sec @ f/5, ISO400, polariser, handheld. Mild gaussian blur effect added in Adobe Photoshop plus slight adjustments to saturation and crop.

JACQUIE WILKES (p.118)
Fuji Finepix S9600. 1/170 sec @ f/6.4, ISO200. Slight adjustments to curves, levels and saturation.

CHRIS FRIEL (p.119)
Canon EOS 5D MkII with 45mm tilt shift lens. In camera B&W jpeg with minimal editing.

TATIANA ZIGAR (p.120)
Canon EOS 400D with EF 50mm f/1.8 lens. 1/60 sec @ f/2.2. Converted to B&W.

CHRIS CONWAY (p.121)
Canon EOS 400D with Tokina 28-70 lens. 1/160 sec @ f/8, ISO400. Auto white balance, multi pattern metering.

ALEX VAREY (p.122)
Canon EOS 40D with 17-85mm EF-S lens at 56mm, 1/250 sec, f/8, ISO100. Conversion to monochrome in Adobe Lightroom, with selective colour desaturation, similar to red filter effect.

TIM MORLAND (p.123)
Nikon D700 @ 180mm. 1/800sec @ f/8, ISO200.

GARY TELFORD (p.124)
Sony Alpha 700 with Minolta 50mm f1.7 lens. 1/800 sec @ f/11, ISO200. Converted to mono in Adobe Photoshop with cool tone applied to shadows.

STEPHEN GARNETT (p.125)
Canon EOS 1D MkII with 16-35mm lens. 1/250 sec @ f/11. Off-camera flash lighting subject from the right. General adjustments in Adobe Photoshop to selective colour and levels.

TALIESIN COOMBES (p.128)
Nikon D300 with 18-200mm @ 27mm. Shutter priority, f/4, ISO400.

CHRISTOPHER RUSSELL (p.129)
Nikon D80 with Tamron SP90. f/10, ISO500. Sharpened in Adobe Photoshop CS4.

JAMIE UNWIN (p.130)
Sony A350, Sigma 18-125mm f3.5-5.6. Minor adjustments to curves.

WILLIAM LEE (p.131)
Canon EOS 300D with EF 28-90mm, 1/30 sec @ f/22, ISO200.

DARREN CIOLLI-LEACH (pp.134–135)
Canon EOS 1Ds MkII with 17-40mm L series lens @ 23mm. 1/3 sec @ f/22 (aperture priority). Perspective correction in Adobe Photoshop.

DAVID STANTON (p.136)
Canon EOS 1Ds MkIII. 30 secs @ f8.

MATTHEW CHEETHAM (p.137)
Canon EOS 5D MkII with a 16-35mm 2.8L lens. Post-capture colour correction and selective brightening.

ANDREW WHITAKER (p.138)
Canon EOS 5D MkII with 70-300mm @ 300mm, 5 secs, f22, ISO100. Conversion from RAW and then slight adjustment of the levels and a tweak of sharpness in Adobe Photoshop.

JONATHAN LUCAS (p.139)
Canon EOS 5D with EF24-105mm L. 1/10 sec @ f/4, ISO1000.

STEPHEN GARNETT (p.140)
Canon EOS 1D MkII with 16-35mm Lens. 1/60 sec @ f/11. Off-camera flash. General adjustments in Adobe Photoshop to contrast and levels.

RYAN WILSON (p.141)
Canon EOS 350D @ 27mm. 1/50 sec @ f/8, ISO400.

KAH KIT YOONG (p.142)
Canon EOS 5D MkII with 16-35mm 2.8L. 1/100 sec @ f/11, ISO100, polariser.

SLAWEK KOZDRAS (p.143)
Canon EOS 7D with Sigma 18-250mm. 1/80 sec, f/16, ISO100. Converted to B&W in Adobe Photoshop and contrast enhanced.

ADRIAN HALL (p.144)
Canon EOS 50D with 10-22mm, 10 stop ND filter, captured in RAW, converted to B&W on PC, tripod, wellies, tide-timetables, plenty of strange looks from commuters.

DONALD CAMERON (p.145)
Canon EOS 40D with EF-S 17-85mm f/4-5.6 @ 17mm. 90 secs @ f/16, ISO100. ND 1000x (110) filter.

GORDON FRASER (p.146)
iPhone 3GS. All post processing was done in phone using a couple of apps.

ROBIN SINTON (p.147)
Canon EOS 1Ds with 217-40mm lens at 32mm. 8secs @ f/14. ISO200. No manipulation apart from some spotting and a curves adjustment layer.

VACLAV KRPELIK (p.148)
Canon EOS 550D with Tokina 11-16mm f2.8 IS USM @ 11mm. 280 sec @ f/11, ISO100, Manual mode, Canon shutter release cable and Induro tripod. Two exposures manually blended in Adobe Photoshop.

PAWEL LIBERA (p.149)
Canon EOS 5D with 24-105 f4 @ 58mm. 1/640s @ f8, ISO100.

MARTIN POSNETT (p.150)
Nikon D70S with 18-70mm lens @ 70mm. 1/6400 @ f/4, ISO400.

CHRIS LEDGER (p.151)
Nikon D70 with Nikkor 24-85mm @ 42mm. 1/500sec @ f/11, ISO400. Levels adjustment in Photoshop.

NIGEL HILLIER (p.152)
Nikon D300 with 70-300mm lens @ 70mm. 1/40sec @ f/25, ISO100.

GARY McGHEE (p.153)
Nikon D700 with 50-135mm f/3.5 AIS lens, tripod mounted. 1/2sec @ f/8, ISO200. The NEF file was processed in Nikon Capture NX2.

ANTHONY BRAWLEY (p.154)
Nikon D700 with AF-S 24-70mm f/2.8G ED lens. 30sec @ f/9, ISO400. A single frame RAW (NEF) processed in Nikon Capture NX2 and Photoshop CS4 for minor levels/contrast adjustments and sharpening.

BILLY CURRIE (p.155)
Canon EOS 5D MkII with EF24-105mm F/4 L IS USM @ 28mm. 25 secs @ f/13. Adjustments to white balance, slight crop and dust removal.

ROGER TAPP (p.156)
Canon EOS 5D with EF 28-135mm IS USM @ 135mm. 1/400 sec, f/9, ISO125.

ANDREW JONES (p.157)
Canon EOS 5D MkII with EF28-200mm f/3.5-5.6 USM @ 170mm. 1/8s, f/16, ISO100, polarising filter, tripod. Brightness and contrast adjustments.

JONATHAN LUCAS (p.158)
Canon EOS 20D with EFS 10-22mm lens @ 10mm. 1/750 sec @ f/3.5, ISO200.

MIKE KEMPSEY (p.159)
Canon EOS 5D MkII with TS-E 24mm f/3.5 L. 30 secs, f/11, ISO100.

CHRIS LEDGER (pp.160–161)
Nikon D200 with Nikkor 18-200mm lens @ 24mm. 40 shots all @ f6.3 and ISO100. Mostly at around 1.6 secs. RAW processing to retain shadow detail and to control noise. Stitched using PTgui. Blending in Adobe Photoshop.

ANTHONY BRAWLEY (p.162)
Nikon D700 with Nikon AF-S 14-24mm f/2.8G ED lens (tripod mounted). 2.5 secs @ f/14, ISO200. A single frame, shot as RAW (NEF) and processed in Adobe Camera RAW and Photoshop CS4. Basic contrast/levels adjustments and sharpening only.

KAH KIT YOONG (p.163)
Canon EOS 5D MkII with 16-35mm 2.8L, 1/5 sec @ f/8, ISO100. Gitzo tripod, neutral density grad filter.

SAM CARTWRIGHT (p.166)
Fuji Finepix S8000fd.

TOM COLE (p.166)
Nikon D40X @ 55mm. f/4, ISO400. Image has not been digitally modified.

WILLIAM LEE (p.167)
Canon EOS 300D with EF 28-135mm. 1/160 sec @ f/8, ISO400. Adobe Photoshop CS4 for levels adjustments and conversion to B&W.

WILLIAM LEE (p.167)
Canon EOS 20D with EF 28-90mm. 1/320 sec @ f/11, ISO400. Adobe Photoshop CS4 levels and B&W conversion.

PAUL ROBINSON (p.170)
Nikon D70 with 12-24mm lens @ 12mm.
1/500 sec @ f/13, ISO200. Post-processing
in Adobe Photoshop.

TOM FAIRCLOUGH (p.172)
Canon 400D with Zuiko 200m lens, 1/250
sec, ISO100. Processed using Photomatix
and Adobe Photoshop CS4.

SIMON PARK (p.173)
Hasselblad 501CM, 50mm lens. 4 secs @
f/16. Red Filter. Konica IR 720 film (from an
outdated stock). The negative was scanned
and tonal adjustments were made in Adobe
Lightroom.

PETER MARTIN (p.174)
Bronica SQA, 80mm lens, Fuji Reala film,
1/8 sec @ f22, ISO100, tripod.

STEVE SHARP (p.175)
Canon 20D IR converted. 24mm lens. 1/320
sec @ f/6.3, ISO100. Manipulation – levels
& USM.

MARCIN BERA (p.176)
Nikon D200 with Nikkor 50mm/1.8. 30 secs
@ f/8, ISO100, tripod, cable release.

MARCIN BERA (p.177)
Nikon D200 with Nikkor 50mm 1.8, ISO100.
Sea – using B+W ND 3.0, 601 secs at f/8.
Sky - 1/10 sec at f/8. Blended in Adobe
Photoshop CS4.

MARCIN BERA (p.177)
Nikon D200 with Nikkor 50/1.8. 30 secs @
f/8, ISO100, tripod, cable release.

CEDRIC DELVES (p.178)
Leica M9, 21 Elmarit. 1/6000 sec @ f/5.6,
ISO160. Edited in Adobe Photoshop and
Lightroom.

STU MAYHEW (p.179)
Canon EOS 5D with 70-200mm 2.8 lens @
200mm. 1/2500 sec @ f/2.8. Cropped and
cleaned up in Adobe Photoshop CS3 but no
manipulation has been carried out.

FORTUNATO GATTO (p.180)
Canon EOS 5D MkII with 17-40mm @
17mm. About 20 min @ f/8. Tripod, Remote
Control. Single exposure, no HDR, no
blending, no filters. Some added saturation
and cropping in Adobe Photoshop.

GRAHAM EATON (p.181)
Nikon D200 with 12-24mm lens at 12mm.
1/60th sec @ f/14, ISO200. The camera was
in an underwater housing with 2 flashguns,
to balance the ambient light.

WILCO DRAGT (p.182)
Nikon D700 with AFS 17-35/2.8, tripod,
cable release. No digital manipulation, only
minor Adobe Lightroom adjustments to
white balance, recovery and blacks.

CRAIG EASTON (p.183)
Hasselblad 500CM.

PETER STEVENS (p.184)
Nikon D700 with Nikkor 70-200 f2.8 at
160mm, f/8, ISO200. Some basic tonal
adjustments in Adobe Lightroom.

MARK LAKEMAN (p.185)
Canon EOS 400D with Sigma 18-50mm,
f/16, ISO100, Manfrotto 190 pro, 329 head.

IAN CAMERON (p.186)
Pentax 67II, 55-100 zoom, (panoramic strip
from central portion) Fuji Velvia 50. 1/15 sec
@ f/11. 0.3ND grad, polariser.

ROBERT WOLSTENHOLME (p.187)
Nikon D700 with 28mm f/2.8 AI-s lens,
f/16, blend in Photomatix of five exposures
up to 30 secs. Levels, contrast, brightness,
colour adjustments and sharpening in
Photoshop.

MARK BRADSHAW (p.188)
Nikon D300 with Sigma 10-20mm lens. 1/3
sec at f/8, ISO200, Manual mode, Lee .6
graduated filter (hard). Virtually as shot,
with channel mixer to convert to mono and
a slight curve adjustment to brighten the
snow.

RICHARD JOHNSON (p.189)
Canon EOS 1Ds MkIII, RAW, 24-70mm lens,
adjusted in RAW Developer and DXO Film.

CHRIS LEWIS (p.190)
Nikon D200 with Nikkor 70-300 @ 135mm,
1/350 sec @ f/11, ISO100, Manfrotto
190B tripod, remote release. RAW file
processed in Capture NX2 and adjustments
made using levels/curves. No filters or
manipulation.

STEWART MITCHELL (p.191)
Nikon D80 with Sigma 24-70mm @ 70mm.
1/400 sec @ f/4.0, ISO400.

IAN SNOWDON (p.192)
Nikon D700 with Nikkor 14-24mm Lens @
14mm. f/22, 3 frame HDR -2 0 +2.

JOHN ECCLES (p.193)
Canon EOS 1D MkIII with 70-200 f/2.8 IS
USM lens. 1/500 sec @ f/2.8, ISO400.

ADAM BURTON (p.194)
Canon 1Ds Mk3 with 17-40mm. 20 secs @
f16. No manipulation.

LEE RUDLAND (p.195)
Canon EOS 5D with EF 17-40mm lens @
30mm, 92 secs @ F16, ISO50, 2 stop Lee
ND Grad filter, tripod and cable release.
Adjusted for colour saturation and contrast.

WILCO DRAGT (p.196)
Nikon D700 with AFS 17-35mm/2.8, tripod,
cable release, a jacket to create shadow.
Adjustments in levels and curves.

DOUG CHINNERY (p.197)
Canon G9, 29mm, 1/800 second at f/5.0,
ISO80. RAW format. Image processed in
Adobe Lightroom, Silver Efex Pro & Adobe
Photoshop CS5.

GARY WAIDSON (p.198)
Canon EOS 5D with EF17-40mm f4 L USM
@ 36mm. 1/500 sec @ f/8, ISO100. Tripod
mounted. Two manually blended RAW
conversions. Cool monochrome conversion
and local contrast control.

MARK VOCE (p.199)
Canon EOS 5D MkII with 17-40mm F4 L Lens
@ 17mm, 2 mins @ f/22, Lee 0.9 ND Grad
and B+W 3.0 ND filters.

MARK VOCE (p.200)
Canon EOS 5D MkII with 17-40mm F4 L @
17mm, 4 mins @ f/11, Lee 0.6 ND Hard Grad
and B+W 1.8 ND filters.

PAUL ROBINSON (p.201)
Nikon D70 @ 12mm. 1/320 sec @ f/14.
Post-processing in Adobe Photoshop.

GARY HORNER (p.202)
Canon EOS 40D with Sigma 17-70mm
lens. f/16, ND8 Graduated Filter. Three
HDR exposures @ -1ev; 0ev; +1ev (1/4sec;
1/2sec; 1sec).

ROBERT BIRKBY (p.203)
Canon EOS 5D MkII with 16-35mm zoom at
20mm, Lee ND grad filter, tripod.1/8 sec at
f/16, ISO100. Image straightened, cropped
at top and bottom, and colour levels
adjusted slightly in Adobe Photoshop CS.

COLIN JARVIS (p.204)
Nikon D300 with 70-300mm f/4.5-5.6 lens
@ 170mm. 0.3 sec @ f/29.

JAMES OSMOND (p.205)
Canon EOS 5D with 70-200mm L. 1/320 sec
@ f/16, ISO100.

ROSLIN ZUHA (p.206)
Canon EOS 350D, 1/60 sec @ f/5.

PETER CAIRNS (p.207)
Canon EOS 5D MkII with 500mm lens, 1/15
sec @ f/8, ISO100.

ADRIAN ASHWORTH (pp.208–209)
Canon EOS 5D Mk II with EF16-35mm f/2.8L
USM @ 23mm. Manual 1/4 sec @ f/13,
ISO100. Shot on RAW, Lee Sunrise Filters.
Curves & adjustments in Adobe Photoshop
CS4.

WILLIAM LEE (p.212)
Canon EOS 300D with EF 28-90mm lens. 25
sec @ f/29, ISO100. Levels, curves, cloning,
dodge and burn tools used in Adobe
Photoshop CS4.

JAMIE UNWIN (p.213)
Sony A350, Sigma 18-125mm. Very minor
adjustments in Adobe Photoshop; it is how
it was!

TALIESIN COOMBES (p.214)
Nikon D300 with 18-200mm lens @ 24mm.
1/800 sec @ f.3.8, ISO500.

TALIESIN COOMBES (p.215)
Nikon D300 with 18-200mm lens @ 105mm.
Shutter priority @ f.5.3, ISO250.

INDEX

Adrian Ashworth www.picturistic.co.uk

Marcin Bera marcinbera.com

Robert Birkby www.flickr.com/calderdalefoto

Anthony Blake www.anthonyblakephotography.co.uk

Alessio Bozzo www.sperkmandel.smugmug.com

Mark Bradshaw www.markbradshaw.me.uk

Anthony Brawley www.anthonybrawley.co.uk

Wayne Brittle www.waynebrittlephotography.com

Jon Brook www.benthamimaging.co.uk

Adam Burton www.adamburtonphotography.com

Peter Cairns www.northshots.com

Sam Cairns www.samcairns.com

Donald Cameron www.monophotography.co.uk

Ian Cameron www.transientlight.co.uk

Tristan Campbell www.tristancampbell.co.uk

Martin Chamberlain www.martinchamberlain.com

Matthew Cheetham www.watchlooksee.com

Rob Cherry www.robcherryphotography.com

Doug Chinnery www.dougchinnery.com

Darren Ciolli-Leach 2222photography.co.uk

David Clapp www.davidclapp.co.uk

Brian Clark www.brianclarkphotography.com

Chris Close www.chrisclose.com

Emmanuel Coupe www.emmanuelcoupe.com

Billy Currie www.billycurrie.co.uk

Rhys Davies www.rhysdaviesphotography.com

Wilco Dragt www.wilcodragt.nl

Andrew Dunn www.andrewdunnphoto.com

Graham Dunn www.grahamdunn.co.uk

Craig Easton www.craigeaston.com

Graham Eaton www.eatonnature.co.uk

John Eccles www.johnecclesphoto.co.uk

Martin Edge www.edgeunderwaterphotography.com

Adam Edwards www.adamedwardsphotography.com

Stephen Emerson www.captivelandscapes.com

Tom Fairclough rilkeandream.blogspot.com

Paul Forgham www.paulforgham.co.uk

Andrew Fox www.foxphotographer.com

Gordon Fraser www.inologist.com

Chris Friel www.chrisfriel.co.uk

Fortunato Gatto www.fortunatophotography.com

Thomas Gorman www.thomasgorman.co.uk

Colin Grace www.dartmoorimages.com

Thomas Graham www.digitalpict.com

Adrian Hall www.shootingthevoid.com

Glenn Harper www.glennharper.co.uk

Nigel Hillier www.nigelhillier.com

Gary Horner www.eastcoastimages.co.uk

Chris Howe www.chrishowe.zenfolio.com

Colin Jarvis www.colinjarvis.co.uk

Andrew Jones www.andrewjonesphotography.com

Mike Kempsey www.dt6.biz

David Kendal www.dkendal.co.uk

Paul Knight www.paulknight.org

Vaclav Krpelik www.vaclavkrpelik.com

Mark Lakeman www.redbubble.com/search/lakemans

Dan Law www.flickr.com/photos/dan-law

Jeanette Lazenby www.jeanielazenby.co.uk

Chris Ledger www.chrisledger.com

William Lee www.flickr.com/williamleephotography

Sergey Lekomtsev www.lekomtsev.com

Chris Lewis www.chrislewisphotography.co.uk

Pawel Libera www.liberadesign.co.uk

Krzysztof Ligeza www.krzysztofligeza.com

Jonathan Lucas www.jonathanlucas.com

Peter Martin www.petermartinphotography.co.uk

Stu Mayhew www.flickr.com/photos/stumayhew

Marcus McAdam www.portraitsofaland.com

Gary McGhee www.garymcgheephotography.co.uk

Stewart Mitchell www.earthlylight.co.uk

Alex Nail www.alexnail.com

Krzysztof Nowakowski www.novakovsky.com

James Osmond www.jamesosmond.co.uk

Simon Park www.simonparkphotography.co.uk

Jim Parren www.millpoolphotography.co.uk

Jon Pear www.juicypear.org

Dave Peck www.imageast.co.uk

Marshall Pinsent www.imagepod.com

David Pulford www.pbase.com/dmpulford

Peter Ribbeck www.flickr.com/photos/peterribbeck

John Robinson www.johnrobinsonphoto.com

Lee Rudland www.leerudlandphotography.co.uk

Christopher Russell www.flickr.com/chrisrussellphotography

Jamie Russell www.islandvisions.co.uk

Paul Sansome www.paulsansome.com

Steve Sharp www.stevesharpphotography.com

Damian Shields www.damianshields.com

Robin Sinton www.robinsinton.co.uk

Kevin Skinner www.kevinskinnerphotography.com

Ian Snowdon www.downtoearthimages.co.uk

Antony Spencer www.antonyspencer.com

David Stanton www.stantonimaging.com

Slawek Staszczuk www.pbase.com/bruslaw

Peter Stevens www.peterstevensphotography.co.uk

Roger Tapp rogertapp.com

Gary Telford gtimages.zenfolio.com

Ian Thorne www.iptphotography.co.uk

Alex Varey www.alexanderbeetle.com

Dimitri Vasiliou www.dvattika.com

Mark Voce www.markvoce.com

Gary Waidson www.waylandscape.co.uk

Andrew Whitaker www.northern-horizons.co.uk

Matt Whorlow www.matt-photo.co.uk

Jacquie Wilkes www.jacquiewilkes.co.uk

Dudley Williams www.dudleywilliams.com

Karl Williams shuggie.redbubble.com

Ryan Wilson www.ryanwilsonphoto.com

Robert Wolstenholme www.flickr.com/photos/rob_wolstenholme

Kah Kit Yoong www.magichourtravelscapes.com

Tatiana Zigar www.tatianazigar.com